MASTER DRAWINGS FROM THE WOODNER COLLECTION

MASTER DRAWINGS FROM THE WOODNER COLLECTION

by George R. Goldner

❧

THE J. PAUL GETTY MUSEUM
MAY 28 – AUGUST 12, 1983

❧

KIMBELL ART MUSEUM
SEPTEMBER 10 – NOVEMBER 13, 1983

❧

THE NATIONAL GALLERY OF ART
DECEMBER 18, 1983 – FEBRUARY 26, 1984

© 1983 The J. Paul Getty Museum
17985 Pacific Coast Highway
Malibu, California 90265

mailing address: P.O. Box 2112
Santa Monica, California 90406
telephone: (213) 459-2306

Library of Congress number 82-049023
ISBN number 0-89236-049-6

Goldner, George R., 1943-
 Master drawings from the Woodner Collection.

Exhibition held at the J. Paul Getty Museum,
5/28-8/12/83; Kimbell Art Museum, 9/10-11/13/83; and the
National Gallery of Art, 12/18-2/26/84.
 Includes Index.
1. Drawing, European—Exhibitions. 2. Woodner, Ian
—Art collections—Exhibitions. I. J. Paul Getty
Museum. II. Kimbell Art Museum. III. National Gallery
of Art (U.S.) IV. Title.
NC225.G64 1983 741.94'074'013 82-49023
ISBN 0-89236-049-6

TABLE OF CONTENTS

Ian Woodner

DIRECTORS' PREFACE

This distinguished collection of Old Master drawings comes from one of the most important private holdings in the United States. The Woodner Family Collection spans more than five hundred years of European art and features an exceptional group of drawings from the beginnings of modern draughtsmanship in the fourteenth and fifteenth centuries. An architect by training, Mr. Woodner began assembling his collection in 1955 and since then has created one of the most representative collections still in private hands. His passion for Redon, Seurat, and Bresdin is equalled, if not surpassed, by his enthusiasm for older masters like Fra Bartolommeo and Barocci. The collection contains fine works by Taddeo Gaddi, Raphael, Bruegel, Cellini, Rembrandt, and Matisse. The exhibition of seventy-seven works, many of which will be publicly shown for the first time, will be a revelation for those who delight in the beauty of line, and immediacy of expression, of the finest master drawings.

The J. Paul Getty Museum, the Kimbell Art Museum, and the National Gallery of Art are grateful that Ian Woodner, Jonathan Woodner, Diane Woodner-Bamford, and Andrea Woodner have agreed to share these treasures with their visitors. Special thanks are due to George R. Goldner, Curator of Drawings at the Getty Museum, for organizing the exhibition and writing the catalogue, and also to Konrad Oberhuber of the Fogg Art Museum, Harvard University, and to Andrew Robison, Curator of Graphic Arts at the National Gallery, for their work on the exhibition.

OTTO WITTMANN EDMUND P. PILLSBURY J. CARTER BROWN

COMPILER'S ACKNOWLEDGMENTS

This catalogue has been the product of the constructive and friendly collaboration of many individuals with whom I have been pleased to work over the last months. The list of drawings to be included in it has gradually evolved and has represented the combined views of my distinguished colleagues Edmund P. Pillsbury, Konrad Oberhuber, and Andrew Robison, as well as my own. Only those drawings which all four of us supported were included, leading to some stimulating and illuminating discussions at various points. Fortunately, the Woodner collection contains so many fine drawings that we had a surplus even after so cautious a procedure. The discussions I have had with these three outstanding connoisseurs have been very helpful in formulating ideas for the catalogue, and I am grateful to each of them.

The catalogue itself has been compiled with the active assistance of many people. First among them is Professor Konrad Oberhuber who organized, orchestrated, and reviewed the preliminary reports on each drawing that were sent to me and that were important in the formulation of the entries in the catalogue. William Robinson, Eunice Williams, Tracie Felker, and a number of students at the Fogg Art Museum, Harvard University (Barbara Baxter, Elizabeth Coombs, Henry Fernandez, Joseph Hershenson, Michael Miller, Carol Smiley, Miriam Stewart, and Susan White), as well as Konrad Oberhuber himself, contributed individual reports that were accompanied by material on condition supplied by members of the Conservation of Paper Department of the Fogg. Jacqueline Tarrant, R.J. Tarrant, and Eckehard Simon transcribed and commented on the fourteenth century inscription on no. 37. I have also greatly benefited from the suggestions made to me by Professor Christiane Andersson about several of the early German drawings. In many cases new ideas were proposed in these reports, and their formulators are duly cited in the texts of the relevant entries. Although I have benefited from all the material sent to me by this small army of fine scholars under the leadership of one of the great connoisseurs of our time, I have departed in certain instances from their suggestions. This is inevitable and in no way diminishes my respect or gratitude to each of them and to Professor Oberhuber in particular. Finally, responsibility for all entries has resided with me, and whatever fault is to be found in the catalogue is mine alone.

Several people have assisted with the catalogue at the Getty Museum. The museum's editor, Sandra Knudsen Morgan, and its designer, Patrick Dooley, have made every effort respectively to improve the literary merit of my entries and to produce a fittingly handsome book. To both of them, and to Barbara Hartmann and Susan Damsky, who checked the footnote references, and to Mary Holtman, who had the mountainous task of typing the entries, goes my gratitude. Andrea Woodner and Ann Philbin unhesitatingly devoted their time to preparing the drawings for exhibition and the special photographic needs of the catalogue.

The Woodner Family Collection has frequently attracted critical and scholarly attention both in Europe and in America. Ian Woodner and his family have been generous in lending individual drawings to special exhibitions over the past twenty years, and extensive selections of his drawings have been exhibited as a group on two occasions: *Woodner Collec-*

tion 1; A selection of Old Master Drawings before 1700, shown at the William H. Schab Gallery, New York, the Los Angeles County Museum, and the Indianapolis Museum of Art in 1971 and 1972 (here abbreviated as Woodner Collection 1) and *Woodner Collection II; Old Master Drawings from the XV to the XVIII Century,* shown at the same locations in 1973 and 1974 (here abbreviated as Woodner Collection 2).

Lastly, a special word of appreciation is due to Ian Woodner. To every true collector, his drawings are like children in whom he has pride and love. It is never easy to have outsiders assess them with relatively clinical objectivity. It is to Ian Woodner's credit that he has seen the merit of this process and has taken an active interest in this catalogue, reflecting the most complete and accurate evaluation of each of the drawings in it.

G.R.G.

INTRODUCTION

The collecting of drawings has always been a field in which artists themselves have played a major role. As early as the first half of the fifteenth century, Lorenzo Ghiberti owned drawings by some of his predecessors, including perhaps Giotto. The early preservation of drawings may well have derived principally from the use of model books in workshops, which allowed images to be recorded and passed on for use by the next generation as well as by contemporary members of the same workshop. This was surely the case with the famous group of Jacopo Bellini drawings now in the Louvre and the British Museum, which were inherited by Bellini's eldest son, the painter Gentile Bellini. In addition, we know that drawings and cartoons by great early Renaissance artists were kept in the house of Lorenzo de' Medici, where young art students could study them. We may speculate whether in at least some instances the early preservation of drawings may not also have been founded on the instinct to save the intimate record of a great figure of the past, and that Ghiberti's possessing a few drawings by Giotto may have been the result of his historic sense rather than any functional use to which the drawings could be put.

We will perhaps never be certain about why certain drawings were saved in the fourteenth and fifteenth centuries, but we can be sure that collecting in the sense that we think of it today began in earnest in the sixteenth century. Dürer was an important figure in this development. He signed and dated many of his drawings, thereby revealing a historical sense about them, and proudly inscribed for posterity a great drawing he received from Raphael. He was also one of the first artists we know of to receive payment for drawings, being frequently remunerated for the portrait drawings he did in the Netherlands. In Italy at this time, Michelangelo made finished presentation drawings, unconnected to paintings or sculptures, which he gave to friends as gifts. However, we also know that he destroyed some of his drawings for the Sistine ceiling so that no one would realize his difficulty in conceiving its decoration.

It was Michelangelo's friend and biographer, the artist and architect Giorgio Vasari, who first created a collection of drawings in the modern sense. His interest was exclusively in Italian drawings, and his approach largely historical. And, like centuries of collectors (and museum curators) to come, he often mistook the hand of one artist for that of another, as the connoisseurship of drawings was — and still is — perhaps the most perilous of all. By the end of the sixteenth century, collecting became the domain of not only artists but also of other collectors. This continued to be the case throughout the next four centuries, though a steady stream of great artist-collectors continued, especially in England with great figures such as Lely, Reynolds, Richardson, and Lawrence.

Ian Woodner is a spiritual descendant of these great artist-collectors, though no one today could hope to amass the riches of these and other collectors of past centuries. He studied architecture at the University of Minnesota and Harvard University and has achieved great success as a real estate developer. At the same time, he has been an active artist himself, painting in a sensitive and poetical manner which owes much to the example of Odilon Redon. This admiration for Redon extends into his collection, and Woodner owns fine examples of Redon's paintings, pastels, and drawings.

The Woodner collection is difficult to characterize briefly. It encompasses drawings of very many different schools, styles, and media, perhaps having greater range and diversity than any private collection in our time. It is remarkably strong in early drawings, especially when one considers how rare they have become in recent years. Beginning with a montage of drawings probably by Taddeo Gaddi, that may have once belonged to Ghiberti and Vasari, and continuing though a diverse group of Italian and Northern fifteenth and early sixteenth century examples, the Woodner collection reflects his keen interest in the beginnings of Western drawing and its early evolution. The collection has great strengths in each period and almost every major European school of drawing, and at the same time includes drawings for almost every taste and mood. It is also very much an exploratory collection, with unattributed and sometimes difficult drawings beside masterworks by artists of great renown. This is all the more admirable in an era in which ever higher prices and excessive timidity have led many a contemporary collector (and curator) to pursue only the blue-chip drawing, thereby denying both the richness of diversity in drawing and the most revered traditions in its collecting history.

The current exhibition has selected a relatively small number of drawings from the Woodner collection. Many were obvious choices, beginning with such masterpieces as the Cellini and the Saenredam, whose inclusion needs no explanation. In other cases, drawings were included for their great rarity as well as for their beauty, this being especially true of the early examples. And a degree of balance was sought between periods, styles, and types of drawings. Therefore, the visitor to this exhibition may see drawings spread over six centuries, executed in virtually every medium, and made for a wide range of purposes. There are many preparatory studies for paintings (beginning with the Taddeo Gaddi), one or two for sculpture (the Cellini and perhaps the Bandinelli), designs relating to the theater, opera, and ballet (Gillot, Moreau, and Picasso), book illustrations (Strassburg Chronicle), and many independent compositions and figure studies. An effort has also been made to add drawings of significance which have been unpublished or inadequately treated in the literature on drawings. At the same time drawings such as the three Seurats are well known and are included for their beauty and the opportunity they allow for us to see his evolution as a draughtsman during the critical mature years of his career.

COLOR PLATES

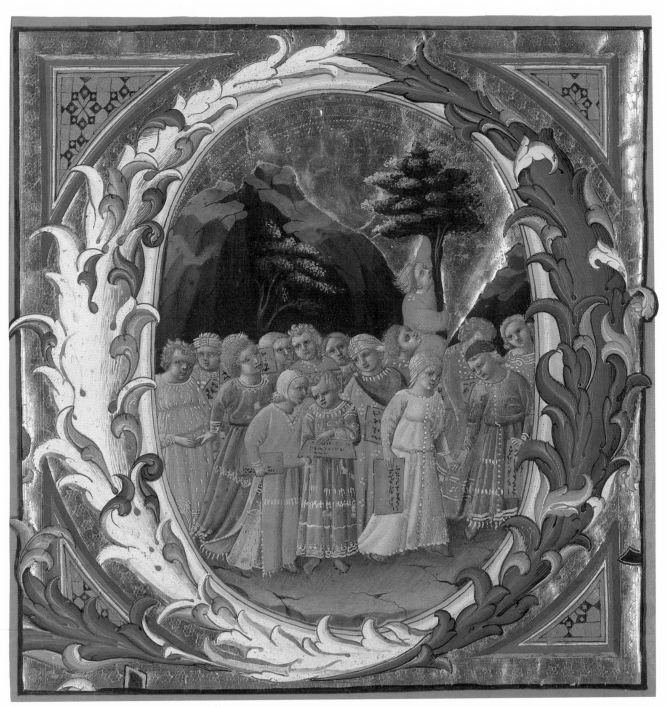

Colorplate 1. ZANOBI STROZZI, *A Procession of Children* (No. 2).

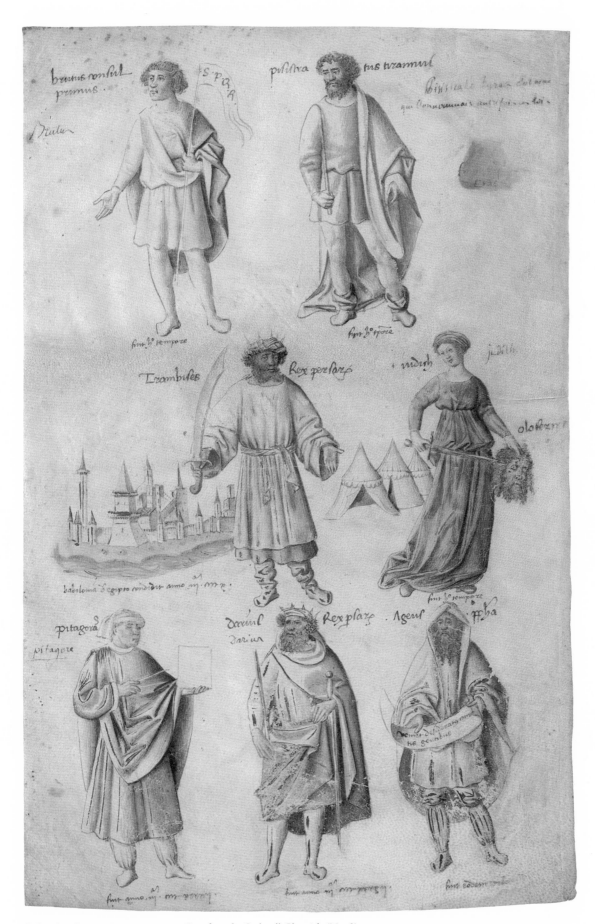

Colorplate 2. FLORENTINE SCHOOL, *Page from the Cockerell Chronicle* (No. 3).

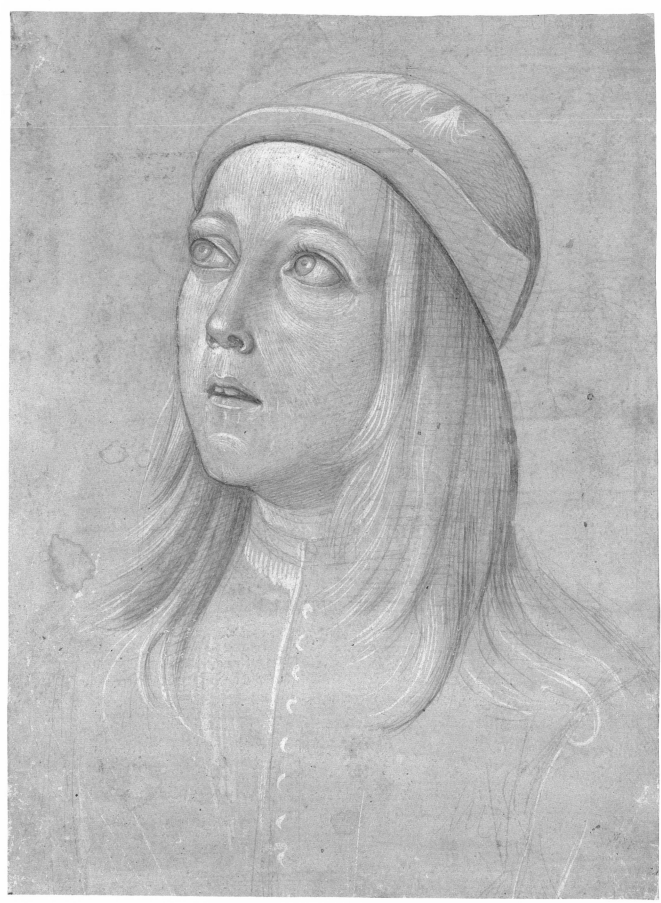

Colorplate 3. UMBRIAN SCHOOL, *Portrait of a Youth* (No. 6).

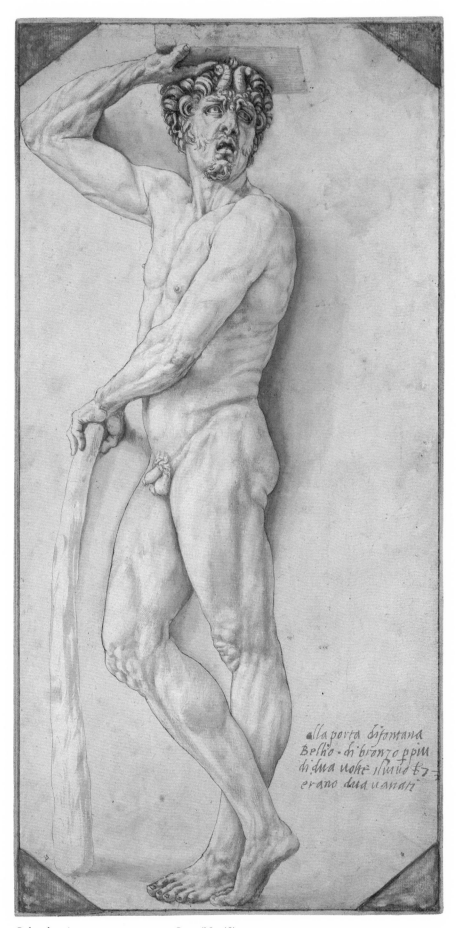

alla porta difontana
Bello · chi bronzo ppiu
di dua uolte ilmino ⁊
erano dua uanari

Colorplate 4. BENVENUTO CELLINI, *Satyr* (No. 18).

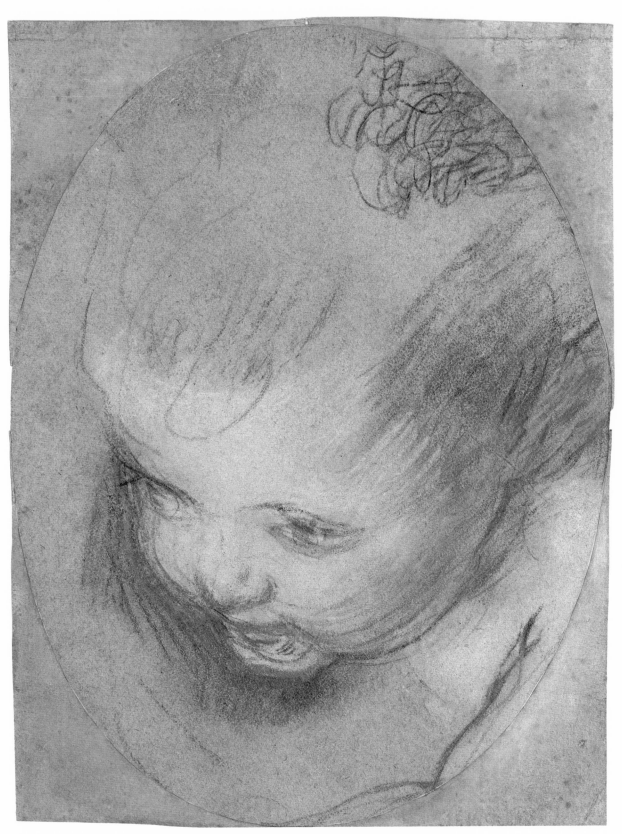

Colorplate 5. FEDERICO BAROCCI, *Study of the Head of a Boy* (No. 23).

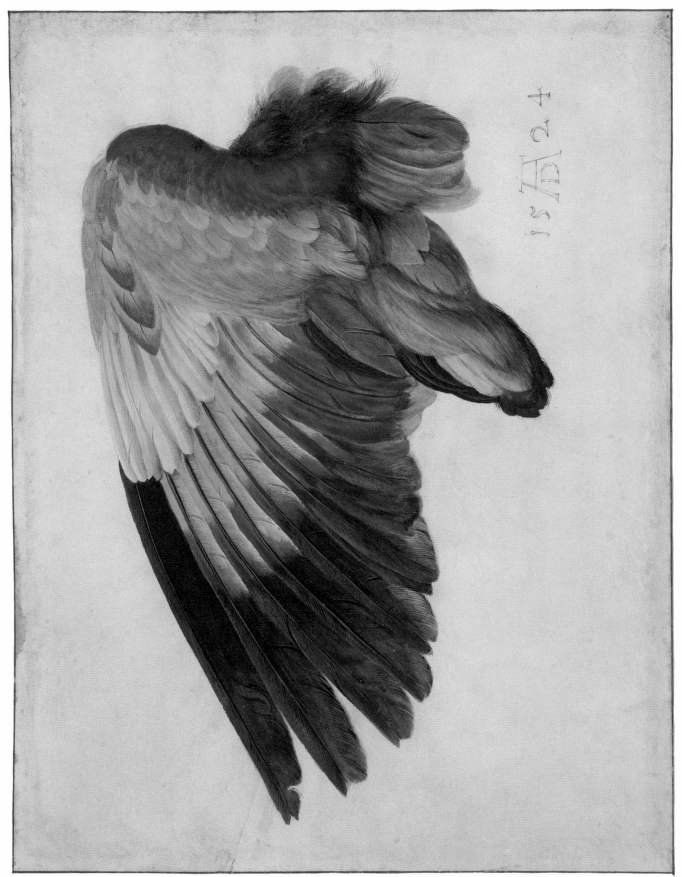

Colorplate 6. ALBRECHT DÜRER (attributed to), *Left Wing of a European Roller* (No. 42).

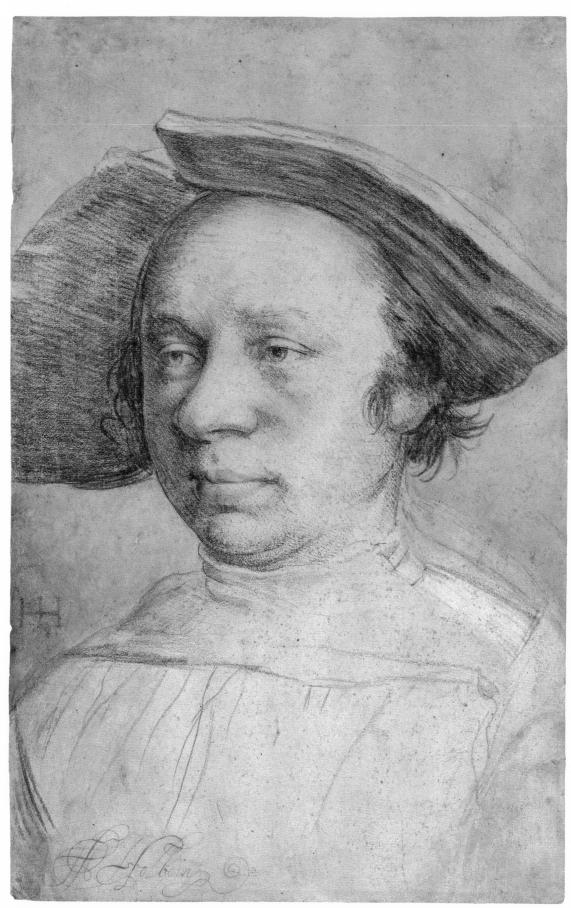

Colorplate 7. HANS HOLBEIN THE YOUNGER (attributed to), *Bust of a Young Man* (No. 43).

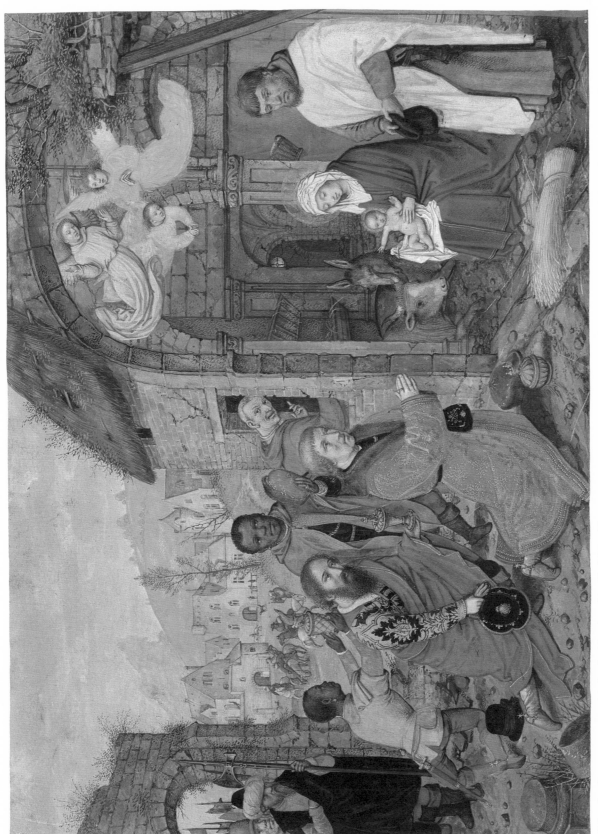

Colorplate 8. SIMON BENING (circle of), *Adoration of the Magi* (No. 45).

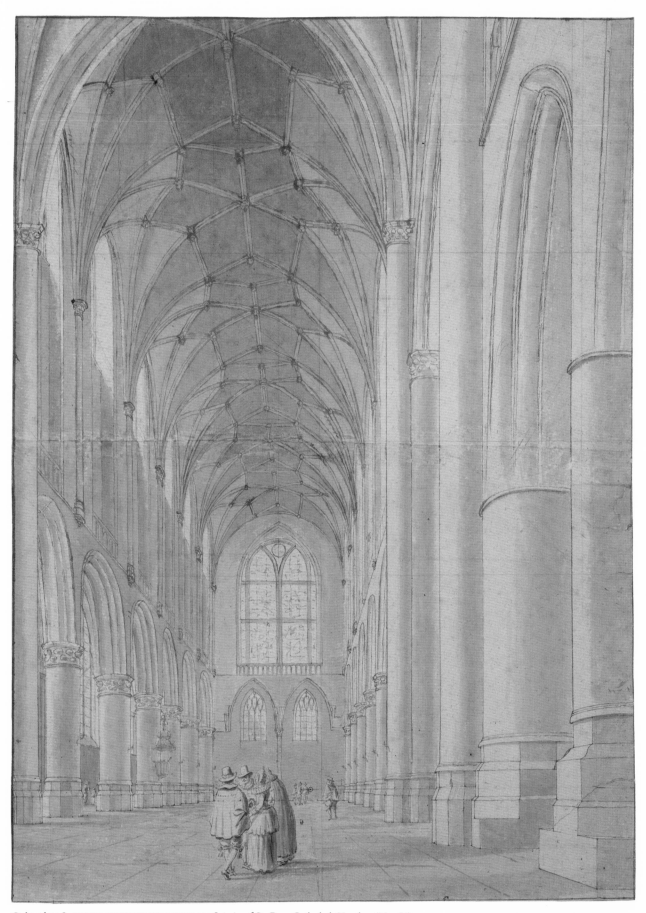

Colorplate 9. PIETER JANSZOON SAENREDAM, *Interior of St. Bavo Cathedral, Haarlem* (No. 51).

ITALIAN DRAWINGS

1 TADDEO GADDI (or his circle)

Florence circa 1300 – Florence 1366

Studies of St. Francis Kneeling and Other Figures

Brush and brown ink and brush and white gouache on green prepared paper; 401 x 246 mm. Inscribed on mount, "Giotto fiorentino, mori anno 1336 e sepolto in sta. Maria dei fiore".

PROVENANCE: John Clerk, Lord Eldin (1757-1832); sale, Winstanley and Sons, Edinburgh, 1833, lot 225: "nine various, early Italian Masters, Giotto, etc."; Sir Archibald Campbell, 2nd Bart. of Succoth (1769-1848); Sir Ilay Campbell (Christie's, London, 26 March 1974).

This drawing is made up of three sheets mounted to a backing. The two figures at the lower left continue through both of the lower sheets, indicating clearly that they were once part of the same drawing. The top section may have also come from the same original sheet, but this is not demonstrable. In addition, the drawing is filled in with smaller fragments which have been trimmed to replace various gaps in the drawing; for example, the figure at the center has been given the head of a woman, even though it seems surely to have been a man in the original drawing. The decorative scrolls and inscriptions were added at the time that the black ink frame was drawn, presumably in the sixteenth century.

The upper section of the drawing contains studies for a kneeling St. Francis and for his drapery. The St. Francis is repeated with minor variations at the lower left and is followed by studies for a female figure and an angel. In the middle register are shown three sleeping figures who seem to have been made in connection with a scene of the Agony in the Garden. All of these parts of the drawing are uniform in style, and there can be do doubt that they are by the same artist. The St. Francis studies are connected to the fresco of the *Lignum Vitae* in the former refectory of the Convent of Santa Croce, Florence, which is generally attributed to Taddeo Gaddi by modern scholars.[1] There are differences of minor detail between the fresco and the drawing, and the former is generally more monumental and sculptural. These distinctions promote rather than argue against the attribution to Taddeo.

The fresco of the *Lignum Vitae,* St. Bonaventura's vision of Christ on the cross as the Tree of Life, was ascribed to Giotto by the Anonimo Magliabecchiano and by Giorgio Vasari.[2] It is possible, as has been suggested by Degenhart and Schmitt, that the attribution of the drawing to Giotto by the person who mounted it and made the scrolls at the sides was derived from his knowledge of the relationship between drawing and fresco.[3] Ragghianti Collobi lists it as having come from Vasari's collection on account of the scrolls,[4] but this is not certain. If true, the Woodner drawing might earlier have belonged to Ghiberti, since we know that Vasari acquired drawings he believed to be by Giotto from Ghiberti's heirs.[5]

1. Eve Borsook, *The Mural Painters of Tuscany,* 2nd ed., Oxford, 1980, pp. 42-43.
2. For a review of the source material see Bernhard Degenhart and Annegrit Schmitt, *Corpus der Italienischen Zeichnungen 1300-1450,* Berlin, vol. 1, 1980, pt. 1, no. 25, pt. 3, pl. 50.
3. Ibid.
4. Licia Ragghianti Collobi, *Il Libro de' disegni del Vasari,* Florence, 1974, p. 29.
5. Giorgio Vasari, *Le Opere di Giorgio Vasari,* ed. G. Milanesi, Florence, 1906, vol. 1, p. 409, vol. 2, p. 249; Richard Krautheimer, *Lorenzo Ghiberti,* preface to the sec-

ond printing, Princeton, 1970, pp. ix-x.

EXHIBITIONS: Glasgow City Art Gallery, 1953, no. 41; *Old Master Drawings from American Collections,* catalogue by Ebria Feinblatt, Los Angeles County Museum of Art, 29 April - 13 June 1976, no. 2, p. 14.

BIBLIOGRAPHY: Bernhard Degenhart and Annegrit Schmitt, *Corpus der Italienischen Zeichnungen, 1300-1450,* Berlin, 1980, vol. 1, pt. 1, no. 25, pp. 68-69, pt. 3, pl. 50; Licia Ragghianti Collobi, *Il Libro de' disegni del Vasari,* Florence, 1974, no. 15, p. 29.

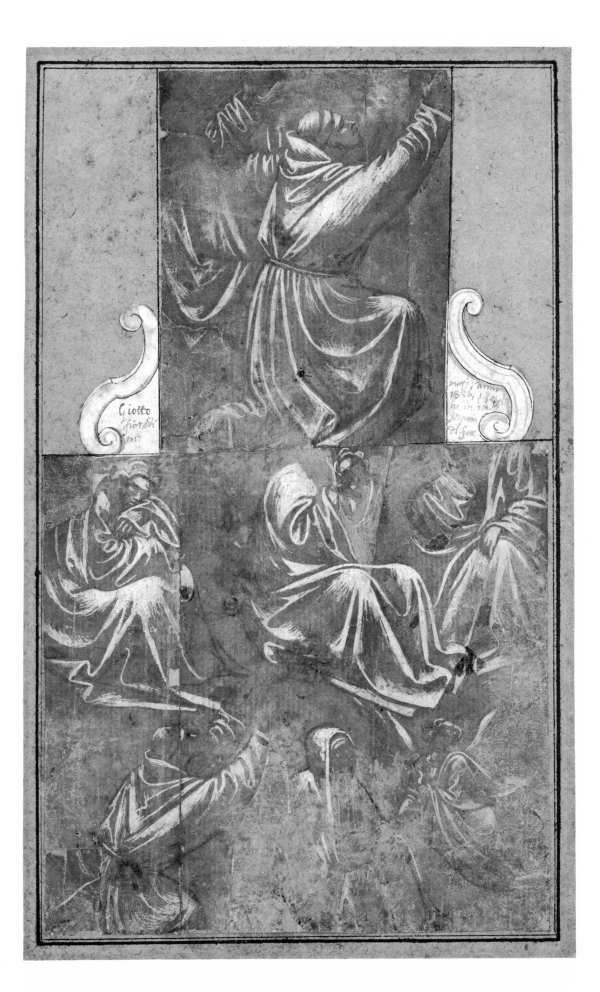

2 ZANOBI STROZZI

Florence 1412 – Florence 1468

A Procession of Children

Tempera on vellum, the background of burnished gold; 218 x 208 mm.

PROVENANCE: Samuel Woodburn (Christie's, London, 25 May 1854, lot 982); H.G. Bohn (Christie's, London, 23 March 1885, lot 535); Sir Herbert Jekyll, R.E., K.C.M.G.

This illuminated miniature shows fifteen children in a procession, one of whom is climbing a tree in the right background. The subject of the illumination is not known, but the illustration is inscribed within an initial made of elaborate foliated decoration which is, in turn, set within a square with borders decorated in burnished gold.

The Woodner miniature has been ascribed to Zanobi Strozzi, though it is unclear who first made the attribution. Strozzi was a fine illuminator and painter working in the circle of Fra Angelico. There are several documented manuscript illuminations by his hand, around which scholars have grouped many more paintings and illuminations, sometimes with too much enthusiasm. M.L. D'Ancona has characterized Strozzi's manner very well as showing specific mannerisms such as an absence of anatomical structure, heavy and pasty drapery folds, faces with wide cheekbones which become pointed at the chin, round eyes marked by shadow, bony hands that do not really grasp objects, and compositions with figures crowded into the foreground which are out of proportion to the space that contains them.[1] This describes many of the characteristics found in the Woodner miniature. The attribution to Strozzi is further supported by the clear similarities between the drawing and several of the predella panels of the Prado *Annunciation* (*Marriage of the Virgin* and *Death of the Virgin*) and the Annalena altarpiece (*The Attempted Martyrdom of SS. Cosmas and Damian by Fire,* Florence, Museo di San Marco).[2] On the other hand, the Woodner illumination is somewhat less closely related to the documented miniatures by Strozzi, and the attribution must thus remain somewhat open to question.[3] The quality of the illumination is high, revealing great subtlety of color and texture. If by Strozzi, it may well come from the period of the mid-1440's when his art was given special stimulus by the example of Fra Angelico, in particular the latter's work of the previous decade.

1. M.L. D'Ancona, "Zanobi Strozzi reconsidered," *La Bibliofilia,* vol. 61, Disp. 1, 1959, pp. 21-22.
2. John Pope-Hennessy, *Fra Angelico,* 2nd ed., Ithaca, New York, 1974, pp. 194, 211-212 for these two sets of predella panels.
3. For the documented miniatures of Strozzi, see M.L. D'Ancona, op. cit., pp. 10-20.

EXHIBITIONS: None.

BIBLIOGRAPHY: None.

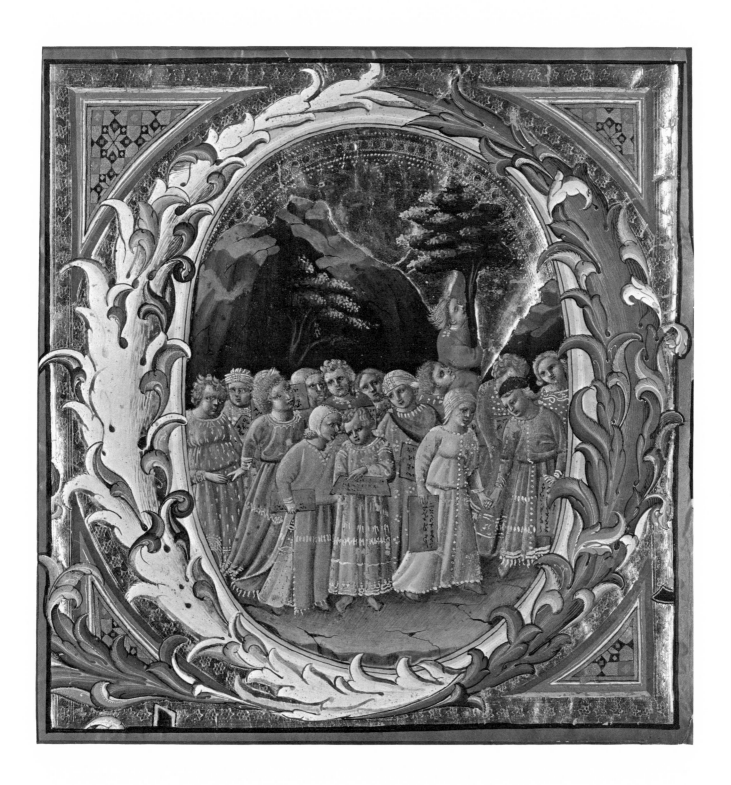

3 FLORENTINE SCHOOL

Circa 1450

Page from the Cockerell Chronicle with Brutus; Peisistratus; Cambyses, King of Persia and a view of Babylon; Judith with the Head of Holofernes; Pythagoras; King Darius; and the Prophet Haggai

Pen and brown ink, black ink, and colored washes on vellum; 313 x 202 mm. Each figure inscribed with a name and description in Latin (and French by a later hand).

PROVENANCE: French collection (?); Quaritch, London; William Morris, Kelmscott House (purchased 1894, sold 1896); Charles Fairfax Murray (Sotheby's, London, 18 July 1919); Sir Sydney Cockerell (Sotheby's, London, 2 July 1958, lot 22); Private collection (Sotheby's, London, 4 July 1977, lot 152).

This page once formed part of a group of eight drawings which belonged to William Morris, Charles Fairfax Murray, and Sir Sydney Cockerell; a ninth related drawing was discovered separately in England (now in the Berlin Museum).[1] These all once formed part of a much larger group of images making up a universal chronicle that contained images of heroic men and women from the Bible, classical history, legend, and the Middle Ages arranged in chronological order. Related manuscripts are in the Biblioteca Reale, Turin (cod. 102), the Gabinetto Nazionale de le Stampe, Rome ("Il Libro del Giusto"), the British Museum ("Florentine Picture Chronicle"), and the Crespi Collection, Milan.[2] The closest connection is with the Crespi manuscript from which the Cockerell leaves were derived. The Crespi manuscript was based upon a fresco decoration which is now lost but which may be the cycle probably painted by Masolino in the Casa Orsini at Monte Giordano, Rome in the 1430's.[3] Leonardo da Besozzo, who signed the Crespi manuscript, presumably took over from the frescoed model the fictive pavements upon which the figures stand and perhaps also the ultramarine background. The artist of the Cockerell leaves does away with these derivations and copies only the figures, setting his figures against the uncolored parchment pages. The derivation of the Cockerell group from the Crespi manuscript enables us to estimate its original size, since the latter is made up of twenty-two pages, with illuminations on both the verso of each leaf.

The Cockerell leaves are delicately colored in red, green, blue, and lavender, which together with the expressive character of the faces of the images has led many scholars to consider them to be of Florentine origin. On the other hand, they bear French inscriptions (as well as the derivative Latin ones), suggesting to others that the artist who drew them was French; Toesca has proposed the participation of the young Jean Fouquet on the manuscript.[4] The French notations could as easily indicate an early provenance as French authorship, and the weight of stylistic evidence favors the view taken by Berenson that the Cockerell leaves are Florentine work of the mid-fifteenth century.[5]

1. The eight leaves belonging to Cockerell were sold as separate lots at Sotheby's, London, 2 July 1958, and are now dispersed.
2. Bernhard Degenhart and Annegrit Schmitt, *Corpus der Italienischen Zeichnungen: 1300-1450,* pt. 1, vol. 2, Berlin, 1968, pp. 573-621.
3. Robert W. Scheller, *Bulletin van het Rijksmuseum* (Amsterdam), no. 2/3, 1962, p. 61.
4. Ilaria Toesca, *Paragone,* vol. 3, no. 25, 1952, p. 20.
5. Bernard Berenson, *Drawings of the Florentine Painters,* Chicago, 1938, no. 164c, p. 35; *European Drawings from the National Gallery of Canada,* catalogue by Myron Laskin, Ottawa, 1969, no. 1, p. 13.

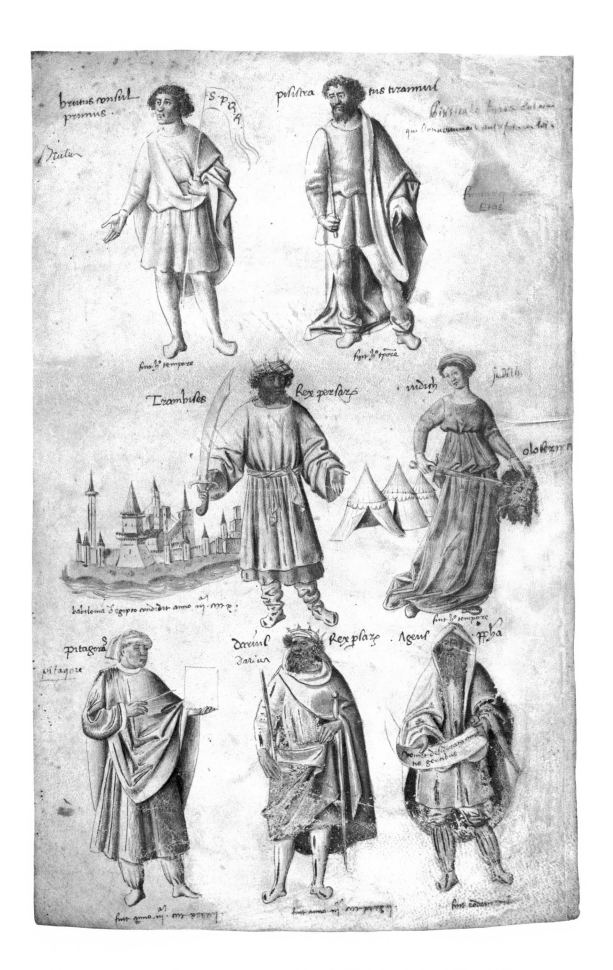

EXHIBITIONS: Society of Antiquaries, London, 1896; *Arte Lombarda dai Visconti agli Sforza,* Milan, 1958, no. 202, p. 64; *European Drawings from the National Gallery of Canada,* catalogue by Myron Laskin, National Gallery of Canada, Ottawa, 1969, no. 1, pp. 12-13; *Antiquity in the Renaissance,* catalogue by Wendy Stedman Sheard, Smith College Museum of Art, Northampton, Massachusetts, 6 April - 6 June, 1978, no. 101.

BIBLIOGRAPHY: Ursula Hoff, "Meditations in Solitude," *Journal of the Warburg Institute,* vol. 1, 1937-38, pp. 292-294; Bernard Berenson, *Drawings of the Florentine Painters,* 2nd ed., Chicago, 1938, no. 164c, p. 17 (and third edition, 1961, no. 164c, p. 35); Ilaria Toesca, "Gli Uomini Famosi della Biblioteca Cockerell," *Paragone,* vol. 3, no. 25, 1952, pp. 16-20; L. Grassi, *Il disegno italiano dal trecento al seicento,* Rome, 1956, p. 86; R. W. Scheller, "Uomini Famosi," *Bulletin van het Rijksmuseum, Amsterdam,* vol. 10, 1962, pp. 56-57; Claus Virch, *Master Drawings in the Collection of Walter C. Baker,* New York, 1962, no. 1, pp. 11-12; R. W. Scheller, *A Survey of Medieval Model Books,* Haarlem, 1963, p. 206; A. E. Popham and K. M. Fenwick, *European Drawings in the Collection of the National Gallery of Canada,* 1965, under no. 1; Carmen Gomez-Moreno, *Medieval Art from Private Collections,* The Cloisters, New York, 1968-69, no. 19.

4 GIOVANNI BADILE

Mid-fifteenth century

Profile Head of a Boy

Pen and greenish-brown ink with some brush on cream colored paper; 207 x 153 mm. Inscribed on recto in greenish-brown ink, "joane badille qual fu prete-" and "2".

PROVENANCE: Antonio Badile, 1500, formerly in an album inscribed with this date; Moscardo; Christie's, London, 6 July 1982, lot 20.

This drawing comes from a well-known album that once belonged to the Moscardo family.[1] It has been related to a portrait drawing of a young man in the Art Institute of Chicago that came from the same source and bears a similar inscription which reads, "joane badille prete."[2] In the catalogue of the Italian drawings in the Art Institute it was suggested that the inscription refers to the sitter, but as Konrad Oberhuber now notes, this is not possible in view of the Woodner drawing and its inscription.[3] It must therefore indicate the name of the artist, as is the case with inscriptions on other drawings from the Moscardo album.

The determination of which member of the Badile family is cited in the inscription is not easy. There was one Giovanni Badile who was a priest ("prete") as indicated by the inscription, who lived from 1449 to 1514. He was the grandson of the better known painter Giovanni Badile (1379-1448). However, it is unlikely that he is the artist who made these drawings, since the inscriptions seem to date from 1500, when Antonio Badile owned the album which bears this date and this Giovanni Badile was not yet dead ("fu prete" on the Woodner inscription). Oberhuber has noted a reference to another Giovanni Badile who was a priest and a painter and who was the son of Bartolommeo Badile and grandson of the first Giovanni Badile.[4] Unfortunately, we know nothing about this artist, so this interesting proposal must remain unconfirmed at this point.

There are two documented works by a Giovanni Badile from the middle of the fifteenth century, the period from which these two drawings must have emerged. One is the fresco with scenes from the life of St. Jerome in Santa Maria della Scala, Verona, of 1443-4; the other is the polyptych with the Madonna and Child, six saints, and a donor in the Museo di Castelvecchio, Verona.[5] The latter is signed "Johes Bajli," and although this signature has been doubted on occasion, there seems little reason for questioning its authenticity. The face of the donor in the polyptych closely parallels that of the boy in the Woodner drawing. This is not only a matter of specific similarities, as in the eyes, but also of the overall character of the image. This would suggest that the drawing is either by the same hand or by someone very close to the painter of this altarpiece.

The foregoing analysis leaves one major point unresolved: the identification of the Giovanni Badile who seems to have drawn it and the related drawing in the Art Institute of Chicago. In spite of this, it is clear that the Woodner drawing comes from the Badile workshop and that it is a sensitively made image, characteristic of that relatively provincial city from about the middle of the fifteenth century. At the time of the Christie's sale in July 1982, it was claimed by some that the drawing was suspect; but the stylistic evidence combined with the clear provenance of the drawing from the Moscardo album should allay such fears with certainty.

1. This was kindly confirmed in a letter from Carlos van Hasselt to Konrad Oberhuber.

2. Harold Joachim and Suzanne Folds McCullagh, *Italian Drawings in the Art Institute of Chicago,* Chicago, 1979, no. 1, p. 19.

3. Ibid.

4. V. Cavazzocca Mazzanti, "I Pittori Badile," *Madonna Verona (Bollettino del Museo civico di Verona)*, vol. 6, 1912, p. 18, n. 1.

5. For a review of the source material on these works, see Pierpaolo Brugnoli, *Maestri della pittura veronese,* Verona, 1974, pp. 75-82.

EXHIBITIONS: None.

BIBLIOGRAPHY: None.

5 FILIPPINO LIPPI

Florence 1457/8 - Florence 1504

Design for an Ornamental Structure

Pen and brown ink on cream colored paper; 165 x 253 mm.

PROVENANCE: Sir J. C. Robinson; John Malcolm; Hon. A. E. Gathorne-Hardy; Geoffrey Gathorne-Hardy; Hon. Robert Gathorne-Hardy (Sotheby's, London, 28 April 1976, lot 10).

Berenson has suggested that this drawing represents a first thought for the top of the altar in the fresco of *St. Philip Exorcizing* in the Strozzi Chapel, Santa Maria Novella, Florence.[1] Although the specific motifs in the drawing barely correspond to those in the fresco, there is reason to feel that Berenson was correct. The character of the ornamental and figurative forms has a great similarity to those in the fresco, with Filippino's rather wild and expressive personal interpretation of antique art given free rein. In addition, the indications of perspective in the drawing (note especially the upper left edge of the altar) suggest that it was to be seen from below, as is true of the fresco. Although they differ in many respects, the Woodner drawing, like the fresco, includes all the elements of a pagan altar, with a central figure of a god, possibly Mars.

Most, if not all, of the work on the Strozzi Chapel was executed between 1494 and 1502. Filippino's important drawing for the *Raising of Drusiana* (Uffizi 186 E) is in a style quite similar to that of the Woodner drawing. As Shoemaker pointed out, it shares with the Uffizi drawing the handling of figures with tiny hands and feet and heads with dotted features.[2] The balance of existing evidence, therefore, sustains the opinion of Berenson and indicates a date of about 1495.[3]

1. Bernard Berenson, *The Drawings of the Florentine Painters,* 2nd ed., Chicago, 1938, vol. 2, no. 1353a, p. 151.
2. Innes Howe Shoemaker, *Filippino Lippi as a Draughtsman,* diss., Columbia University, 1975, vol. 1, no. 114, p. 375.
3. There are a small group of ornamental drawings by Filippino which are generally comparable to details in the Woodner drawings (Uffizi 1632 E, 1634 E, 1635 E, 1637 E); none are apparently related to documented work by him and therefore cannot assist in dating the Woodner drawing.

EXHIBITIONS: *Loan Exhibition of Old Masters from the Collection of Mr. Geoffrey Gathorne-Hardy,* P. and D. Colnaghi and Co., London, 12 October - 5 November 1971, and Oxford, Ashmolean Museum, 20 November 1971 - 2 January 1972, no. 22; *Old Master Drawings Presented by Lorna Lowe,* National Book League, London, 1973.

BIBLIOGRAPHY: Sir John Charles Robinson, *Descriptive Catalogue of Drawings by the Old Masters Forming the Collection of John Malcolm of Poltalloch, Esq.,* London, 1869, no. 399; *Descriptive Catalogue of Drawings...in the Possession of the Hon. A. E. Gathorne-Hardy,* 1902, no. 41; Alfred Scharf, *Filippino Lippi,* Vienna, 1935, pp. 131, 147, no. 325; Bernard Berenson, *The Drawings of the Florentine Painters,* 2nd ed., Chicago, 1938, vol. 1, p. 106, n. 2; vol. 2, no. 1353a, pp. 131, 147, vol. 3, fig. 229; Innes Howe Shoemaker, *Filippino Lippi as a Draughtsman,* diss. (unpub.), Columbia University, New York, 1975, vol. 1, no. 114, p. 375; vol. 2, fig. 114.

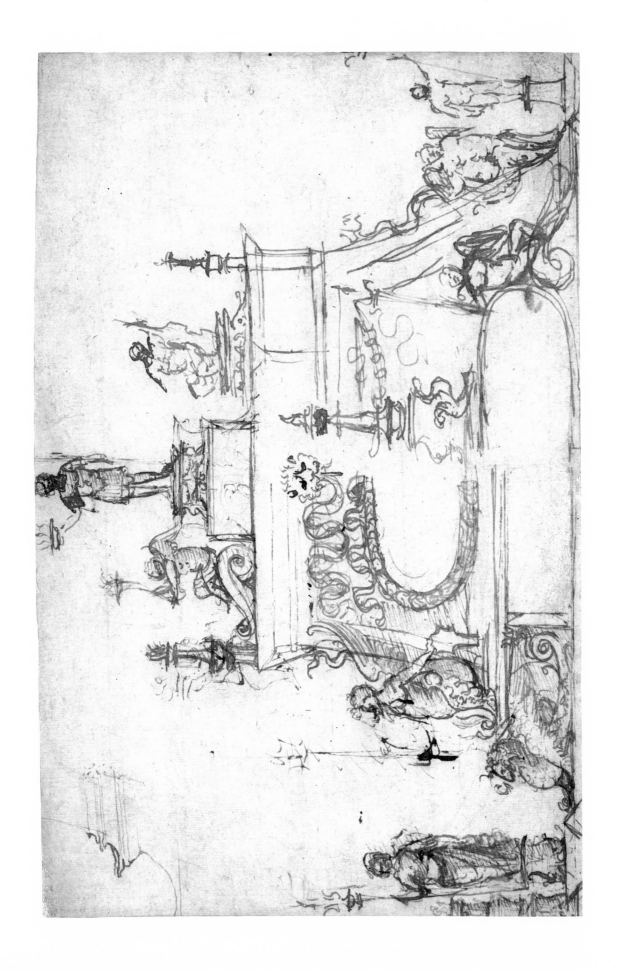

6 UMBRIAN SCHOOL

Circa 1490

Portrait of a Youth

Metalpoint heightened with white gouache on pinkish-gray prepared paper; 252 x 193 mm.

PROVENANCE: Antonio Mario Zanetti (Lugt 2992 f.); Darmstadt, Kupferstichkabinett; Baron Robert von Hirsch (Sotheby's, London, 20 June 1978, lot 22).

This drawing has traditionally been ascribed to Pintoricchio, first by Meder, largely on the basis of its resemblance to the painted *Portrait of a Boy* in the Gemäldegalerie, Dresden.[1] However, the association of the two works does little to assist in arriving at a proper attribution for the drawing, since the Dresden painting is highly controversial in this respect. Adolfo Venturi and Canuti considered the painting to be by Perugino, while Ricci, Berenson, and Carli attributed it to Pintoricchio.[2] Most recently and improbably, Ragghianti has suggested Lorenzo di Credi.[3] Finally, Zeri has proposed the little known painter Ingegno as its author.[4]

In fact, the relationship between the painting in Dresden and the Woodner drawing is not demonstrably more than generic, with similar meticulous drawing and broad lighting of the face and comparable treatment of the eyes. Underlying the problem of attribution is the extreme difficulty of trying to establish the identity of an artist solely on the basis of a drawing's stylistic similarities with a painting. Therefore, in the absence of any close analogy with a certainly attributed drawing or a direct connection to a painting, the Woodner drawing will remain without firm ascription. Unfortunately, the attribution of Umbrian drawings of this period remains quite unresolved, as was demonstrated by the inconclusive results of the fine Uffizi exhibition of 1982.[5] Despite this problem of the identification of its artist, the Woodner drawing is a work of considerable quality. Its high degree of precision and subtle use of white highlights give a feeling of refinement and sensitivity that perfectly underscores the intimacy of mood conveyed by the youth's eyes.

1. Joseph Schönbrunner and Joseph Meder, *Handzeichnungen alter Meister aus der Albertina und anderen Sammlungen,* 1896-1908, vol. 5, no. 552. The attribution to Pintoricchio is also accepted by Sylvia Ferino Pagden, according to Konrad Oberhuber.
2. Adolfo Venturi, *Storia dell'arte italiana,* Milano, 1913, vol. 7, pt. 2, p. 466; Fiorenzo Canuti, *Il Perugino,* Siena, 1931, vol. 2, no. 18, p. 324; Corrado Ricci, *Pintoricchio,* London, 1902, p. 72; idem, *Pintoricchio,* Perugia, 1902, pp. 110-111; Bernard Berenson, *Italian Pictures of the Renaissance: Central Italian and North Italian Schools,* London, vol. 1, 1968, no. 41, p. 344; Enzo Carli, *Il Pintoricchio,* Milan, 1960, p. 18.
3. C. L. Ragghianti, "Lorenzo di Credi non Pinturicchio," *Critica d'arte,* no. 154-156, 1977, pp. 91-97.
4. This proposal was made in a lecture at a conference in Gubbio in 1981. I am grateful to Professor Federico Zeri for communicating this information to me.

5. *Disegni Umbri del Rinascimento da Perugino a Raffaello,* catalogue by Sylvia Ferino Pagden, exhibition at the Gabinetto Disegni e Stampe degli Uffizi, Florence, 1982, no. 20, p. 44. It does bear considerable resemblance to a study of the adoring Virgin made in connection with Perugino's *Crucifixion* for Santa Maria Madalena dei Pazzi, now in the Uffizi (417 E), which was recently exhibited as by a collaborator of Perugino.

EXHIBITIONS: None.

BIBLIOGRAPHY: Joseph Schönbrunner and Joseph Meder, eds., *Handzeichnungen alter Meister aus der Albertina und anderen Sammlungen,* Vienna, 1896-1908, vol. 5, no. 552; Oskar Fischel, *Die Zeichnungen der Umbrer,* Berlin, 1917, no. 111, p. 203.

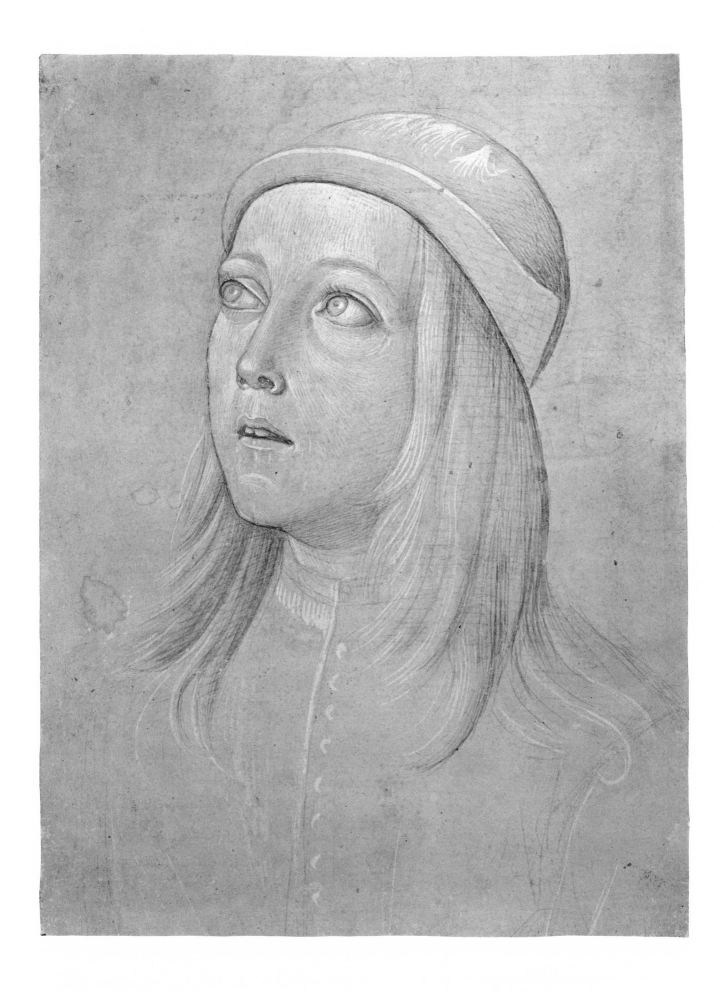

7 LUCA SIGNORELLI

Cortona circa 1441 – Cortona 1523

St. John the Baptist

Black and brown chalk on cream colored paper; 290 x 192 mm. (silhouetted).

PROVENANCE: Jean-Luc Baroni, London.

This drawing first appeared in 1981 at a London exhibition with the attribution to Signorelli (endorsed by Philip Pouncey).[1] It undoubtedly depicts St. John and is a study for a *Baptism of Christ*. In overall pose, it may be compared with a painting by the workshop of Signorelli in the Pinacoteca, Città di Castello, although the morphological details of the two do not correspond closely and the painting is of distinctly lower quality.[2] Michael Miller has noted that the right arm of the Baptist is very similar to that of the central figure in the *Allegory of Abundance* by Signorelli or his workshop now in the Uffizi.[3] In addition, the figure bears a general resemblance to the Adam at the extreme left of the fresco of the *Coronation of the Elect* in the Cathedral of Orvieto, noticeable especially in the schematic anatomy and sharply linear drapery.[4] The rather overgraphic description of the calf muscles and the rigid depiction of details of the legs can also be seen in a very similar form in the man to the right of Eve in the same fresco. Despite these similarities to the painted work of Signorelli, the drawing is somewhat problematical in that it lacks the vitality and strongly accented anatomical structure usually found in drawings that are certainly by Signorelli. It should be noted, however, that the head and hair of the Baptist are in fact quite animated and that the rather restive character of the image may derive as much from its interpretation of subject as from its graphic manner. The analogies suggested above indicate a date between 1500 and 1505.

1. *Old Master Drawings presented by Jean-Luc Baroni,* London, 29 June - 11 July 1981, no. 39.
2. Luitpold Dussler, *Signorelli,* Stuttgart, 1927, pl. 185.
3. Ibid., pl. 161.
4. Ibid., pl. 106.

EXHIBITIONS: *Old Master Drawings presented by Jean-Luc Baroni,* London, 29 June - 11 July 1981, no. 39.

BIBLIOGRAPHY: None.

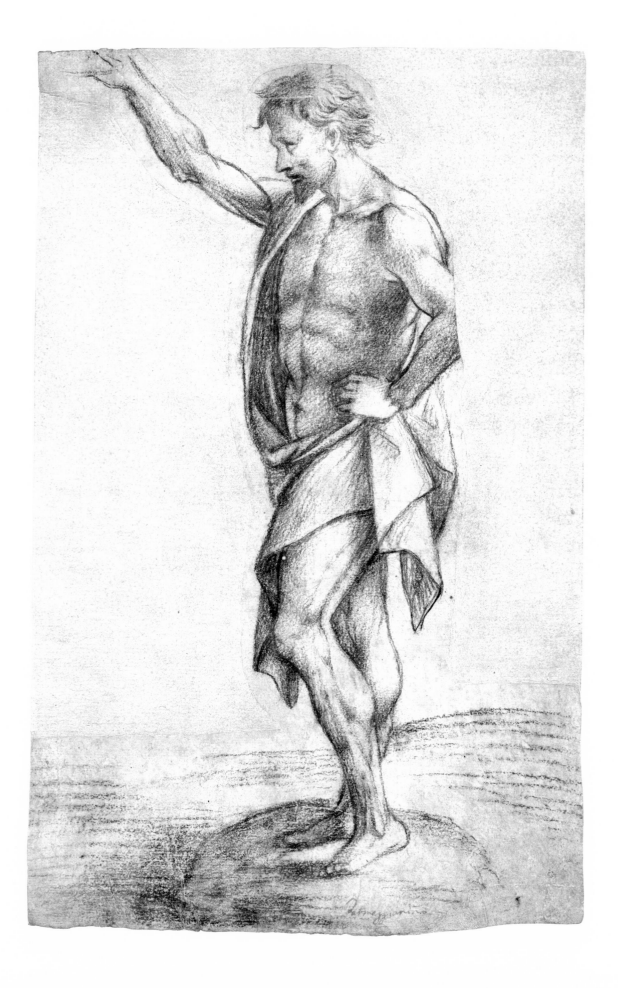

8 VITTORE CARPACCIO

Venice 1455/65 – Capo d'Istria (?) 1525/6

Study of Six Figures

Pen and brown ink and gray wash on cream colored paper; 141 x 161 mm.

PROVENANCE: None.

This sheet contains studies which can be associated with a projected painting, perhaps of a *Circumcision* or *Presentation.* None of the surviving paintings by Carpaccio can be specifically related to the drawing, though examples of these subjects exist. As was pointed out by Muraro, the only work by Carpaccio with which this drawing may be associated is the elaborate drawing of the *Circumcision* or *Presentation in the Temple* in the Uffizi (1691 F).[1] The Uffizi drawing has often been considered a preparatory study for the painting of the *Presentation* in the Accademia, Venice; but the connection is not easily sustained since they do not correspond in detail and are of different formats.[2] It is perhaps best simply to view both drawings as stages in the development of a composition which either was left unexecuted or is now lost.

The Woodner drawing represents a secondary stage of evolution of the overall concept for a painting. Initially, Carpaccio must have made one or more general, suggestive sketches for the entire scheme, which were modified and refined through partial studies of this kind. The group of women was first conceived with the foremost figure nude, and then she was more clearly defined with clothing. By contrast, the male figure at right is obviously a preliminary study of the priest, if this is indeed for a painting of the *Presentation.* The drawing also reflects some effort to begin clarifying the expressive quality of the faces, in fact with greater vitality than is true of paintings by Carpaccio of this subject. A date in the first decade of the sixteenth century seems very likely, although this is not certain.

1. Michelangelo Muraro, *I Disegni,* Florence, 1977, p. 85; see also, Woodner Collection 1, no. 26.
2. For bibliography and discussion of opinions on the Uffizi drawing, see M. Muraro, op. cit., pp. 44-45.

EXHIBITIONS: Woodner Collection 1, no. 26.

BIBLIOGRAPHY: Michelangelo Muraro, *I Disegni di Vittore Carpaccio,* Florence, 1977, p. 85, fig. 42A.

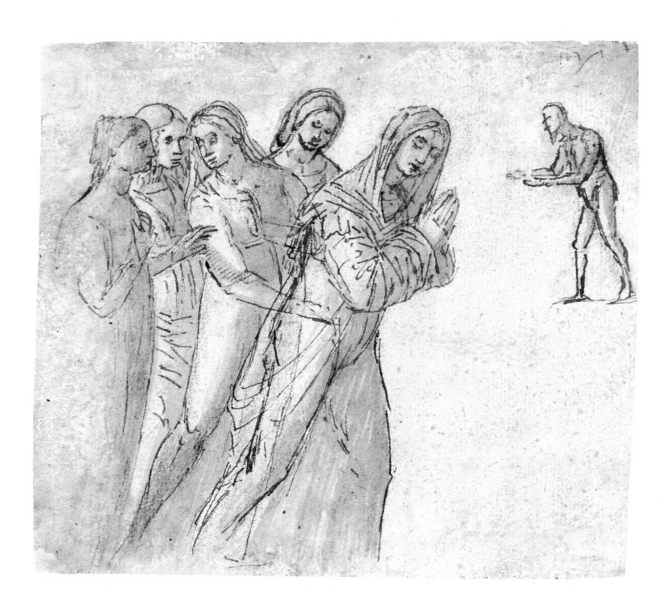

9 BACCIO DELLA PORTA, called FRA BARTOLOMMEO

Florence 1472 - Florence 1517

Dancing Angels

Pen and brown ink on cream colored paper; 167 x 129 mm. Left figure squared for transfer in red chalk overlay.

PROVENANCE: Jonathan Richardson, Sr. (Lugt 2183); John Barnard(?); John Thane (Lugt 1544); George John, 2nd Earl Spencer (Lugt 1531); William Esdaile (Lugt 2617); Charles Sackville Bale (Lugt 640); John Postle Heseltine; Henry Oppenheimer (Christie's, London, 10 July 1936, lot 29); Baron Robert von Hirsch (Sotheby's, London, 20 June 1978, lot 11).

Long ago Bernard Berenson noted that to those who know Fra Bartolommeo through his paintings, "an acquaintance with his pen-drawings will begin with a charming surprise."[1] The lightness of touch and ease of movement manifest in this drawing characterize the artist's relatively early manner of draughtsmanship, especially in pen and ink. His early drawings often reflect his debt to Piero di Cosimo and Domenico Ghirlandaio in both graphic technique and figure types. However, by the time of the Woodner drawing (circa 1505) Fra Bartolommeo's own draughtsmanship has fully emerged with greater fluency and monumentality than that of his closest antecedents.

The Woodner drawing cannot be related to any known painting, even though the left side of the sheet has been squared for transfer in red chalk. It has been suggested that the drawing is a study for a Coronation of the Virgin and is, perhaps coincidentally, most closely related in graphic manner to a pen and ink study of dancing angels in the Uffizi, which is also thought to have been made for a painting of this subject.[2] The dating of these two sheets around 1505 seems very likely—though not absolutely demonstrable—since they mark the point at which the artist's early style in pen and ink reaches its maturity.

1. Bernard Berenson, *The Drawings of the Florentine Painters,* 2nd ed., Chicago, 1938, vol. 1, p. 155.
2. Ibid., vol. 2, no. 279, p. 29.

EXHIBITIONS: *Exhibition of Italian Drawings,* Royal Academy, London, 1930, no. 583, p. 284.

BIBLIOGRAPHY: Gustave Gruyer, *Fra Bartolommeo della Porta et Mariotta Albertinelli,* Paris, 1886, p. 101; Fritz Knapp, *Fra Bartolommeo della Porta und die Schule von San Marco,* London, 1903, no. 1, p. 314; Bernard Berenson, *The Drawings of the Florentine Painters,* New York, 1903, vol. 2, no. 433, p. 21; Hans von der Gabelentz, *Fra Bartolommeo und die Florentiner Renaissance,* Leipzig, 1922, vol. 2, no. 303, p. 131; A. E. Popham, *Italian Drawings Exhibited at the Royal Academy, Burlington House, London, 1930,* London, 1931, no. 191, p. 53; Bernard Berenson, *The Drawings of the Florentine Painters,* 2nd ed., Chicago, 1938, vol. 2, no. 433, p. 39; idem, *I Disegni dei pittori fiorentini,* 3rd ed., Milan, 1961, vol. 2, no. 203 L - 1, p. 45 and vol. 3, fig. 372; Axelle de Gaigneron, "Les nouveaux choix de M^r Woodner," *Connaissance des Arts,* no. 348, February 1981, p. 77.

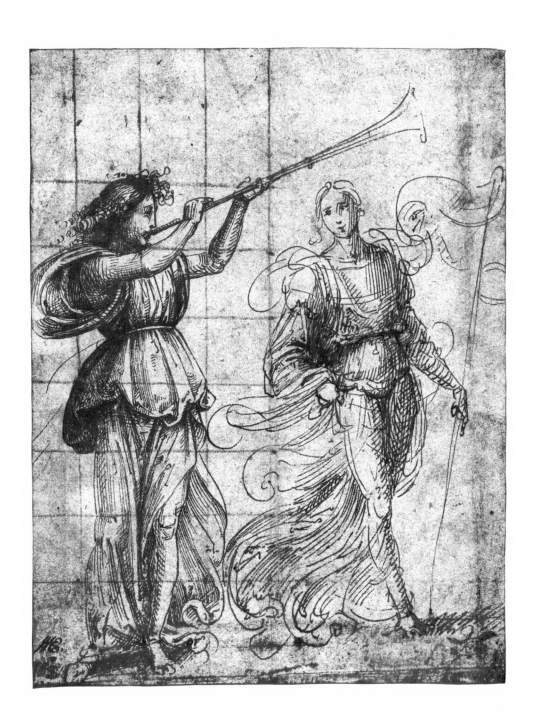

10 BACCIO DELLA PORTA, called FRA BARTOLOMMEO

Florence 1472 – Florence 1517

Landscape

Pen and brown ink on cream colored paper; 283 x 219 mm. (irregular).

PROVENANCE: Fra Paolino da Pistoia, Florence; Suor Plautilla Nelli, Convent of St. Catherine, Piazza San Marco, Florence; Cav. Francesco Maria Niccolò Gabburri, Florence; William Kent, England (according to Mariette); private collection, Ireland (Sotheby's, London, 20 November 1957, lot 18).

Although the estate of Fra Bartolommeo is recorded to have contained more than one hundred landscape drawings, very few were known in modern times until the discovery of the so-called Gabburri Album and its sale at Sotheby's in 1957.[1] Cavaliere Gabburri was president of the Academy of Painters in Florence and a collector and connoisseur. He acquired these drawings in 1730 from the Convent of St. Catherine (San Marco, Florence). Before this time they had belonged to Fra Paolino (Fra Bartolommeo's assistant and heir) and then to Sister Plautilla Nelli. The drawings came to England after Gabburri's death in 1742.

The distinguished and fascinating provenance of these drawings is fully matched by their artistic merit and interest. The great fluency of the artist's penwork is evident, and it is more subtle and suggestive than in the drawing of two angels also in this collection (no. 9). The light pen strokes create a convincing sense of atmosphere and simulate the illusion of light and air in the empty areas of the sheet. The concern for these qualities may relate this drawing to the artist's visit to Venice in 1508, even if the graphic style of the drawing is not connected to Venetian landscape drawing of the period. This new subtlety of light may also be seen in paintings, as in the bottom section of the *Lucca Madonna* of 1509. The relationship to Venice is strengthened by Michael Miller's observation that this sheet and lot 24 in the Gabburri Album sale are both reminiscent of the environs of Venice and show the same scene.

1. For a complete discussion of the Gabburri Album provenance, see Carmen Gronau, "Preface," *Drawings of Landscapes and Trees by Fra Bartolommeo,* Sotheby's, London, 20 November 1957, pp. ii-v, and Cara D. Denison, Helen B. Mules, and Jane V. Shoaf, *European Drawings: 1375 - 1825,* Pierpont Morgan Library, New York, 1981, no. 11, pp. 38-39.

EXHIBITIONS: Woodner Collection 1, no. 6.

BIBLIOGRAPHY: None.

II RAFFAELLO SANZIO, called RAPHAEL

Urbino 1483 – Rome 1520

Head of a Horse

Metalpoint heightened with white silverpoint, reworked in black chalk on gray prepared paper; 144 x 108 mm. Inscribed on verso in a seventeenth century hand, "mano del Gioseppino m. c. 67".

PROVENANCE: Hon. Edward Bouverie, Jr. (Lugt 325); Christie's, London, 6 July 1982, no. 21.

This drawing first appeared in a sale at Christie's in 1982 where, in spite of an old inscription attributing it to Cavalier d'Arpino, the drawing was correctly given to Raphael. Joannides noted the similarity in type between this horse and one depicted in the cartoon for the *Expulsion of Heliodorus*. Despite the great disparity in scale, the comparison is justifiable and helps to sustain the attribution to Raphael.[1] In addition, Oberhuber has related the Woodner drawing to other metalpoint drawings on prepared paper that Raphael made at the time he was working on the Stanza d'Eliodoro. The most pertinent comparison is between this drawing and a study of a horse and rider seen from behind in the Städelsches Kunstinstitut, Frankfurt,[2] in which the pose of this figure is greatly elaborated from that preserved in the copy of what is presumed to be one of Raphael's early compositional studies for the *Meeting of Leo I and Attila* (Ashmolean Museum, Oxford).[3] Joannides has suggested a connection between the Woodner drawing and the horse furthest to the back at the right side of the Oxford copy. The same horse reappears near the center of the next stage of the composition, which is recorded by a drawing in the Louvre,[4] although the ears and placement of the mane differentiate it from the horse in the Woodner drawing. Finally, the horse is moved to the left of center in the fresco and is partially obscured by two soldiers. As Oberhuber notes, the final position of the right ear of the horse is already indicated in the Woodner drawing.

1. Paul Joannides, *The Drawings of Raphael,* no. 340 (publication forthcoming), quoted in Christie's, 6 July 1982, no. 21, p. 16.
2. Oskar Fischel and Konrad Oberhuber, *Raphaels Zeichnungen,* vol. 9, Berlin, 1972, no. 402, pl. 7 and no. 406, pl. 8.
3. Ibid., no. 405, pl. 8.
4. Ibid., no. 407, pl. 11, and Joannides, loc. cit.

EXHIBITIONS: None.

BIBLIOGRAPHY: Paul Joannides, *The Drawings of Raphael,* London, forthcoming 1983, no. 340.

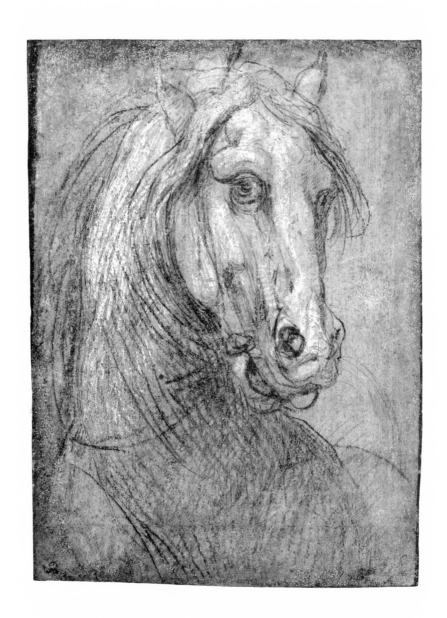

12 ANTONIO ALLEGRI, called IL CORREGGIO

Correggio 1489 – Correggio 1534

Two Studies: (A) *A Bearded Figure Shielding his Face with his Arm* and (B) *Head of a Bearded Man Looking Upward.*

(A) Red chalk on off-white paper; 62 x 111 mm. (B) Red chalk on off-white paper; 54 x 89 mm.

PROVENANCE (A and B): Jonathan Richardson, Sr. (Lugt 2183); Hon. Edward Bouverie, Jr. (Lugt 325); Rev. Dr. Henry Wellesley (Sotheby's, London, 26 June 1866, lot 350, Lugt 1384); Richard Johnson (Lugt 2216); Henry Oppenheimer (Christie's, London, 10 July 1936, lot 74C); François Strolin, Lausanne.

These two drawings were probably cut from the same sheet and are both preparatory studies for figures in Correggio's fresco of the *Assumption of the Virgin* in the cupola of the Duomo of Parma. As was first noted by Popham, the larger drawing (A) is an early study for one of the Apostles on the parapet.[1] The relationship is a loose one, probably indicating that the drawing was made early in the artist's conception of the figure. The smaller fragment (B) has often been called an Apostle as well, but Michael Miller has convincingly suggested that it is an early idea for the figure of Abraham in the fresco, which is much further developed in a drawing at Windsor.[2] The dating of the two sketches may be broadly ascertained by reference to the Duomo frescoes. They were begun in 1523 at the earliest; the stage of evolution of the project represented by these drawings falls around 1525.[3]

In both cases a certain measure of reserve should prevail in terms of precise identification of the drawings with figures in the fresco, since Correggio characteristically worked from early, broadly indicated drawings to more finished ones, the former often lacking the sort of definition necessary for precise identification. In the two Woodner sketches, one has the opportunity to come as close as is possible to the first moment of creative intuition by a great artist.

It has been suggested by Popham that these two drawings and the Woodner sketch of the woman with the torch (no. 13) all were once part of the same sheet. This is a plausible but not provable hypothesis.

1. Arthur Ewart Popham, *Correggio's Drawings,* London, 1957, no. 65, p. 163, pl. 71.
2. Ibid., no. 55.
3. Cecil Gould, *The Paintings of Correggio,* Ithaca, New York, 1976, pp. 107, 184-185.

EXHIBITIONS: Woodner Collection 2, no. 42.

BIBLIOGRAPHY: Corrado Ricci, *Correggio,* London, 1930, p. 176, pl. 277b; Arthur Ewart Popham, *Correggio's Drawings,* London, 1957, no. 65, pp. 76, 90, 162f., pl. 73b.

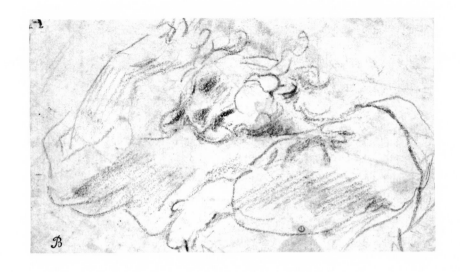

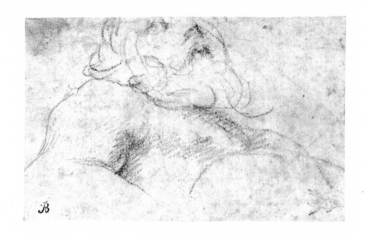

13 ANTONIO ALLEGRI, called IL CORREGGIO

Correggio 1489 – Correggio 1534

Woman Brandishing a Torch

Red chalk on cream colored paper; 78 x 59 mm.

PROVENANCE: Jonathan Richardson, Sr. (Lugt 2183); Hon. Edward Bouverie, Jr. (Lugt 325); Rev. Dr. Henry Wellesley (Sotheby's, London, 26 June 1866, lot 360A?, Lugt 1384); Richard Johnson (Lugt 2216); Henry Oppenheimer (Christie's, London, 10 July 1936, lot 74A); François Strolin, Lausanne.

This drawing of a woman running towards the left brandishing a torch is related to two figures on the verso of a sheet in the Musée Bonnat, Bayonne (Popham 86). The recto of the Bayonne drawing has two versions of an archeress who appears to be taking the attack of the torch-bearer, as well as a kneeling woman who may be binding someone.

Popham suggested that this and the Bayonne drawings are studies for a replacement for Perugino's *Battle of Chastity and Lust* for the studiolo of Isabella d'Este.[1] This is a very plausible theory but not absolutely demonstrable. He goes on to propose a date of 1530 or a little later for the drawing. This dating is contested by Michael Miller, who considers the style of the drawing analogous to that of a sheet in the British Museum (Popham 79) with studies for the *Agony in the Garden* in Apsley House and the *School of Love* in the National Gallery, London. On this basis he dates the Woodner drawing to the mid–1520's. These analogies are helpful, but one must note that none of the works in this group are firmly dated and that the Woodner drawing may also be related to Correggio's study after Michelangelo's *Leda,* now in the Louvre (Popham 84), which cannot date from before October 1530. If the Woodner drawing comes from the same sheet as the studies of Apostles (see the previous catalogue entry), support for a date in the middle part of the 1520's would be concrete, since they surely date from before 1530.

The Woodner drawing fully displays Correggio's suggestive and painterly manner of drawing. Following Leonardo, he and Andrea del Sarto were the first to master fully the medium of red chalk and to explore its potential in formulating a figure or composition without definitive clarity of line.

1. Arthur Ewart Popham, *Correggio's Drawings,* London, 1957, pp. 96-97; Silla Zamboni, "A. E. Popham: Correggio's Drawings," *Arte Antica e Moderna,* no. 2, 1958, p. 193; Stefano Bottari, *Correggio,* Milan, 1961, p. 43; Arthur Carlo Quintavalle and Alberto Bevilacqua, *L'Opera Completa del Correggio,* 1970, no. 95, p. 111; Egon Verheyen, *The Paintings in the Studiolo of Isabella d'Este at Mantua,* New York, 1971, p. 51; Cecil Gould, *The Paintings of Correggio,* Ithaca, New York, 1976, p. 130.

EXHIBITIONS: Woodner Collection 2, no. 40.

BIBLIOGRAPHY: Arthur Ewart Popham, *Correggio's Drawings,* London, 1957, no. 87, p. 167, pl. CId; Axelle de Gaigneron, "Ian Woodner, amateur américain de réputation mondiale, commente quelques oeuvres majeures de sa collection," *Connaissance des Arts,* no. 310, December 1977, pp. 106-107.

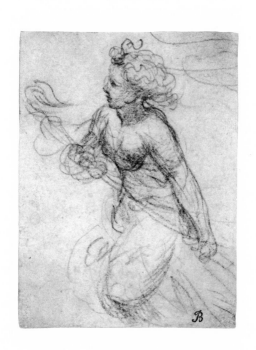

14 FRANCESCO MAZZOLA, called IL PARMIGIANINO

Parma 1503 – Casalmaggiore 1540

Madonna and Child
verso: Male Figure

Red chalk on cream colored paper; 175 x 149 mm. Inscribed on recto in upper right corner in black ink, "Parmegiano", and on verso in graphite, "23 x 96", "c10 perdai(?) / Erfed(?) 373(?) 524".

PROVENANCE: Hanley Collection.

This drawing depicts the Madonna and Child in a novel manner, with the two physically separated yet emotionally linked. Parmigianino contrasts the lively expressiveness of the Christ Child with the more introspective Madonna who gently restrains Him. The pose of the Christ Child relates this drawing to several studies by Parmigianino for the *Madonna della Rosa,* now in the Gemäldegalerie, Dresden.[1] It would be tempting to hypothesize that the Woodner drawing is an early, rejected study for this painting and to date it to the late 1520's, as has been suggested already.[2] However, the graphic manner and figural style of the drawing argue strongly for a much earlier date. The rather loose draughtsmanship and the relatively imprecise characterization of form are comparable to such early drawings as a study after the *Diana* from the Camera di S. Paolo, now in the Metropolitan Museum; two studies of women now in the University Art Museum, Princeton, and a study for an altarpiece now in the Albertina.[3] Equally, the drapery style and the rendering of the face and hands of the Madonna find close parallels in the painted Bardi altarpiece of 1521. Therefore, it seems very likely that this is an early drawing containing a motif which would later recur in one of Parmigianino's major paintings.

The verso of this sheet has a figure in red chalk at the extreme right that cannot be connected to any known painting or drawing by Parmigianino. Nevertheless, the style of the verso is completely consistent with the artist's drawings of the early 1520's and may be compared with those cited in reference to the recto and also with the *Seated Woman Supported by Two Putti* in the British Museum which appears to date from around 1522.[4] This would confirm the dating of the sheet in this part of the decade.

1. Arthur Ewart Popham, *Catalogue of the Drawings of Parmigianino,* New Haven, 1971, no. 740, p. 213; no. 494, p. 160; no. 88, p. 70.
2. Woodner Collection 1, no. 22.
3. Popham, op. cit., no. 295, p. 118; no. 563, p. 176; no. 601, p. 186.
4. Ibid., no. 162.

EXHIBITIONS: Woodner Collection 1, no. 22.

BIBLIOGRAPHY: None.

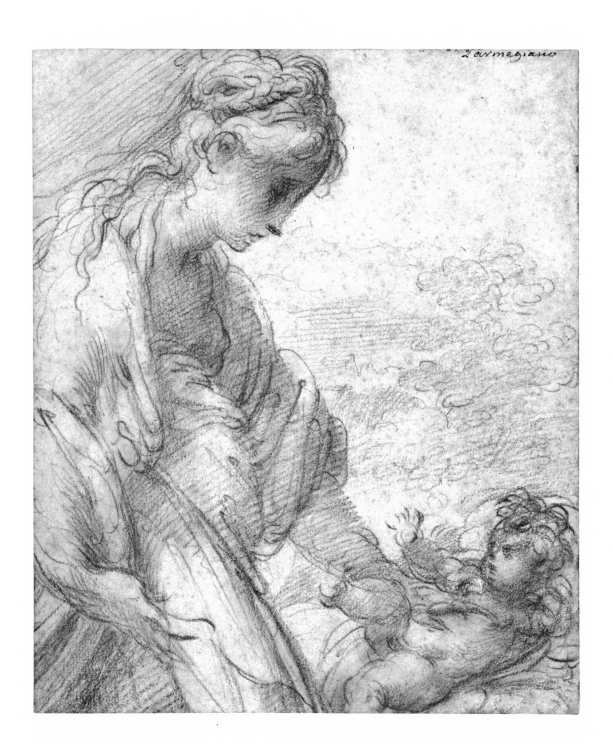

No. 14 verso. *Male Figure*

15 DOMENICO CAMPAGNOLA

Venice circa 1484 – Padua 1562

St. Anthony and St. Paul the Hermits Receiving Bread from a Raven

Pen and brown ink on cream colored paper (watermark: an indistinct circle); 391 x 256 mm. Inscribed on upper right corner in graphite: "65"; on lower right corner in black chalk (illegible); and on lower right corner in black chalk: "C. Cort".

PROVENANCE: Maurice and Hubert Marignane Collection.

This is a fine example of Campagnola's work in the later 1520's. As is true of many of his drawings, this one reflects the work of his great contemporary Titian. The tree formation at the back recalls the much more animated group in the famous painting of *The Martyrdom of St. Peter Martyr* (destroyed, formerly SS. Giovanni e Paolo, Venice). The figure of St. Paul at the right is very close to the *St. Jerome in Penitence,* a rare early drawing by Campagnola (National Gallery, Washington, D.C.).[1] Though the physiognomic types and torsos of the two are quite similar, they illustrate well the development of Campagnola's graphic style in the 1520's towards a more restrained and precise manner and away from his more expressive Titianesque style of a few years earlier. In this respect, the Woodner drawing may be seen as parallel in its point of development to Titian's paintings of the early 1530's such as the *St. Jerome in Penitence* in the Louvre.

The iconography is unusual in Italian art of the period. Pintoricchio painted the same scene in the Borgia apartments in the Vatican; however, as Michael Miller has proposed, the inspiration for Campagnola probably came from the woodcut of the subject by Dürer of about 1503-4.

1. Terisio Pignatti, *Venetian Drawings from American Collections,* International Exhibitions Foundation, Washington, D.C., 1974-1975, no. 9, p. 10.

EXHIBITIONS: Woodner Collection 2, no. 48.

BIBLIOGRAPHY: None.

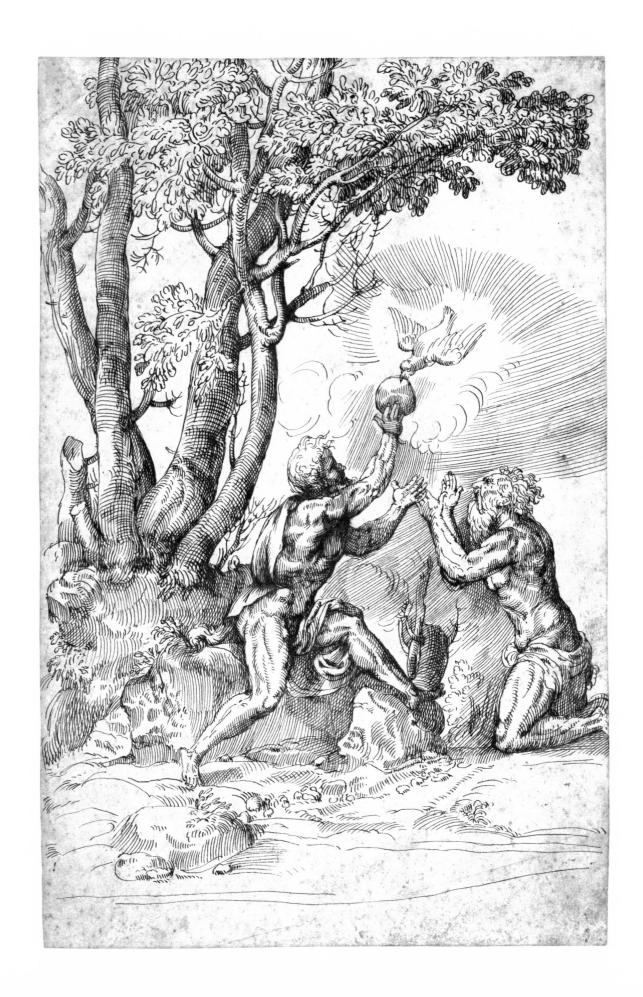

16 NICCOLÒ DELL'ABBATE

Modena circa 1512 – Fontainebleau 1571

Two drawings: (A) *Gentleman Playing Lute and Three Ladies* and (B) *Gentleman in Plumed Hat with Two Ladies*

(A) Pen and brown ink with brown wash, heightened with white gouache (partly oxidized) on cream colored paper (possibly over black chalk underdrawing), trimmed to follow figures, mounted on paper painted brown, the whole mounted on canvas; 352 x 294 mm. (trimmed drawing), 395 x 479 mm. (including backing). (B) Pen and brown ink with brown wash, heightened with white gouache (partly oxidized) on cream colored paper (possibly over black chalk underdrawing), trimmed to follow figures, mounted on paper painted brown, the whole mounted on canvas; 311 x 486 mm. (trimmed drawing), 398 x 493 mm. (including backing).

PROVENANCE: Hans M. Calmann (1976).

These two drawings are very probably fragments of the cartoon for Niccolò's octagonal ceiling fresco in the castle of Scandiano, which was detached in 1772. Together with other parts of the decoration, the ceiling is now in the Galleria Estense, Modena.[1] The original scheme in the *Aeneid* cabinet of the castle included scenes from the *Aeneid,* landscapes with episodes from contemporary or near contemporary life, and female musicians. According to tradition, the octagon shows Giulio Ascanio Boiardo with members of his family reaching as far back as Giovanni Boiardo, who built the castle, and the poet Matteo Maria Boiardo (1434-94), author of the courtly epic, *L'Orlando innamorato.*[2] Tradition also says that the frescoes were commissioned by Giulio Ascanio Boiardo in 1540.[3]

Neither the identification of the individuals in the fresco nor the date of 1540 can be confirmed, and both suppositions have been challenged by Langmuir.[4] She dates the fresco to 1530 and claims that only the couple of the young bearded man with the white plume and the lady next to him are portraits. She identifies them as Count Giulio Boiardo and his wife and the occasion as his full investiture in the county of Scandiano by Alfonso d'Este in 1530. These latter points are unprovable, but Langmuir seems quite correct in denying that the other figures in the octagon have the character of portraits.

There are three further cartoon fragments for the octagon, which are preserved in the Royal Library, Windsor Castle.[5]

1. Erika Langmuir, *Journal of the Warburg and Courtauld Institutes,* vol. 39, 1976, p. 156.
2. *Mostra di Nicolò dell'Abate,* catalogue by Sylvie M. Béguin, Bologna, 1969, pp. 53-55.
3. Walter Bombe, "Gli Affreschi dell'Eneide di Niccolò dell Abate nel Palazzo di Scandiano," *Bolletino d'Arte,* vol. 10, 1931, p. 546.
4. Erika Langmuir, *Burlington Magazine,* vol. 117, 1975, p. 729.
5. Arthur Ewart Popham and Johannes Wilde, *The Italian Drawings of the XV and XVI Centuries in the Collection of His Majesty the King at Windsor Castle,* London, 1949, p. 183.

EXHIBITIONS: None.

BIBLIOGRAPHY: Erika Langmuir, "Two Unpublished Drawings by Nicolò dell'Abate," *Burlington Magazine,* vol. 117, 1975, p. 729, figs. 57 and 58; idem, "Arma Virumque... Nicolò dell'Abate's Aeneid Gabinetto for Scandiano," *Journal of the Warburg and Courtauld Institutes,* vol. 39, 1976, pp. 151-170.

17 NICCOLÒ DELL'ABBATE

Modena circa 1512 – Fontainebleau 1571

The Rape of Ganymede

Pen and brown ink with brush and brown wash heightened with white gouache on buff paper laid down; 384 x 286 mm. Inscribed at the top in brown ink, "Ganymede"; on the old mount in brown ink, "Perino", also an obscure graphite inscription.

PROVENANCE: Unidentified eighteenth century collector; Jonathan Richardson, Sr. (Lugt 2183); John Clayton (Christie's, London, 11 May 1908, lot 85).

The Rape of Ganymede is part of a series of drawings illustrating the loves of Jupiter. As was noted in the Christie's sale catalogue, there are two drawings in the British Museum, *Jupiter and Semele* (1895-9-15-678) and *Jupiter Embracing a Woman* (1945-11-10-1), of similar size and medium, which form part of this group.[1] In addition, there is a drawing of *Jupiter and Juno* in the Louvre (RF 572) that was also part of this series. The *Jupiter and Semele* shows indications of squaring for transfer, demonstrating that the drawings were not independent works of art. Unfortunately, no painted project survives or is documented that is derived from the drawings. Perhaps also related to these three sheets is a pen and wash drawing of *Jupiter and Juno* (Yvonne Tan Bunzl Collection, London), also squared for transfer, which seems clearly by the same hand, thereby sustaining its attribution to Niccolò.[2] The rather painterly manner and the medium of these drawings relate them to several others of as yet undetermined subjects in the Louvre, Munich, the Uffizi, and particularly in the Royal Library (Windsor 1122). These, in turn, are analogous to the painted work Niccolò did at Scandiano in 1540 (see no. 16) and to the Palazzo Torfanini frescoes of approximately a decade later. They provide an approximate dating for the Woodner drawing in the mid-1540's. It is instructive to compare the Woodner drawing with Michelangelo's interpretation of the same subject just a few years earlier: the idealized mood and sculptural form of Michelangelo have been replaced by a life-like young man in full contemporary costume.

1. Christie's, London, 6 July 1976, lot 90. It is interesting to note that the Woodner drawing bears an old attribution to Perino on its mount, that *Jupiter and Semele* was called Perino in the Willett and Ottley sales (14 June 1808, lot 240, and 15 June 1814, lot 969), and that *Jupiter Embracing a Woman* has an old label with an attribution to Perino on the back of its mount. I am very grateful to Nicholas Turner of the British Museum for providing me with this and other helpful information about their two drawings in the series and to Ann Huyghues Despointes for sending me a photograph of the Louvre drawing.
2. Filippa M. Aliberti Gaudioso and Eraldo Gaudioso, *Gli Affreschi di Paolo III a Castel Sant'Angelo, 1543-1548,* Rome, 1982, vol. 2, p. 196. The attribution to Niccolò is challenged by Gaudioso who relates the drawing to Domenico Zaga.
3. *Mostra di Nicolò dell'Abate,* catalogue by Sylvie M. Béguin, Bologna, Museo Civico, 1 September-20 October 1969, pp. 88-89.

EXHIBITIONS: None.

BIBLIOGRAPHY: None.

50

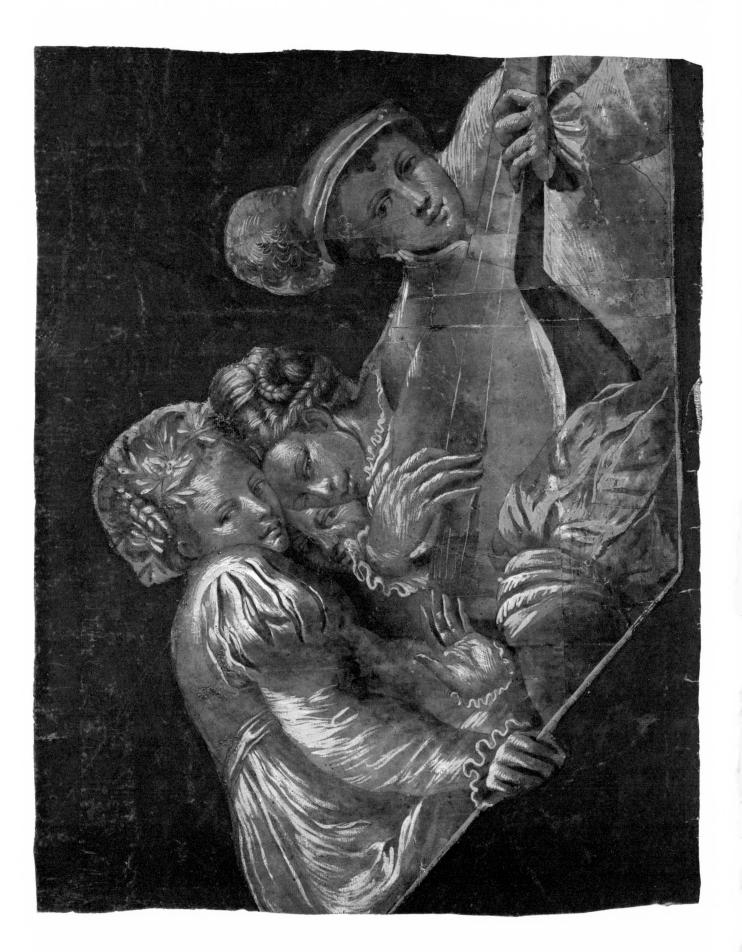

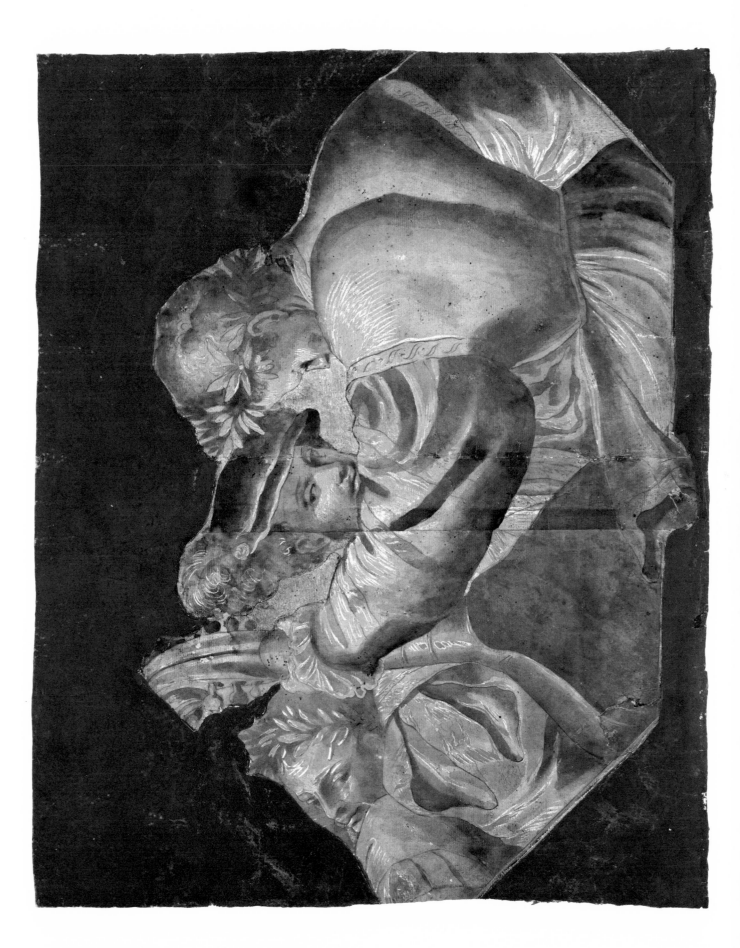

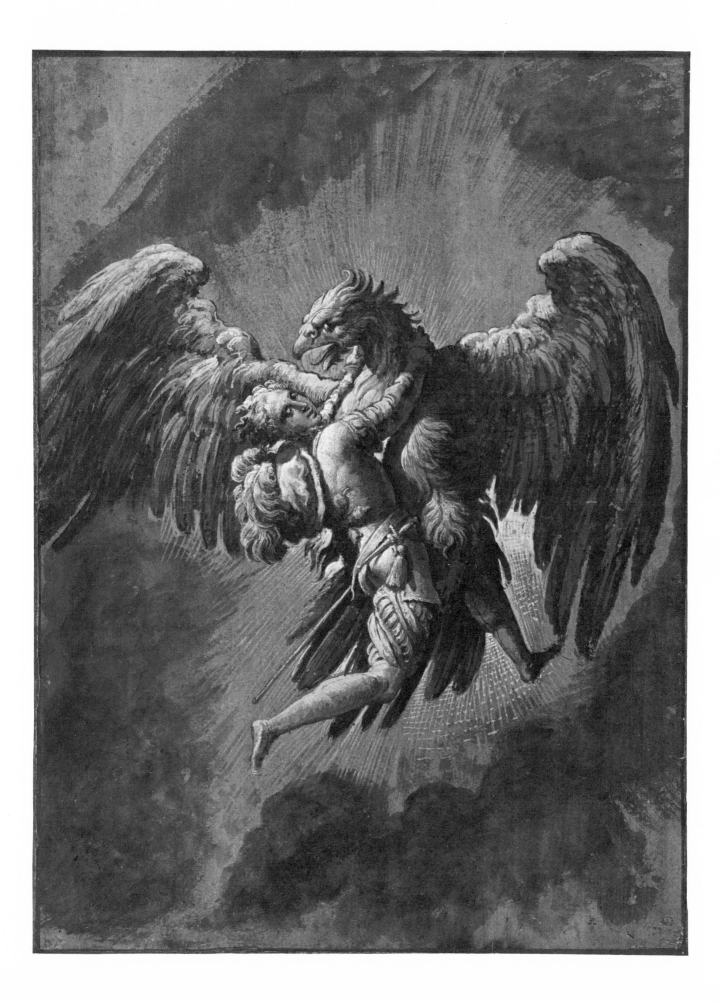

18 BENVENUTO CELLINI

Florence 1500 - Florence 1571

Satyr

Black chalk, pen and brown ink and brown and golden wash on cream colored paper; 414 x 202 mm. Inscribed on recto at lower right in brown ink, "alla porta di fontana / bellio di bronzo p[er] piu / di dua volte il vivo b[raccie] 7 / erano dua variati".

PROVENANCE: John Barnard (Lugt 1419); Sir Thomas Lawrence (Lugt 2445); Hans M. Calmann; William H. Schab Gallery, New York.

This celebrated drawing, one of the most important of the sixteenth century now in the United States, was made in connection with Cellini's project for a sculptured portal for the Château of Fontainebleau. In his autobiography Cellini writes:

> I corrected the proportions of the doorway, and placed above it an exact half-circle; at the sides I introduced projections, with socles and cornices properly corresponding; then, instead of the columns demanded by this disposition of parts, I fashioned two satyrs, one upon each side. The first of these was in somewhat more than half-relief, lifting one hand to support the cornice, and holding a thick club in the other; his face was firey and menacing, instilling fear into the beholders. The other had the same posture of support; but I varied his features and some other details; in his hand, for instance, he held a lash with three balls attached to chains. Though I call them satyrs, they showed nothing of the satyr except little horns and a goatish head; all the rest of their form was human.[1]

The project called for the bronze relief known as the *Nymph of Fontainebleau* in the lunette above the doorway, the two satyrs below, and two *Victory* reliefs (now known only from casts) above the lunette.[2] The *Nymph of Fountainebleau* is in the Louvre. The *Victories* were cast but no longer exist. The two *Satyrs* were never cast in bronze, though Cellini states that they were ready for casting when he left France. The *Nymph* and the two *Satyrs* were of equal scale, seven *braccie* (350-60 cms. approximately), that is approximately twice life-size.[3]

The Woodner drawing must be studied in connection with a bronze model in a Swiss private collection which has recently been published by Pope-Hennessy.[4] The bronze was made in preparation for the same Fountainebleau *Satyr* as the one in the Woodner drawing; however, its modeling is smoother and the anatomy much less particularized than in the drawing. This distinction is effectively employed by Pope-Hennessy to resolve the question of when the Woodner drawing was made. The autograph inscription on the sheet is in the past tense, forcing one to conclude either that it is a preparatory drawing that Cellini inscribed after his return to Florence or that the drawing itself was made on the basis of his recollections of his work in France, thereby postdating the actual project.[5] The modeling of the bronze, which is characteristic of Cellini, suggests that it and not the drawing was preparatory to the final project, and that therefore the drawing was made afterwards by Cellini to record it.

The Woodner drawing is one of the only two major extant drawings by Cellini, the other being a study in the Louvre for the silver figure of Juno.[6] Although it has been twice compared to Michelangelo, the figure is rather passive, more notable for its goldsmith-like precision and refinement of detail than for its expressive power.[7]

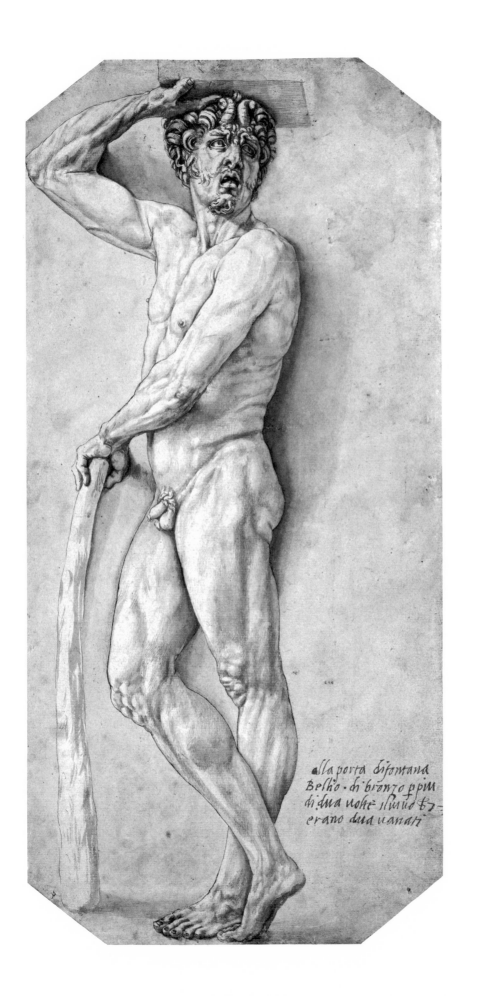

alla porta difontana
Belli o di bronzo p piu
di dua uolte il uiuo b?
erano dua uanati

1. *The Life of Benvenuto Cellini Written by Himself,* ed. by Sir John Pope-Hennessy, translated by John Addington Symonds, London, 1949 (reprinted 1960), based on the 3rd ed. of 1889, p. 283.

2. For the best review of this project, see John Pope-Hennessy, "A bronze Satyr by Cellini," *Burlington Magazine,* vol. 124, 1982, pp. 406-412.

3. Ibid., p. 408. The inscription on the Woodner drawing gives the height of the figure as 7 braccie.

4. Ibid., fig. 1.

5. Ibid., pp. 409-410. This is also true of Cellini's drawing of *Juno,* now in the Louvre, as noted in Catherine Monbeig-Goguel, *Vasari et son Temps,* Paris, 1972, p. 45.

6. C. Monbeig-Goguel, loc. cit.

7. Virginia Bush, *Colossal Sculpture of the Cinquecento,* New York, 1976, p. 265.

EXHIBITIONS: *Old Master Drawings,* catalogue by Elaine Evans Gerdts and William H. Gerdts, The Newark Museum, Newark, New Jersey, 17 March - 22 May 1960, no. 25; *Drawings from New York Collections 1, The Italian Renaissance,* The Metropolitan Museum of Art and the Pierpont Morgan Library, catalogue by Jacob Bean and Felice Stampfle, New York, 1965, no. 82; *The Age of Vasari,* catalogue by Michael Milkovitch and Dean A. Porter, University Art Gallery, State University of New York at Binghamton, 12 April - 10 May 1970, no. D 7, p. 74; Woodner Collection 1, no. 14; *L'Ecole de Fontainebleau,* Grand Palais, Paris, 17 October 1972 - 15 January 1973, no. 51 (Sylvie Béguin); *Fontainebleau, Art in France, 1528-1610,* catalogue by Sylvie Béguin, National Gallery of Canada, Ottawa, 15 March - 15 April 1973, no. 51, p. 38; *Old Master Drawings from American Collections,* catalogue by Ebria Feinblatt, Los Angeles County Museum of Art, 29 April - 13 June 1976, no. 26; *Sculptors' Drawings over Six Centuries, 1400-1950,* catalogue by Colin Eisler, New York, 1981, no. 10 (Ian Wardropper).

BIBLIOGRAPHY: Walter Vitzthum, "Drawings from New York Collections," Burlington Magazine, vol. 108, 1966, p. 110; Detlef Heikamp, "APPUNTI: In margine alla 'vita di Baccio Bandinelli del Vasari," *Paragone,* vol. 17, 1966, pp. 53, 61, n. 3; Matthias Winner, "Federskizzern von Benvenuto Cellini," *Zeitschrift füer Kunstgeschichte,* vol. 31, 1968, pp. 294-296; John Forrest Hayward, "A newly discovered Bronze Modello by Benvenuto Cellini," in *Art at Auction,* 1968, p. 264, n. 11; Alessandro Parronchi, "Une tête de satyre de Cellini," *Revue de l'Art,* no. 5, 1969, pp. 43-44; Catherine Monbeig-Goguel, *Vasari et son Temps,* Paris, 1972, p. 45-Me; Virginia Bush, *The Colossal Sculpture of the Cinquecento,* PhD. diss., Columbia University, New York, 1967, published New York, 1976, pp. 265-266; Axelle de Gaigneron, "Ian Woodner, amateur américain de réputation mondiale, commente sur quelques oeuvres majeures de sa collection," *Connaissance des Arts,* no. 310, 1977, p. 100; Charles Avery and Susanna Barbaglia, *L'Opera completa del Cellini,* Milan, 1981, no. 33, p. 90; John Pope-Hennessy, "A bronze Satyr by Cellini," *Burlington Magazine,* vol. 124, 1982, pp. 406-412.

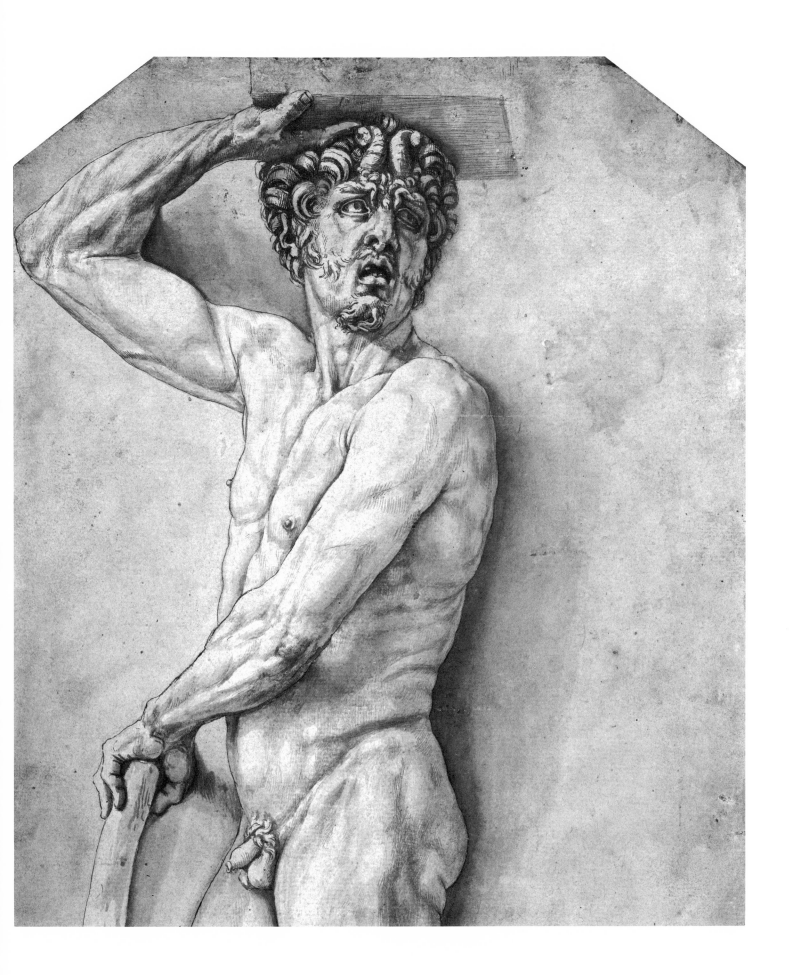

19 PIETRO BUONACORSI, called PERINO DEL VAGA

Florence 1501 – Rome 1547

Alexander the Great Consecrates Twelve Altars

Black chalk, pen and brown ink, and gray wash on cream colored paper; 313 x 208 mm. Inscribed on recto at lower left in brown ink, "perin[o] / del vaga" and on verso in red crayon, "A".

PROVENANCE: Collector's marks on verso, monogram "SG" black stamp in two places and "LFF" in graphite; Jacques Seligmann and Co., Inc., New York.

This drawing is a study for the fresco in the Cappella Paolina in Castel Sant'Angelo in Rome, which was painted by Perino or his workshop in 1547.[1] The Cappella Paolina was commissioned by Pope Paul III, who was born Alessandro Farnese. The fresco themes in the room are mainly episodes in the lives of St. Paul and Alexander the Great, reflecting respectively the adopted and given first names of the Pope. As Richard Harprath has demonstrated,[2] the individual scenes refer to specific events in the life of the Pope, in the case of this fresco, the building of St. Peter's.

The Woodner drawing shows the composition in very similar form to the final fresco. The main alteration is in the figure of Alexander, who holds his left hand to his breast and his right hand at his side in the fresco. The drawing exemplifies the lively linearism of Perino's graphic style very well, together with a very potent use of wash to create contrast. The fresco itself, which may have been painted by Domenico Zaga, is less animated.[3]

A copy of the Woodner drawing is in the National Gallery of Edinburgh, and a drawing of comparable character and purpose by Perino for another fresco in the room is in the collection of John Gere in London.[4]

1. For a discussion of the Sala Paolina, see Filippa M. Aliberti Gaudioso and Eraldo Gaudioso, *Gli Affreschi di Paolo III a Castel Sant'Angelo 1543-1548,* Rome, 1981, vol. 2, pp. 104-117, 126, 145.
2. Richard Harprath, *Pabst Paul III als Alexander der Grosse,* Berlin, 1978, pp. 43-46.
3. F. M. A. and E. Gaudioso, op. cit., vol. 2, no. 74, p. 126.
4. Ibid., no. 92, p. 145; no. 74, p. 126.

EXHIBITIONS: *Master Drawings,* Jacques Seligmann & Co., 19 November - 10 December 1966, New York, no. 29; *The Age of Vasari,* catalogue by Michael Milkovich and Dean A. Porter, University Art Gallery, State University of New York, Binghamton, and Art Gallery, University of Notre Dame, 1970, no. D 24, p. 80; Woodner Collection 1, no. 18.

BIBLIOGRAPHY: Jacob Bean, "National Gallery of Scotland: Catalogue of Italian Drawings," *Master Drawings,* vol. 7, 1969, p. 57; Richard Harprath, *Pabst Paul III als Alexander der Grosse: das Freskenprogramm der Sala Paolina in der Engelsburg,* Berlin, 1978, p. 43-46; Filippa M. Aliberti Gaudioso and Eraldo Gaudioso, *Gli Affreschi di Paolo III a Castel Sant'Angelo 1543-1548,* Rome, 1981, vol. 2, pp. 126, 145.

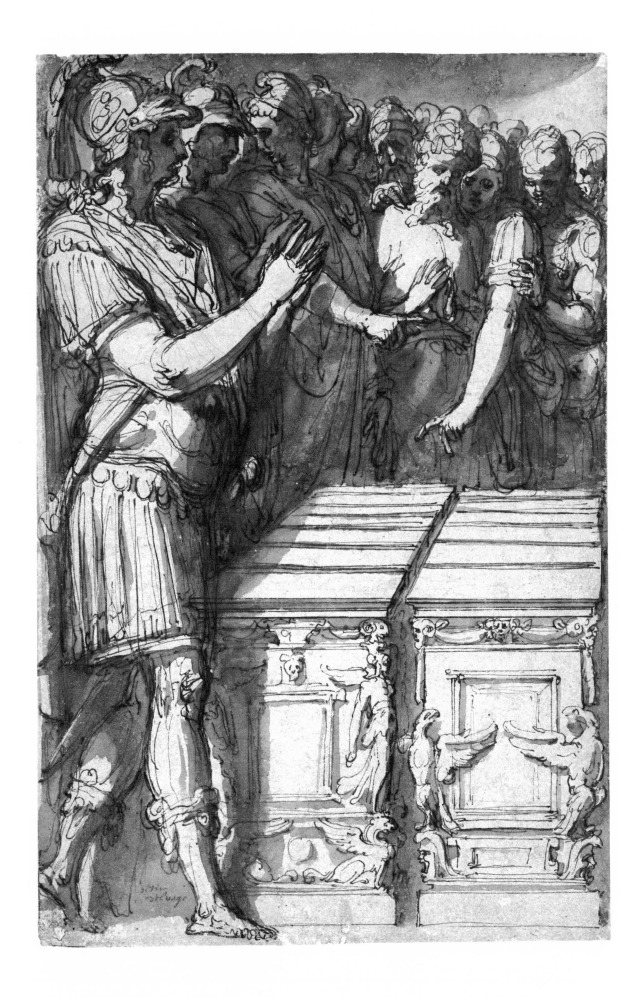

20 FRANCESCO SALVIATI

Florence 1510 - Rome 1563

The Resurrection

Pen and brown ink, brown wash with white heightening on buff paper; 279 x 190 mm. (oval). Inscribed on the lower left edge in brown ink, "Primaticio".

PROVENANCE: Sir Peter Lely (Lugt 2092); Hans M. Calmann; I. Spector; M. H. Valton; Daphné Wilkinson; William H. Schab Gallery, New York.

The attribution of this drawing to Salviati, first proposed by Hyatt Mayor, has achieved general acceptance despite one attempt to see it as the work of Niccolò dell'Abbate.[1] The Woodner drawing served as the basis for a print of unknown origin of the same subject in the British Museum;[2] the print shows several minor alterations to accommodate the rectangular format.

The drawing has been associated by Bussmann with several other drawings of the Passion by Salviati and is especially close to the *Christ before Pilate* in Berlin (KdZ 18376). Analogies of a more general kind exist between it and the painted work of Salviati, such as the *Annunciation* in San Marcello, Rome. The drawing is also, though more distantly, related to a fresco by Salviati of the *Resurrection* in the Margrave Chapel of Santa Maria dell'Anima, Rome, dating from between 1541 and 1550. The pose of Christ is altogether different in the fresco, but several of the poses and figure types of the soldiers recur with relatively modest changes. In addition to these relationships to Salviati's work, the Woodner drawing has been linked to the enamel rendering of the same subject by Léonard Limosin for the Sainte-Chapelle (1553); the remaining enamels were based on drawings by Niccolò dell'Abbate.[3] Since Salviati did not arrive in France until 1554/5, the enamel of the *Resurrection* must reflect the engraving after his drawing. This is likely to be the case even though both the enamel and the Woodner drawing are ovals, whereas the engraving is rectangular.

Bussmann suggests a date of 1541 for the Woodner drawing. It reflects the gracefulness of Parmigianino and Salviati's concern at this point in his career for precision of detail.[4]

1. *Fifteenth and Sixteenth Century European Drawings,* catalogue by Alpheus Hyatt Mayor, National Gallery of Art, Washington, D.C., 1967-1968, no. 17; Woodner Collection 1, no. 17.
2. Sylvie Béguin, *Revue de l'Art,* no. 5, 1969, fig. 1, p. 104.
3. Woodner Collection 1, no. 17; *De Michel-Ange à Géricault: Dessins de la Donation Armand-Valton,* catalogue by Emmanuelle Brugerolles, Ecole Nationale Supérieure des Beaux-Arts, Chapelle des Petits-Augustins, Paris, 19 May - 12 July 1981, pp. 2-5.
4. Hildegard Bussmann, *Vorzeichnungen Francesco Salviatis; Studien zum zeichnerischen Werk des Kunstlers,* Berlin, 1969, p. 81.

EXHIBITIONS: Smith College, Northampton, Massachusetts, 1962; *Fifteenth and Sixteenth Century European Drawings,* catalogue by Alpheus Hyatt Mayor, National Gallery of Art, Washington, D.C., 1967-1968, no. 17; Woodner Collection 1, no. 17; *L'Ecole de Fontainebleau,* catalogue by Sylvie Béguin, Grand Palais, Paris, 17 October 1972 - 15 January 1973, no. 220, p. 196; *Fontainebleau: Art in France, 1528 - 1610,* catalogue by Sylvie Béguin, National Gallery of Canada, Ottawa, 1 March - 15 April 1973, no. 220, p. 66, fig. 87.

BIBLIOGRAPHY: Hildegard Bussmann, *Vorzeichnungen Francesco Salviatis; Studien zum zeichnerischen Werk des Kunstlers,* diss., Berlin, 1969, pp. 81 and 151-152, n. 9; Sylvie Béguin, "review of Henri Zerner, *Ecole de Fontainebleau, Gravures,*" *Revue de l'Art,* no. 5, 1969, pp. 103-104, fig. 1.

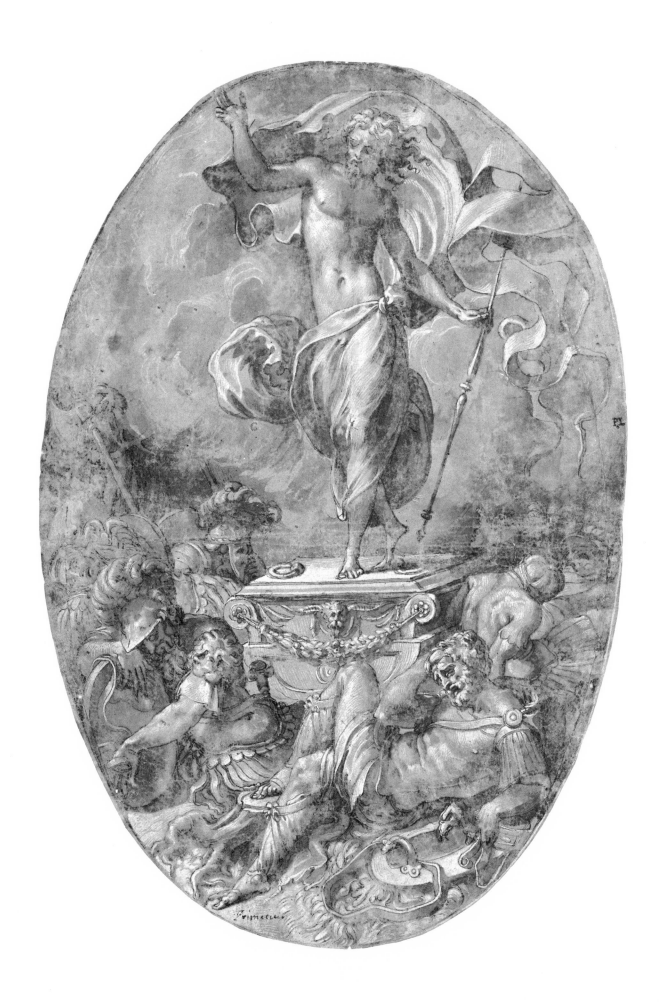

21 LUCA CAMBIASO

Moneglia 1527 – El Escorial 1585

Cain and Abel

Pen and brown ink and brown wash over graphite on cream colored paper; 293 x 167 mm. Inscribed on verso in graphite, "5 0 M", and in lower right corner in brown ink, "Luca".

PROVENANCE: Alfonso IV d'Este (1634-1622; Lugt 106).

This drawing differs from the characteristic drawings of Cambiaso's maturity in its relatively clear articulation of limbs, in the volumetric structure of the torso, and in the degree of specificity in its depiction of anatomical detail. It is removed in these respects from the more abstract graphic style of his later work and also from the free linear manner which seems to recur at various points in his career.

As Michael Miller has proposed, the drawing dates from the mid-1540's and is analogous in many respects to the figures in the painted *Resurrection* by Luca and his father Giovanni in the Church of SS. Giacomo e Filippo in Taggia Alta for which there is extant a contract dated February 4, 1547.[1] One may also note parallels with several of the figures in the earlier (1544) frescoes in the Palazzo della Prefettura, Genoa, notably those in the foreground.[2] As Miller points out, the Woodner drawing and these frescoes reflect the example of Pordenone; in the case of the former, the *Cain and Abel* of 1532 formerly in the Church of Santo Stefano, Venice, today known only through Piccini's engraving of 1616.[3]

It is difficult to determine the early evolution of Cambiaso's drawing style since this drawing is almost contemporary with what appear to be studies for the Palazzo della Prefettura frescoes,[4] which show a rather flamboyant linear manner, devoid of the solidity and definition found in the Woodner drawing. Perhaps it is best to suppose that these two types of drawing coexisted in Cambiaso's early work and were employed as mood and the character of an idea dictated.

1. Bertina Suida Manning and William Suida, *Luca Cambiaso: la vita e le opere,* Milano, 1958, no. 18, p. 116 and no. 3, pp. 212-213.
2. Ibid., pp. 14-15, 74-75, and figs. 4-5.
3. For a discussion of Pordenone's *Cain and Abel,* see Walter Friedlander, "Titian and Pordenone," *Art Bulletin,* vol. 47, 1965, p. 119, fig. 4.
4. B. S. Manning and W. Suida, op. cit., fig. 10; Piero Torriti, *Luca Cambiaso: Disegni,* Genoa, 1966, pl. 4.

EXHIBITIONS: Woodner Collection 1, no. 24.

BIBLIOGRAPHY: None.

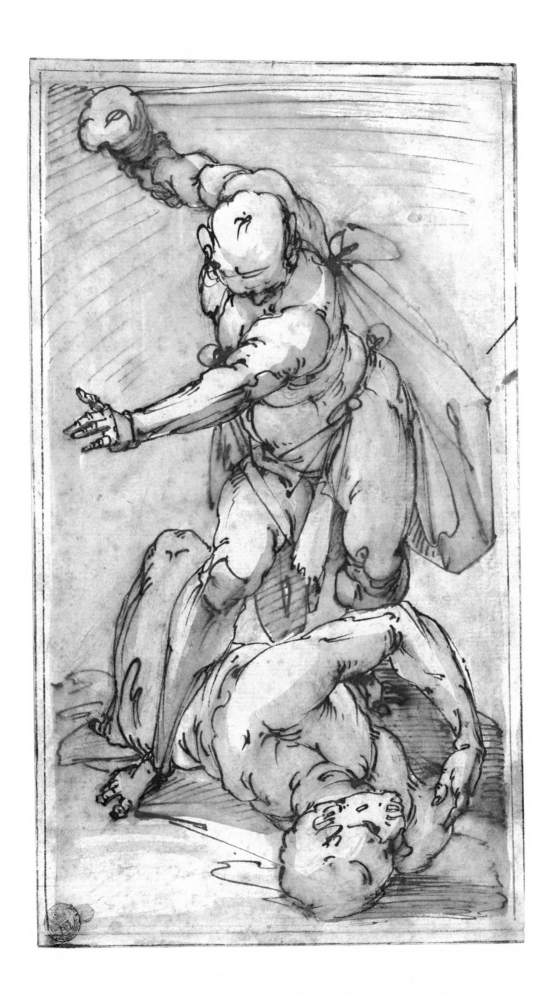

22 BACCIO BANDINELLI

Florence 1493 – Florence 1560

Study of Two Male Nudes

Pen and brown ink on buff paper (watermark: ladder [Briquet, vol. 2, 5904 or 5908; Italian, fifteenth century]); 388 x 255 mm. Inscribed in lower right corner in brown ink, "1.70", and in upper left corner in brown ink, "2".

PROVENANCE: None.

This page contains two life studies that Michael Miller has correctly connected with the period 1549-51 when Bandinelli was working on replacements for the sculptures of Adam and Eve that had been rejected for situation near the high altar of the Cathedral of Florence.[1] The study at the left is similar to the final statue of Adam in the position of the legs and in the overall facial type, although differing in a number of respects, such as in the placement of the arms and the head. Differences of this kind exist to a more or less equal degree between the final statue and all the other drawings related to it by Ciardi Dupré and Michael Miller.[2] It is notable that the figure at the right of the Woodner sheet, with its rather Leonardesque character, reappears in bust length profile in one of these drawings (Uffizi 519 F).

In addition to the differences of detail between the Woodner drawing and the sculpture of Adam, there is also considerable distinction of proportion, the sculpture having a taller and thinner torso. This may suggest that the Woodner drawing was made quite early in the development of the statue's conception. Unlike other drawings of this group, as well as many other pen studies by the artist, this sheet is almost devoid of the strong parallel lines which lend a hard, sculptor's modeling to forms. In this respect, it is much more naturalistic and less abstracted than the majority of Bandinelli's pen drawings and has the quality of a first response to the model and overall concept of the project.

1. For a discussion of Bandinelli and the choir of the Cathedral of Florence, see John Pope-Hennessy, *Italian High Renaissance and Baroque Sculpture,* 2nd ed., New York, 1970, pp. 365-366.
2. Maria Grazia Ciardi Dupré, "Alcuni aspetti della tarda attività grafica del Bandinelli," *Antichità viva,* vol. 5, no. 1, 1966, pp. 22-31. Particularly close are Uffizi 519 F and 529 F and a drawing in Hamburg.

EXHIBITIONS: Woodner Collection 2, no. 47.

BIBLIOGRAPHY: "Old Master Drawings from the Woodner Collection II," *The Connoisseur,* vol. 186, no. 747, May 1974, p. 56.

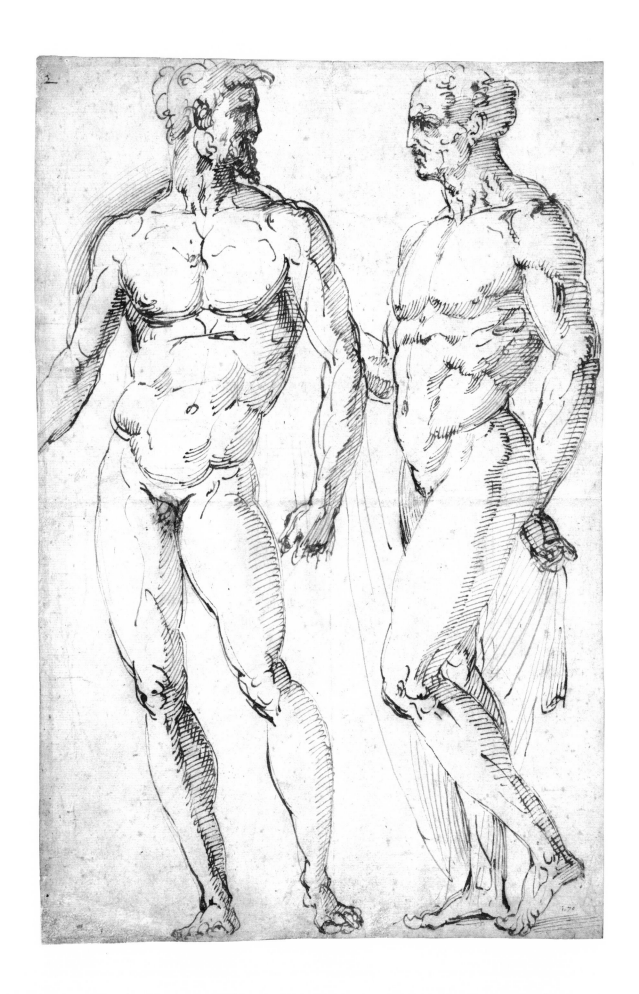

23 FEDERICO BAROCCI

Urbino 1526 – Urbino 1612

Study of the head of a boy

Black, red, and white chalks on green paper; 218 x 177 mm. (oval).

PROVENANCE: John Skippe; Mrs. Rayner-Wood; Edward Holland Martin, Esq. (Christie's, London, 20 November 1958, lot 13); Adolphe Stein, Paris (Bury Street Gallery, London, 1981, no. 5).

The *Madonna del Popolo,* now in the Uffizi, is one of the most important of Barocci's paintings. It was commissioned by the Confraternity of the Misericordia in 1574 and painted between 1575 and 1579.[1] As Olsen noted, the Woodner drawing is a preparatory study for the putto in the upper right corner of the altarpiece.[2] This is no doubt a study from life, though specifically made for the figure in the painting. As Pillsbury suggests, this relationship is clear from the correspondence in lighting between the painting and the drawing.[3] It is, however, uncertain whether the drawing was made early in the evolution of the design or in the later stages of its development. The Woodner drawing is one of several dozen drawings made in connection with the *Madonna del Popolo* which still survive.[4]

Barocci's use of pastels was derived, according to Bellori, from Correggio.[5] There are no surviving drawings in this medium by Correggio, and this derivation remains unprovable; but irrespective of his inspiration to use this medium, Barocci developed it with great sophistication. As Lavin has shown, the manner in which Barocci chooses the ground and the tonal and coloristic range of these drawings reflects his intentions for the painting to which they are related.[6] The balance of light and shade, as well as many elements of color, is studied as actively as the contour and expression of the figure.

1. Harold Olsen, *Federico Barocci,* Copenhagen, 1962, p. 168.
2. Ibid.
3. *The Graphic Art of Federico Barocci: Selected Drawings and Prints,* catalogue by Edmund P. Pillsbury and Louise S. Richards, Yale University Art Gallery, New Haven, 1978, p. 9.
4. *Mostra di Federico Barocci,* catalogue by Giovanna Gaeta Bertelà, Bologna, Museo Civico, 14 September – 16 November 1975, nos. 87-106, pp. 106-116.
5. E. P. Pillsbury, op. cit., p. 8.
6. Marilyn Aronberg Lavin, "Colour Study in Barocci's Drawings," *Burlington Magazine,* vol. 67, 1956, pp. 435-439.

EXHIBITIONS: None.

BIBLIOGRAPHY: Harold Olsen, *Federico Barocci,* Copenhagen, 1962, p. 168.

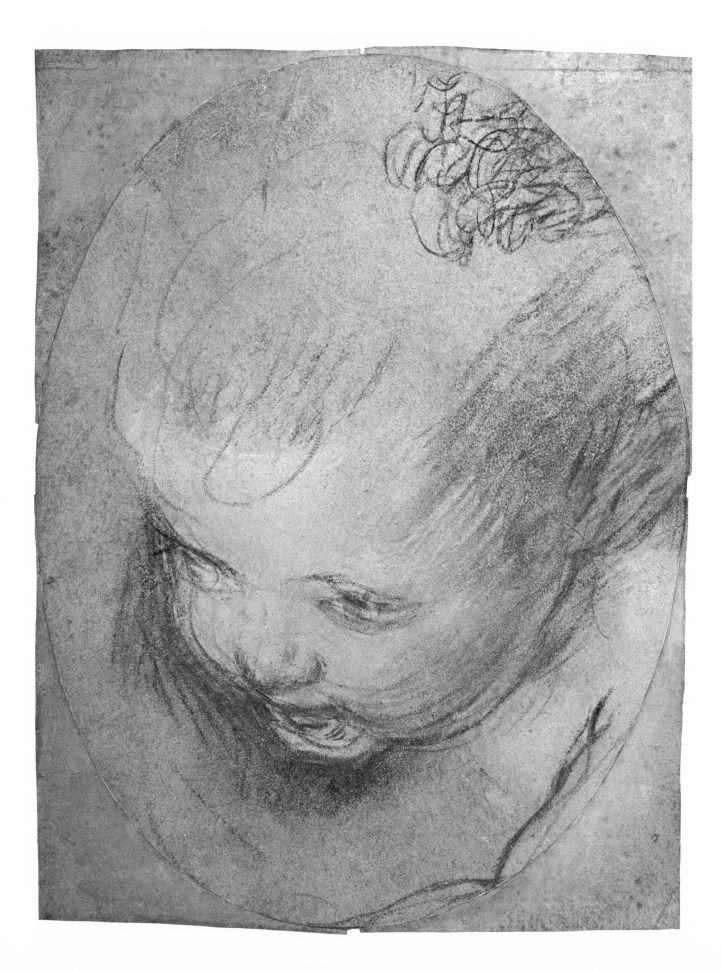

24 FEDERICO BAROCCI

Urbino circa 1526 – Urbino 1612

The Presentation of the Virgin

Black chalk, brush, and brown wash, heightened with white and gray gouache and touches of pink on light brown paper; 396 x 338 mm. Inscribed in lower right corner recto in brown ink: "Ba...".

PROVENANCE: Unidentified collector's mark, similar to Lugt 2883; William H. Schab Gallery, New York.

This important drawing was made in preparation for the *Presentation of the Virgin* in the Cesi Chapel of the Chiesa Nuova, Rome, which was painted between 1593 and 1603 (the latter date is inscribed on the painting).[1] The drawing was first published by Pillsbury, who identified it as the small cartoon for the painting.[2] The compositions are very similar though, as Pillsbury notes, the lightly sketched shepherd at the right of the drawing is shown holding his staff and looking at the high priest, where in the painting he appears to be looking away and is partially in shadow. The character of the draperies is also different, with those in the drawing having a greater particularization of each fold and a sharper emphasis on areas of brilliant light. These distinctions support the attribution to Barocci, as does an analogy with a drawing for the Entombment in Chatsworth, which is comparable in purpose and technique.[3] They also share the detail of an area of the sheet having been only lightly sketched in an otherwise highly finished composition.

Pillsbury has tentatively suggested that the drawing once belonged to a collector in Urbino named Giorgio Lavalas and that it is mentioned in a letter of 21 August 1673 as Barocci's "Cartone grande della Presentazione."[4] Viewed alongside the life study of a young boy (no. 23), it provides an indication of the artist's graphic range.

1. *The Graphic Art of Federico Barocci: Selected Drawings and Prints,* catalogue by Edmund P. Pillsbury and Louise S. Richards, Yale University Art Gallery, New Haven, 1978, no. 67, p. 88.
2. Ibid., p. 89.
3. Ibid.
4. Ibid.

EXHIBITIONS: *Old Master Drawings and Prints,* William H. Schab Gallery, New York, 1974, no. 1; *The Graphic Art of Federico Barocci: Selected Drawings and Prints,* catalogue by Edmund P. Pillsbury and Louise S. Richards, Yale University Art Gallery, New Haven, 1978, no. 67, p. 88.

BIBLIOGRAPHY: None.

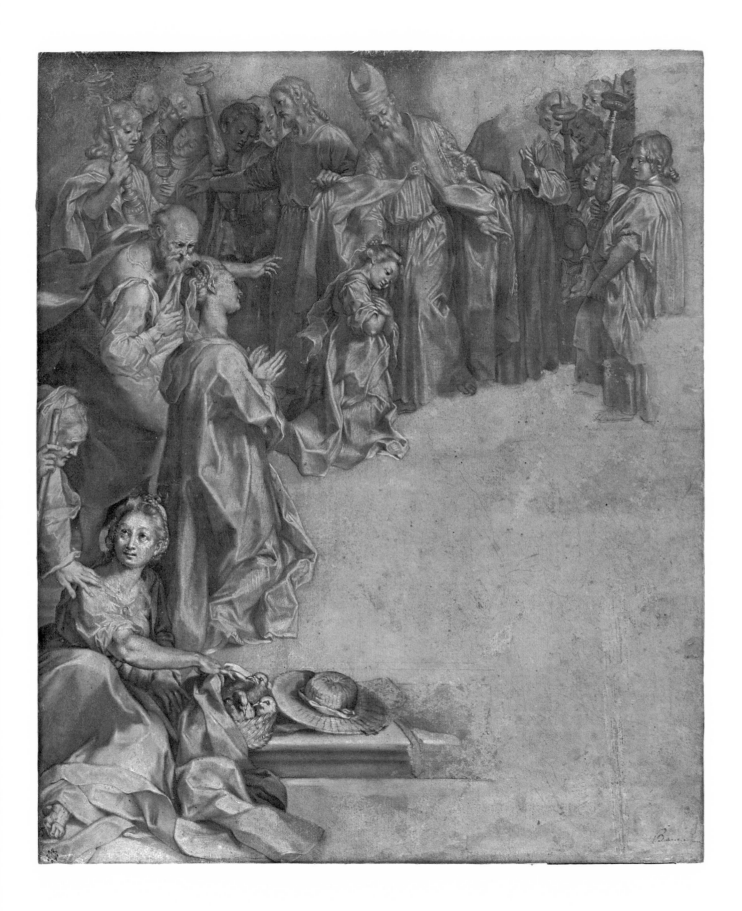

25 FEDERICO ZUCCARO

S. Angelo in Vado 1543 - Ancona 1609

Emperor Frederick Barbarossa Kneeling before Pope Alexander III

Pen and brown ink with brown wash on cream colored paper, with some squaring for transfer in black chalk; 525 x 455 mm.

PROVENANCE: Sotheby's, London, 8 December 1972, lot 28.

The scene shows the Emperor prostrating himself before the Pope, thereby ending the lengthy and complicated feud between them. The event took place on July 24, 1177 in front of the Basilica of San Marco in Venice with great pomp and ceremonial splendor.

This is a preliminary study for a painting by Federico Zuccaro in the Sala del Gran Consiglio in the Doges' Palace, Venice, which dates from 1582. A drawing by Zuccaro in the Scholz Collection in the Morgan Library records the painting of the same subject by Tintoretto that was replaced by Zuccaro's following the fire of 1577.[1] The earliest surviving drawing for Zuccaro's painting is in the Morgan Library and shows the scene from the Piazzetta, looking towards the Torre del Orologio;[2] therefore it has the Basilica of San Marco at the right. A later drawing, now in a private collection in London, contains a view towards the Piazzetta and most of the elements of the final design.[3] The Woodner drawing (and what appears to be a copy of it by a follower of Zuccaro at Christ Church[4]) represents the last stage of the evolution of the design for the painting. All of the principal features are the same as those used in the painting, with the exception of the pillar with a cartouche at the left in the drawing (which becomes a cartouche alone at the top of the painting) and the addition of a baldachin over the Pope in the painting, a detail which had also been present in the sketch in a private collection in London cited above.

1. John A. Gere, "The Lawrence-Phillips-Rosenbach Zuccaro Album," *Master Drawings,* vol. 8, 1970, no. 20, p. 131.
2. Cara D. Denison and Helen B. Mules, with the assistance of Jane V. Shoaf, *European Drawings: 1375-1825,* Pierpont Morgan Library, New York, 1981, no. 27, p. 52.
3. J. A. Gere, op. cit., no. 21, p. 132.
4. James Byam Shaw, *Drawings by Old Masters in Christ Church, Oxford,* 1976, no. 553, p. 158.

EXHIBITIONS: None.

BIBLIOGRAPHY: None.

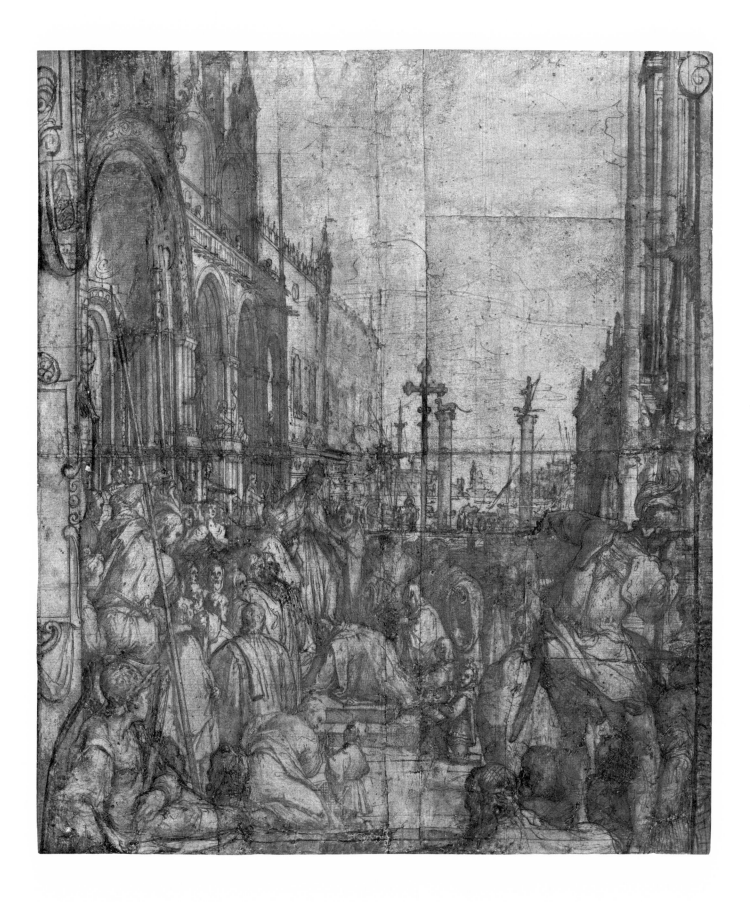

26 ANNIBALE CARRACCI

Bologna 1560 - Rome 1609

Mary Magdalene at Prayer

Pen and brown ink wash, heightened with (partly oxidized) white, over red chalk on tan paper; 278 x 202 mm. Inscribed on recto in lower left corner with the collector's mark of Sir Thomas Lawrence, and in lower right corner with an unidentified collector's mark of a shield with crest.

PROVENANCE: Jean-Baptiste-Joseph Wicar; Sir Thomas Lawrence (Lugt 2445); Lord Francis Egerton, 1st Earl of Ellesmere (Lugt 2710ᵇ; Sotheby's, London, 11 July 1972, lot 65); Lawrence Gallery, London.

This drawing was simply called Bolognese School by Tomory; the attribution to Annibale is due to Julien Stock in the 1972 sale catalogue of the Ellesmere drawings.[1] This idea was followed in the first Woodner catalogue, where the attribution to Annibale was sustained by comparison with his drawing of *Circe Transforming the Companions of Ulysses* at Windsor.[2] The medium of pen and ink wash over red chalk appears to have been derived by Annibale from his cousin Lodovico, and the drawing of *Circe* is quite close to the latter's style. The Woodner drawing is more clearly by Annibale, conceived with the monumentality of form that is characteristic of his work, especially after his move to Rome in 1595.

The date of the Woodner drawing is difficult to ascertain. The medium's derivation from Lodovico may suggest that the drawing comes from Annibale's Bolognese period. However, the first Woodner catalogue is correct in noting the relationship between the head of the Magdalene and the drawing in Windsor made by Annibale of the Niobid that was discovered near the Lateran in 1583 and set up at the Villa Medici in Rome.[3] Furthermore, if one compares the Magdalene with the figure of Dido (*Death of Dido,* Palazzo Francia, Bologna, 1592) on the one hand and with the reclining figure at the lower right of the *Triumph of Bacchus and Ariadne* (Palazzo Farnese, Rome) on the other, the placement of the Woodner drawing in Annibale's Roman period becomes very likely. A painting of Mary Magdalene in a landscape by Annibale, now in Galleria Doria-Pamphilj, Rome, dates from his Roman years (about 1600/1 according to Posner),[4] and it is not impossible that the Woodner drawing was an early rejected design for this painting.

1. *The Ellesmere Collection of Old Master Drawings,* catalogue by Peter Alexander Tomory, Leicester Museums and Art Gallery, 1954, no. 109, p. 39; *Catalogue of The Ellesmere Collection of Drawings by the Carracci and other Bolognese Masters Collected by Sir Thomas Lawrence,* part 1, Sotheby's, 11 July 1972, lot 65, p. 143 (Julien Stock).
2. Woodner Collection 1, no. 56; Rudolf Wittkower, *The Drawings of the Carracci in the Collection of Her Majesty the Queen at Windsor Castle,* London, 1952, no. 389, p. 151, fig. 54.
3. Woodner, loc. cit.; Wittkower, loc. cit.
4. Donald Posner, *Annibale Carracci: A Study in the Reform of Italian Painting Around 1590,* London, 1971, vol. 2, no. 125, p. 55.

EXHIBITIONS: *The Ellesmere Collection of Old Master Drawings,* by Peter Alexander Tomory, Leicester Museums and Art Gallery, 1954, no. 109, p. 39; Woodner Collection 1, no. 56.

BIBLIOGRAPHY: None.

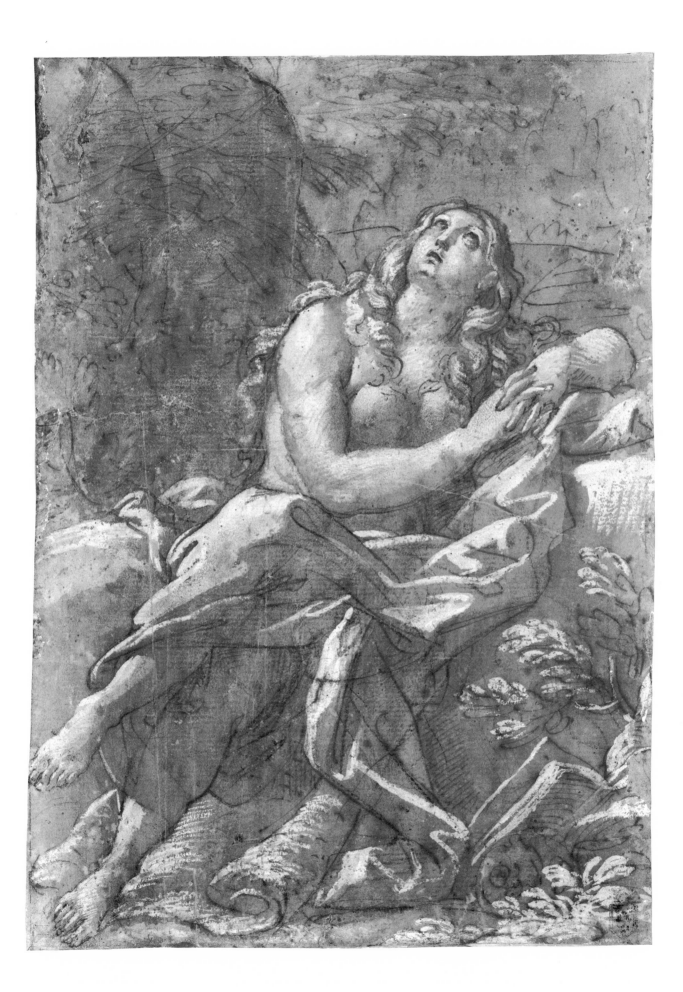

27 JACOPO LIGOZZI

Verona circa 1547 - Florence 1626

The Massacre of the Innocents

Pen and brown ink with brown wash, heightened with gold, over black chalk on tan paper (backed); 400 x 262 mm. Inscribed on recto at left edge, in brown ink, "1609", and in lower right corner: "4".
Accession number "xxx6y (paraph)," visible on verso, through backing.

PROVENANCE: Abbé Desneux de la Noue (died before 1657 in Paris, for his biography see Lugt 661); Lugt 3015; P. and D. Colnaghi and Co.; Jean-Luc Baroni, London.

Ligozzi was born and trained in Verona as a miniaturist and came to Florence in 1575. Many drawings by him survive which, like this one, are signed with his monogram and heightened with gold. The gold is a rather unusual touch which Oberhuber has suggested may have stemmed from Ligozzi's work as a miniaturist or from his acquaintance with early German chiaroscuro woodcuts.[1] The Woodner drawing is not squared for transfer (as is the case with modelli by Ligozzi) and was undoubtedly made as a finished work in its own right. The number "4" at the lower right may indicate that it was part of a series, perhaps one dealing with the Life of the Virgin or the Youth of Christ.

As Oberhuber suggests, the virtuoso display of movement in this crowded scene may have been inspired by Andreani's woodcut (B.XII, no. 94.4) of the *Rape of the Sabines* after the relief by Giovanni Bologna. Oberhuber further relates the drawing's graphic style to a *Holy Family* formerly in a Berlin private collection and to *Good Triumphant over Evil* in the Albertina[2] and the drawing's general composition to two altarpieces of 1607 and 1611, the *Nativity of the Virgin* in Santa Maria del Sasso in Bibiena and the *Martyrdom of St. Lawrence* in Santa Croce, Florence. The *Massacre of the Innocents* is a brilliant and characteristic example of Ligozzi's style. The stage-like effect of the composition and the metallic glow of coppery figures lend ideality to his expressively real world and animated drama.[3]

1. This and other substantive suggestions were derived from notes supplied by Konrad Oberhuber.
2. Hermann Voss, *Zeichnungen der Italienischen Spätrenaissance,* Munich, 1928, pl. 30; Alfred Stix, *Beschreibender Katalog der Handzeichnungen in der Graphischen Sammlung Albertina,* vol. 1, Vienna, 1926, no. 213.
3. Joy Keuseth, *Jacopo Ligozzi: Pittore Miniatore,* thesis, Harvard University, 1976, vol. 1, p. 93.

EXHIBITIONS: *Exhibition of Old Master Drawings,* P. and D. Colnaghi and Co., London, June-July 1974, no. 44; *Old Master Drawings,* Jean-Luc Baroni, London, 30 June - 12 July 1980, no 12.

BIBLIOGRAPHY: None.

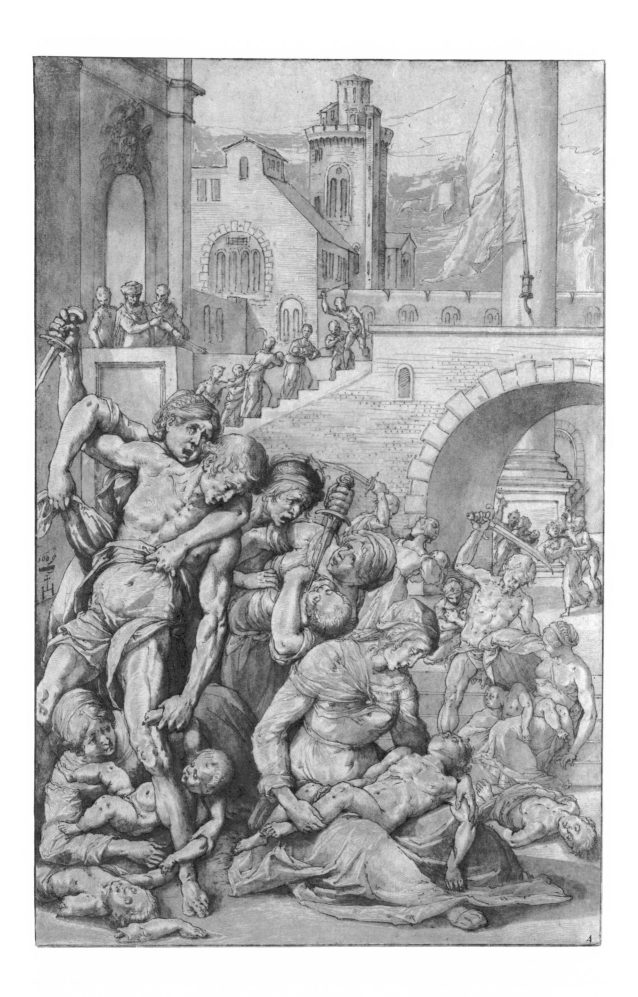

28 GUIDO RENI

Calvenzano 1575 – Bologna 1642

Study for the Head of Christ

Black and red chalks on pale green paper (Verso: red chalk square, as in a frame); 376 x 278 mm. Inscribed on the verso in graphite, "S + L" over "75" in a circle.

PROVENANCE: George John, 2nd Earl Spencer (Lugt 1532); Sotheby's, London, 8 December 1972, lot 34; L. Lowe, London; Adolphe Stein, Paris.

According to Malvasia, Reni sent a painting of the *Baptism of Christ* to a silversmith named Jacobs in Flanders in 1623. Jacobs was the founder of the Flemish college in Bologna and a friend of Reni, who "cherished him for his good-heartedness and sincerity."[1] The painting, now in the Kunsthistoriches Museum, Vienna, later belonged to the Duke of Buckingham, from whose collection it was sold in 1648.[2] It has long been regarded as one of the major paintings of this period of Reni's career.

The Woodner drawing is a study from life for the head of Christ. In purpose and medium it is comparable to a drawing in the Royal Library, Windsor Castle, for the angel furthest to the right in the same painting.[3] The Windsor sketch is more delicately drawn but lacks the vitality and forcefulness of the Woodner sheet.

1. Carlo Cesare Malvasia, *The Life of Guido Reni,* transl. Catherine and Robert Enggass, University Park, Pennsylvania, 1980, p. 84.
2. Cesare Gnudi and Gian Carlo Cavalli, *Guido Reni,* Florence, 1955, no. 57, pp. 76-77, pls. 106-109.
3. Otto Kurz, *Bolognese Drawings of the XVII and XVIII Centuries in the Collection of Her Majesty the Queen at Windsor Castle,* London, 1955, no. 345, p. 118.

EXHIBITIONS: *Master Drawings Presented by Adolphe Stein,* London, 1973, no. 68, fig. 52; *Guido Reni: Zeichnungen,* catalogue by Veronika Birke, Graphische Sammlung, Albertina, Vienna, 1981, no. 97, p. 140.

BIBLIOGRAPHY: D. Steven Pepper, *Guido Reni,* Oxford, 1982, no. 86.

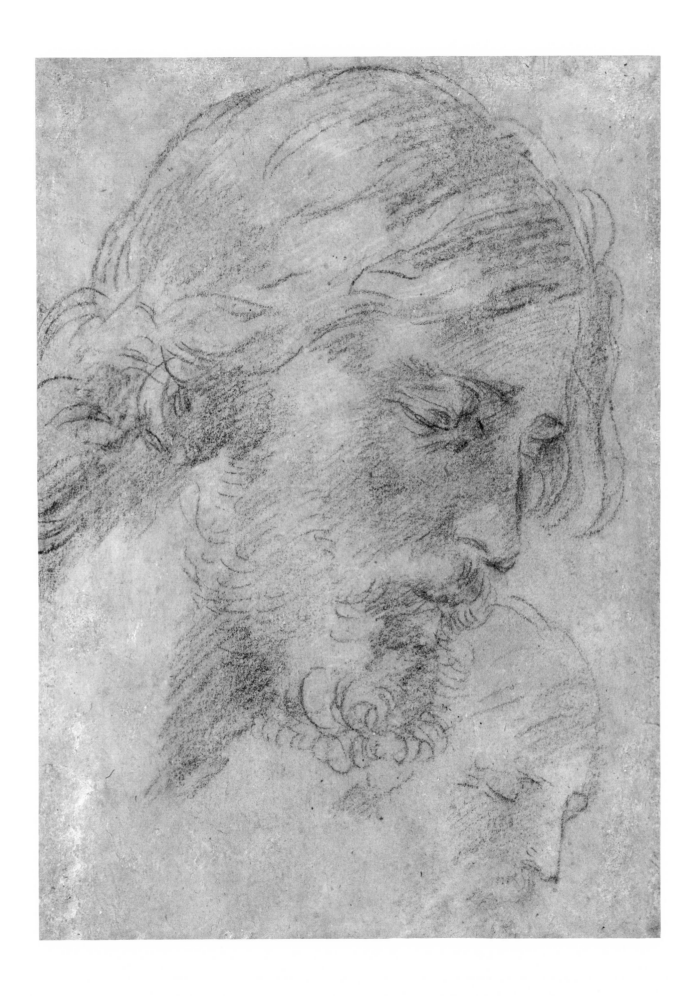

29 GIOVANNI ANDREA SIRANI, attributed to

Bologna 1610 – Bologna 1670

Liberality

Red chalk heightened with white chalk on cream colored paper; 363 x 243 mm. Inscribed on verso of mount in brown ink, "This Elegant and Beautifule Drawing by Guido is the Originale study for his fine figure of Liberality in Lord Spencer's picture of Modesty and Liberality, but is so far superior to the picture or to the fine Engraving Mr. Strange has made from it. R.U."(Robert Udney).

PROVENANCE: Ercolo Lelli (Lugt Supplement 2852); Robert Udney (Lugt 2248); Thomas Banks (Lugt 2423); Sir Edward J. Poynter (Lugt 874; sale, 24-25 April 1918); Viscount Lascelles; Earl of Harewood; Christie's, London, 6 July 1965, lot 136; William H. Schab Gallery, New York.

This drawing has always been attributed to Guido Reni, based on its association with the painting *Liberality and Modesty* formerly in Earl Spencer's collection.[1] The Spencer painting, however, is only one of several extant versions, though it appears to be the best of them. The Woodner drawing differs from the figure of Liberality in the Spencer painting of *Liberality and Modesty* in that it is shown with a scepter rather than with a compass. On the other hand, it has been noted by Henry Fernandez that the painting in the Galleria Nazionale di Capodimonte, Naples, contains the figure of Liberality holding a scepter.[2] Although Kurz considered the Naples version to be the primary one, it is almost certainly by a follower of Reni.[3] In this respect, it is interesting to note that, according to Malvasia, the Spencer painting was begun by Reni and completed by his assistant Giovanni Andrea Sirani.[4] Furthermore, Konrad Oberhuber has pointed to the great similarity between the figure of Modesty in the Naples painting and the *Sibyl* by Sirani in the Kunsthistoriches Museum, Vienna. He notes both the similarity in expressive feeling and the comparable heavy shadows and sensuous surfaces in the two paintings.

The case for the Woodner drawing being the work of Sirani is strengthened by the similarity between it and a sheet with *Two Nude Boys Representing History and Painting* at Chatsworth. Oberhuber argues, I believe correctly, that the Chatsworth drawing not only shares a common medium — red chalk — but also that both drawings lack the boldness of definition prevalent in Reni's late figure studies. Lastly, the Naples painting differs from the one in the Spencer collection in many details, including the treasures at the left, the draperies, and the colors. This would indicate that it was developed from the Spencer painting, or, more likely, from drawings for it, with some originality and is not simply a copy. It would therefore seem that the Naples painting was made by Sirani and that the Woodner drawing is a preparatory study that he made for it.

1. For the Spencer painting and related background material, see *England and the Seicento,* catalogue by Clovis Whitfield, Thomas Agnew and Sons, London, 6 November – 7 December 1973, no. 49.
2. It is unclear whether the Naples painting is one and the same as the painting which Malvasia saw in the Palazzo Falconieri in Rome.
3. Otto Kurz, "Guido Reni," *Jahrbuch der Kunsthistorischen Sammlungen in Wien,* N.F. 11, 1937, p. 217.
4. C. C. Malvasia, *Felsina Pittrice,* 1841, vol. 2, p. 42.

EXHIBITIONS: Woodner Collection 1, no. 44; *Old Master Drawings from American Collections,* catalogue by Ebria Feinblatt, Los Angeles County Museum of Art, 1976, no. 93, p. 78.

BIBLIOGRAPHY: D. Stephen Pepper, *Guido Reni,* Oxford, 1982, no. 172.

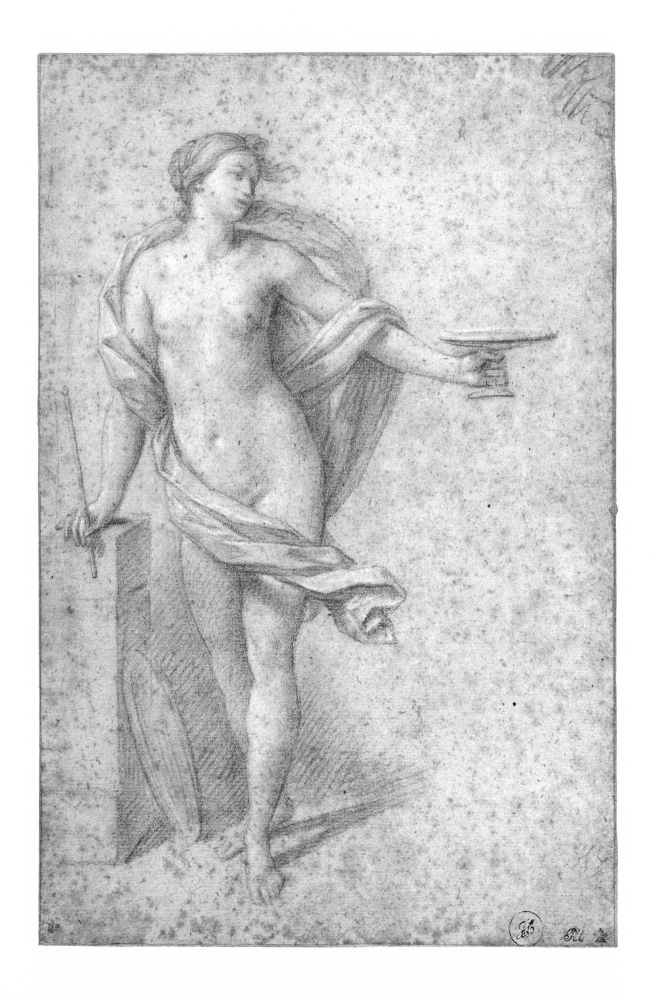

30 GIOVANNI BENEDETTO CASTIGLIONE

Genoa 1610 – Mantua 1670

Adoration of the Shepherds

Brush and red-brown pigment mixed in oil, brown ink, and gouache on cream colored paper (laid down, corners damaged and repaired); 410 x 607 mm. Inscribed on old mount, "Bene: Castigli".

PROVENANCE: C.R. Rudolf Collection (Sotheby's, London, 4 July 1977, lot 107).

The *Adoration of the Shepherds* permitted Castiglione to combine his love of pastoral subjects involving masses of figures and animals with the spiritual inspiration of supplication and divine mystery. The interpretation of the theme in this drawing, with the Virgin turning her head upwards to gaze ecstatically at two angels, marks a break with Castiglione's earlier versions. The composition is frieze-like, with movement surging to the left. The lucid and controlled structure is a model of classical Baroque organization and recalls Poussin. Eunice Williams has pointed out that the influence of Poussin may be detected specifically in the relationship of the drawing to his painting of the *Adoration of the Magi* (National Gallery, London). They are related in reverse, which suggests that Castiglione may have been using Etienne Picart's engraving after Poussin.[1] The two compositions share a similarity of organization, the two fluted columns, and the fruit-bearing figure.

Williams dates the drawing to circa 1650–60, placing it at the same period as the *Adoration of the Kings* in Windsor.[2] This would set it within the "ecstatic Baroque" phase of Castiglione's career, alongside drawings such as *God the Father and Two Angels Appearing to the Virgin and Child* in the Fogg Art Museum, Cambridge (1965.373). In fact, the figures of the Virgin in the Fogg and the Woodner drawings are extremely similar.

The Woodner *Adoration* is one of the finest examples in America of Castiglione's draughtsmanship. In it he employs his highly personal technique of drawing with a brush dipped in coarsely ground pigment mixed only with linseed oil. This allows him to outline forms and to model in a painterly manner almost simultaneously. It also shows the rich colorism of his drawings: warm reddish-browns varying from dry transparency to opaque richness and flat, cool blue-grays enhancing the frieze-like composition.

1. Georges Wildenstein, "Les Graveurs de Poussin au XVIIIe siècle," *Gazette des Beaux-Arts,* s. 6., vol. 46, 1955 (1957), no. 37, pp. 148-9.
2. Anthony Blunt, *The Drawings of G. B. Castiglione and Stefano della Bella in the Collection of Her Majesty the Queen at Windsor Castle,* London, 1954, no. 178, p. 40.

EXHIBITIONS: None.

BIBLIOGRAPHY: Axelle de Gaigneron, "Les nouveaux choix de Mr Woodner," *Connaissance des Arts,* no. 348, February 1981, pp. 74-75.

31 GIOVANNI FRANCESCO BARBIERI, called IL GUERCINO

Cento 1591 – Bologna 1666

Study of a Young Man

Black chalk on cream colored paper (backed); 221 x 178 mm. Inscribed on verso in graphite, "40".

PROVENANCE: Leo Franklin, London.

This drawing does not appear to be a study for a specific painting. The figure is rather idealized, perhaps a generalized life study made in the studio. Black chalk is used less frequently than red chalk or pen and ink in Guercino's graphic work, and it is used with greater subtlety and more restraint than the pen. It depends upon tonal contrasts and carefully graduated light and shade effects for impact. Only in the hair, in the lower back, and in the arms does one see the bravura line that is so characteristic of Guercino's pen drawings. There is, however, a correspondingly greater degree of atmospheric control and suggestion here.

This drawing seems to date from the period around 1650–55. It is comparable to a red chalk study of a young man on the verso of a drawing datable to 1650.[1] Contrary to the information given in the first Woodner catalogue, the black chalk is not oiled and the "natural ridges of the material" are really the pattern formed by laid and chain lines on the antique laid paper.[2]

1. *Il Guercino: catalogo critico dei disegni,* catalogue by Denis Mahon, Bologna, Palazzo dell'Archiginnasio, 1 September – 18 November 1968 (1969), no. 164.
2. Eunice Williams, unpublished notes.

EXHIBITIONS: Woodner Collection 1, no. 45; *Old Master Drawings from American Collections,* catalogue by Ebria Feinblatt, Los Angeles County Museum of Art, 29 April – 13 June 1976, no. 97, p. 80.

BIBLIOGRAPHY: None.

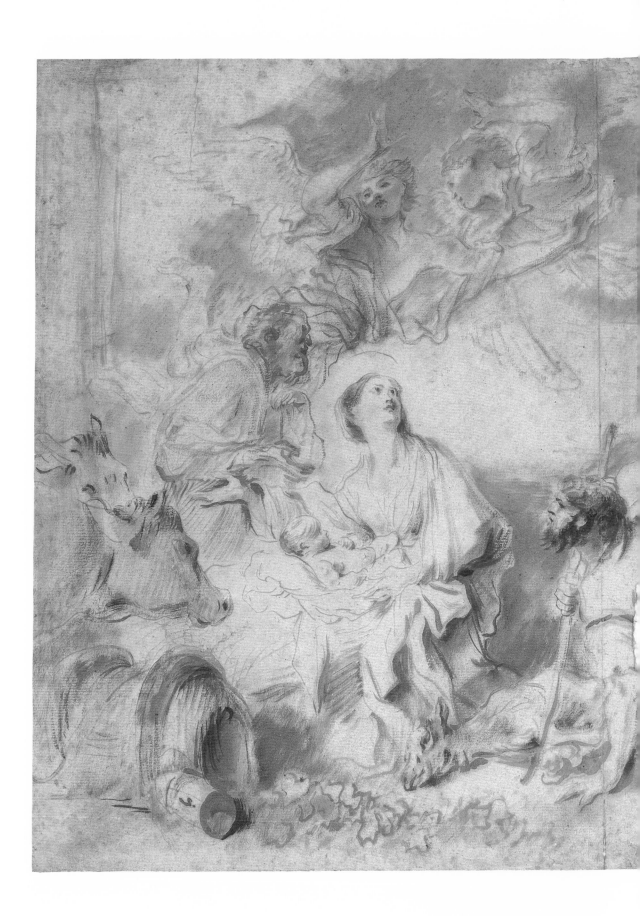

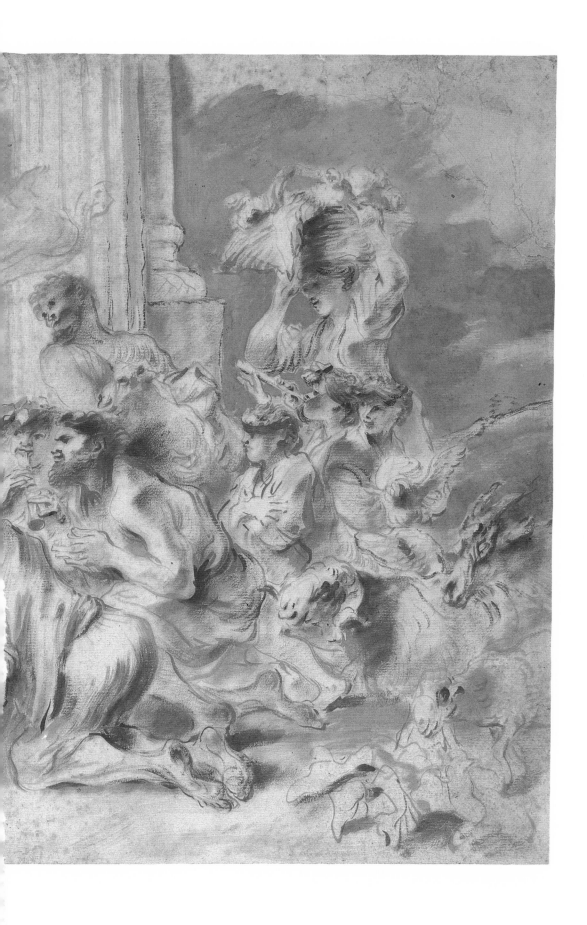

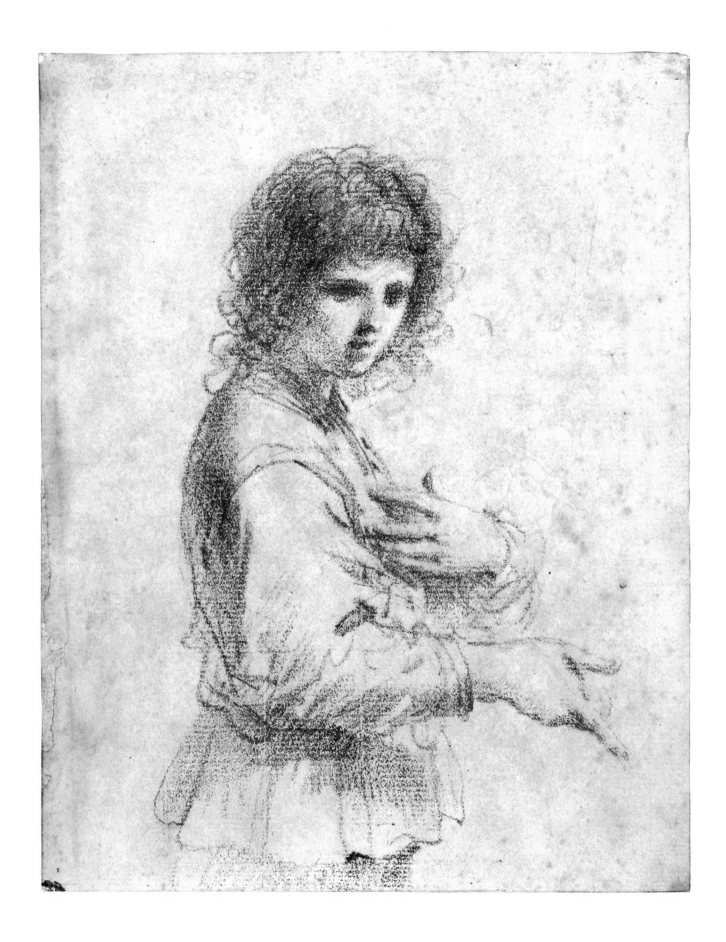

32 GIOVANNI BATTISTA TIEPOLO

Venice 1696 – Madrid 1770

Head of a Young Man

Red and white chalk on blue paper; 241 x 168 mm. Inscribed on verso in brown ink, "No. 3799c (?) / Xrs 48".

PROVENANCE: Johann Dominik Bossi; Carl C. F. Beyerlen; Dr. Hans Wendland, Lugano; Savile Gallery, London (1930); Sir Thomas Barlow; Huntington Hartford (Sotheby's, London, 1 July 1971, lot 63).

This is one of many drawings by Tiepolo and his school that were formerly in the Bossi-Beyerlen collection. Johann Dominik Bossi (1767-1853) was a professor and court artist in Munich, and there is a remote chance that he may have been a student of Domenico Tiepolo.[1] The drawing is a fine example of Giambattista's use of the chalk medium at the height of his powers. The surface radiates a changing pattern of light and shadow, while the eyes suggest great sensitivity of expression.

Knox has suggested that this may be a study for the figure of a man who appears full-length in a drawing by Giambattista in Stuttgart and in versions by Domenico and Lorenzo Tiepolo in the Martin von Wagner Museum, Würzburg, and formerly in the Adolphe Stein Collection, Paris.[2] The resemblance of the Woodner drawing to the study in Stuttgart is strong in the overall physiognomy, in the way the head is set, and in the form of the collar. The latter two points may be studied more fully in a copy of the Woodner drawing by Lorenzo Tiepolo in the Martin von Wagner Museum, Würzburg.[3]

None of these drawings can be related to an existing painting, though Knox has noted that figures in similar costume appear in a painting by Giambattista, the *Banquet of Cleopatra* (Arkhangelskoye Museum, Moscow) of circa 1743.[4] More concrete evidence for dating may be found in a drawing of a man's head in the Ashmolean Museum, Oxford (Knox M.662, Parker 1080) made in preparation for a fresco in the Villa Cordellina, Montecchio Maggiore, of 1743.[5] The verso of the Oxford sheet has an offprint of the Woodner drawing, probably the accidental result of the two pages following one another in an album. This, together with the fact that Lorenzo Tiepolo's copy dates from approximately 1752, places the Woodner study around 1742-3, as Knox has concluded.[6]

1. James Byam Shaw, *The Drawings of Domenico Tiepolo,* London, 1962, p. 19, n. 2.
2. George Knox, *Giambattista and Domenico Tiepolo; A Study and Catalogue Raisonné of the Chalk Drawings,* Oxford, 1980, vol. 1, no. M. 343, p. 252 (Stuttgart); no. G.19, p. 167 (Würzburg); and no. M.76, p. 218 (ex-Stein).
3. Ibid., no. H.73, p. 178.
4. Ibid., in no. M.343, pp. 251-2.
5. Ibid., no. M.662, p. 287; Karl Theodore Parker, *Catalogue of the Collection of Drawings in the Ashmolean Museum,* Oxford, 1956, vol. 2, p. 536, in no. 1080.
6. Sotheby's, London, 1 July 1971, no. 63; G. Knox, op. cit., no. M. 629, p. 284.

EXHIBITIONS: *Drawings by Old Masters,* Savile Gallery, London, 1930, no. 34; Woodner Collection 2, no. 68.

BIBLIOGRAPHY: Karl Theodore Parker, *Catalogue of the Collection of Drawings in the Ashmolean Museum,* Oxford, 1956, vol. 2, in no. 1080, p. 536; George Knox, "Francesco Guardi as an Apprentice in the Studio of Giambattista Tiepolo," *Studies in Eighteenth Century Culture,* Madison, Wisconsin, 1976, vol. 5, p. 35, fig. 9; idem, *Giambattista and Domenico Tiepolo: A Study and Catalogue Raisonné of the Chalk Drawings,* Oxford, 1980, vol. 2, no. M.629, p. 284, also in nos. H.73, p. 178, M.343, p. 251, and M.662, p. 287.

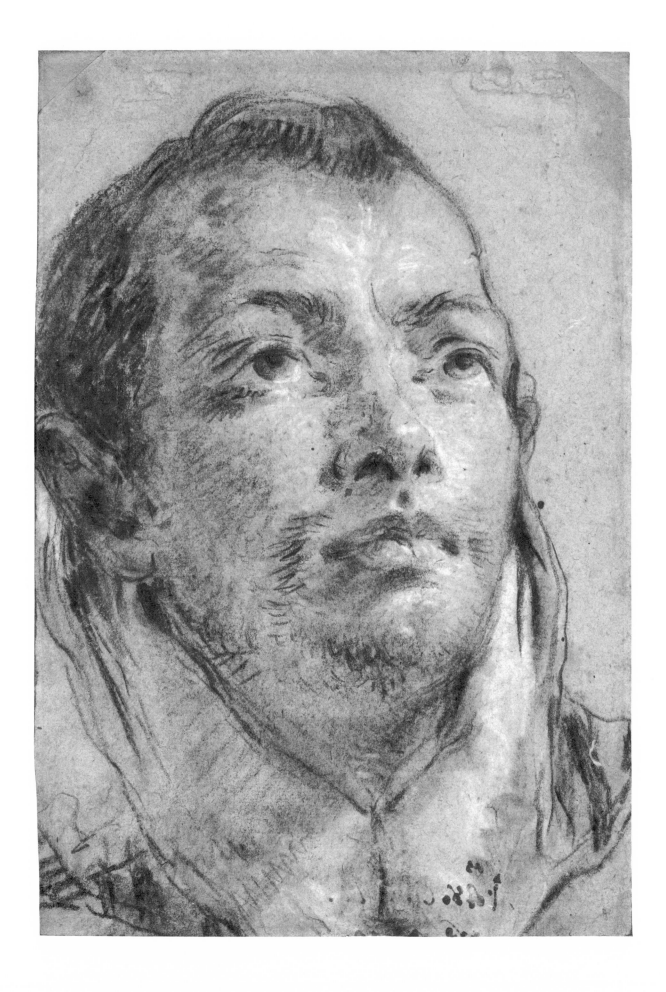

33 GIUSEPPE GALLI DA BIBIENA

Parma 1696 – Berlin 1756

Architectural Design with Christ Given over to the People

Pen and brown ink with gray and brown washes on cream colored paper; 606 x 399 mm. Unidentified mark on lower left in red ink, "AT" joined inside a circle (see Lugt 183[b]: perhaps Dr. A. Tardieu [1818-1879], Paris).

PROVENANCE: Perhaps Dr. A. Tardieu (1818-1879), Paris (see Lugt 183[b]).

This drawing is a highly finished preparatory design for an engraving by Johann Andreas Pfeffel in *Architetture e Prospettive,* part 3, plate 8.[1] Its theatricality is overt; this is the setting for a *theatra sacra,* a presentation of sacred liturgical dramas given on Good Friday in the Court Chapel, Vienna. The design uses a perspective system characteristic of the Bibiena family, with the stage set at a forty-five degree angle to give the illusion of greater space. Within an elaborately staged courtyard, which almost obscures the narrative, Christ is shown being handed over to the mob. The general animation and the variety of gestures compensate for the rather static figures that may have been traced before application of the washes.[2] The drawing also demonstrates Giuseppe's control over pen and brush, combining as it does transparent gray wash and dark brown wash without adversely affecting the linear structure of the underdrawing.

The date of the engraving for which the drawing was made, and therefore of the drawing itself, is not certain. The drawing shows differences from the engraving, such as the addition of a proscenium in the latter, which clearly indicate that it precedes the engraving. It has been assumed that the plates of *Architetture e Prospettive* could all be dated to 1740, based on the date of the frontispiece. This has been disproved, and the question of the evolution of this great project remains to be fully discussed.[3]

1. *Architetture e Prospettive, dedicate alla Maestà di Carlo Sesto, Imperador de' Romani,* Augsburg, 1740, pt. 3, pl. 8.
2. Eunice Williams, unpublished notes.
3. Arthur H. Saxon, "Giuseppe Galli-Bibiena's *Architetture e Prospettive,*" *Maske und Kothurn,* vol. 15, 1969, pt. 2, p. 112. Eunice Williams has discovered two sketches containing seminal ideas for the Woodner drawing in a sketchbook of Bibiena drawings, thus far unpublished, in the Houghton Library at Harvard University, and will shed new light on this matter when she publishes her findings.

EXHIBITIONS: Woodner Collection 2, no. 75.

BIBLIOGRAPHY: None.

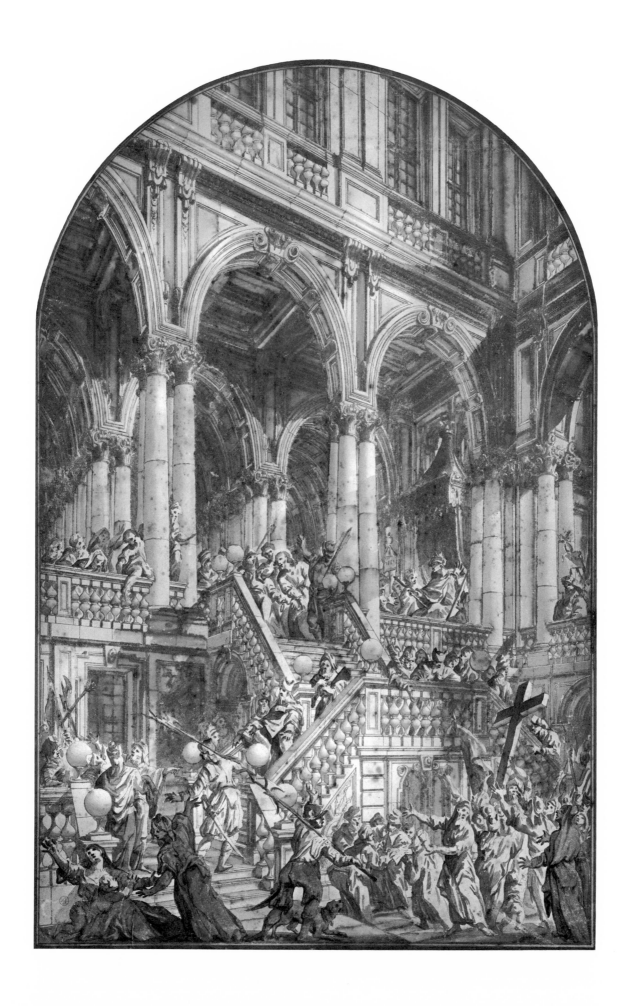

34 GIOVANNI BATTISTA PIRANESI

Venice 1720 – Rome 1778

Study of a Standing Man

Pen and brown ink with brown wash on heavy cream colored paper; 151 x 109 mm. Italian and Latin printed text on verso; inscribed in graphite beneath drawing on mount, "pose des / Bas".

PROVENANCE: Adolphe Stein, Paris (1977).

This figure was probably cut from a larger sheet containing several studies drawn from life. As is typical of Piranesi, the figure is rapidly sketched, with a few vigorous outlines describing the pose. Beyond this, bold diagonal hatching shades the form and suggests a spatial context. As is true of his figure studies in general, Piranesi seems unconcerned with individual personality or appearance and emphasizes gestures and poses that express categorical states of activity or lassitude. Furthermore, his figure studies are rarely relatable to the anonymous people who inhabit his prints, although Eunice Williams has pointed to the similarity between this study and the man in the center of plate 81 of the *Vedute.*[1]

The dating of this and other Piranesi figure drawings is difficult. The artist often drew on the backs of trial-proofs, thereby accidentally providing a basis for dating the drawing. The Woodner study was made on the back of a printed text page with fragmentary and unidentified inscriptions in Latin and Italian. The notation "c.173" also appears but cannot be read as 1773, as is the case with the Piranesi drawing formerly in the collection of Baron von Hirsch.[2]

1. *Veduta Interna dell'Antico Tempio di Bacco, in Oggi Chiesa di S. Urbano,* 1767, reprod. in John Wilton-Ely, *The Mind and Art of G.B. Piranesi,* London, 1978.
2. Sotheby's, London, 20 June 1978, lot 60.

EXHIBITIONS: None.

BIBLIOGRAPHY: None.

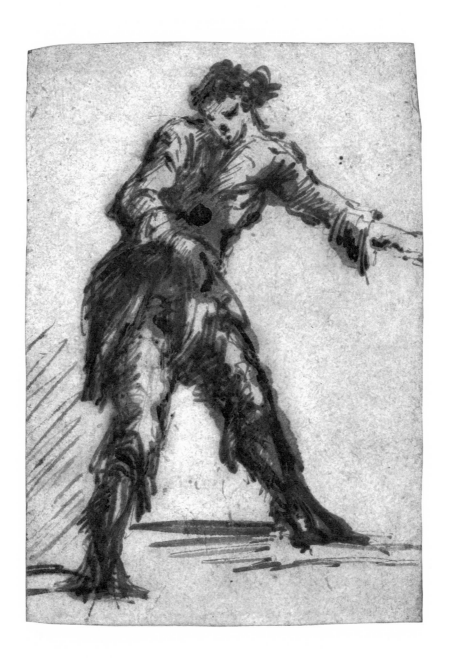

35 GIOVANNI DOMENICO TIEPOLO

Venice 1727 – Venice 1804

The Raising of Tabitha

Pen and brown ink with brown wash over black chalk on cream colored paper (watermark: radiant sun above FGA [unidentified]); 487 x 377 mm. Inscribed on verso at upper left in graphite, "A IX 40 (?)", and at upper right, "61".

PROVENANCE: None.

The episode of the Raising of Tabitha concerns the miracle at Joppa when St. Peter raised the pious woman Tabitha who had become sick and died (*Acts* 9.36-42). The moment depicted in this drawing is that of St. Peter showing the revived Tabitha to the "saints and widows" he had called into the chamber in which her body had been kept. Domenico interprets the subject with grandeur of scope and great animation. The magnitude and concentration of dramatic action in the drawing put it firmly within the by then already ancient tradition of Italian narrative art, reaching back to Donatello and Titian.

This drawing was once part of a great sequence of religious drawings by Domenico numbering more than two hundred, the largest group of which is now in the Louvre. Byam Shaw has with good reason dated them in the latter part of the eighteenth century, which would make them among the last major religious narratives in the Italian tradition.[1]

Byam Shaw suggests that Domenico's major series of religious drawings may well have been intended to demonstrate his ability as a "history painter," that is, an artist capable of conceiving compositions of the highest seriousness of subject and of the greatest complexity in organization.[2] He seems surely correct in considering this series to have been made for its own sake rather than in preparation for prints or paintings.

1. James Byam Shaw, *The Drawings of Domenico Tiepolo,* London, 1962, p. 37.
2. Ibid., p. 36.

EXHIBITIONS: Woodner Collection 2, no. 73.

BIBLIOGRAPHY: None.

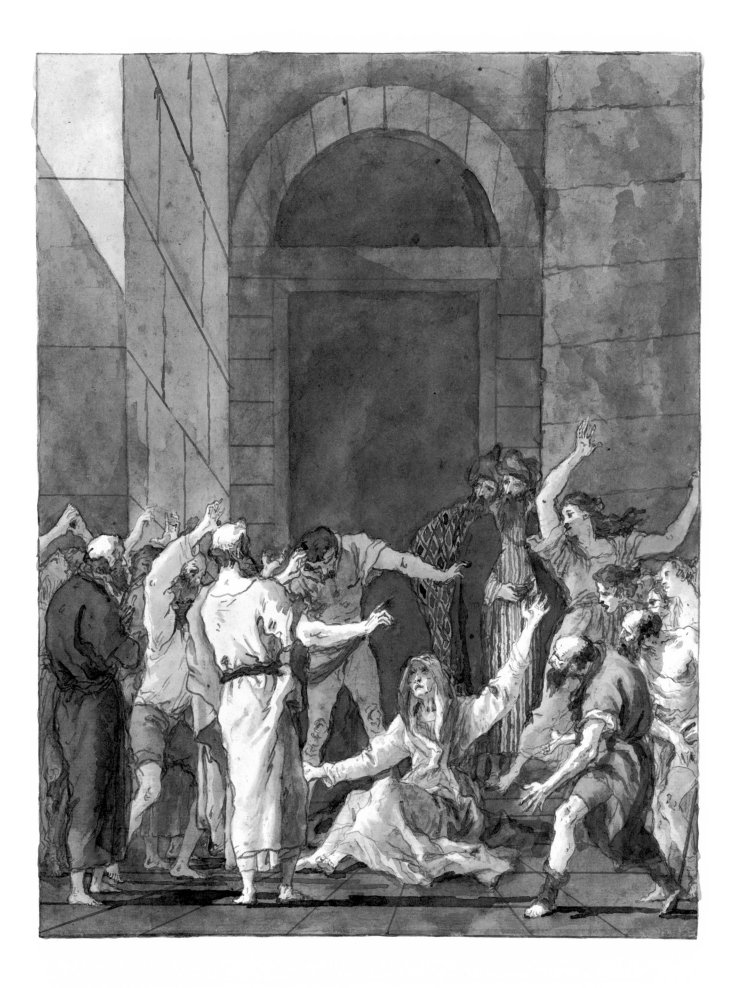

36 GIOVANNI DOMENICO TIEPOLO

Venice 1727 – Venice 1804

Punchinellos Hunting Water Fowl

Pen and brown ink and brown wash over black chalk on white paper (watermark: graduated triple crescents); 347 x 470 mm. Inscribed at lower right in brown ink, "Domo Tiepolo f." and at upper left in brown ink, "3", and in graphite, "2".

PROVENANCE: Sotheby's, London, 6 July 1920, lot 41; P. and D. Colnaghi, London; Richard Owen, Paris; Palais Galliera, Paris, 16 June 1967, lot K; William H. Schab Gallery, New York.

Punchinellos Hunting Water Fowl is one of 103 drawings illustrating the life and activities of Punchinello that the artist entitled *Divertimento per li regazzi*. Punchinello was a popular character of the Comedia dell'arte who was of Neapolitan origin. He always appeared with hunched back, dressed in a white costume with cylindrical hat and a black mask with a long beaked nose.[1] He was sly, lazy, clever, witty, and bawdy, the epitome of the most fallible aspects of the human condition. As one recent writer has put it, Punchinello was the "quintessential expression of popular culture."[2] Attempts have been made to attach political and patriotic interpretations to the series of drawings, but perhaps the straightforward explanation of its purpose by Byam Shaw is still the most convincing.[3] He sees it as a diversion for children visiting the now elderly Domenico about 1800, extensions of the frescoes at the Tiepolo villa at Zianigo with similar subjects.

The Woodner drawing from this series shows the youthful Punchinellos amusing themselves by hunting water fowl. It is lively and energetic, showing a point in the protagonist's life before he was arrested. As is characteristic of Tiepolo, the medium is golden-brown ink and wash over black chalk underdrawing. The animation of line and subtle variations of tone in the wash create an overall effect of great luminosity and movement.

1. For discussions of Punchinello's costume, see James Byam Shaw, *The Drawings of Domenico Tiepolo,* London, 1962, p. 53 and Adelheid M. Gealt, in *Domenico Tiepolo's Punchinello Drawings,* Indiana University Art Museum, Bloomington, 1979, p. 12.
2. Marcia E. Vetroq, in *Domenico Tiepolo's Punchinello Drawings,* op. cit., p. 28.
3. J. B. Shaw, *Drawings,* op. cit., p. 59.

EXHIBITIONS: Musée des Arts Décoratifs, Paris, 1921; Woodner Collection 2, no. 71; *Domenico Tiepolo's Punchinello Drawings,* catalogue by Marcia E. Vetroq, Indiana University Art Museum, Bloomington, 1979, no. 18.

BIBLIOGRAPHY: James Byam Shaw, *The Drawings of Domenico Tiepolo*, London, 1962, p. 55; Axelle de Gaigneron, "Ian Woodner, amateur américain de réputation mondiale, commente quelques oeuvres majeures de sa collection," *Connaissance des Arts,* no. 310, December 1977, p. 103.

GERMAN AND SWISS DRAWINGS

37 GERMAN SCHOOL (or English School)

Fourteenth century

St. Christopher
verso: *Flowers*

Pen and black ink with black wash on vellum; 152 x 216 mm. Inscribed on recto in black ink:

 Propensus. extensus uel festinus
 Propensius. festinanter
 Propyciatorium. ain pethauss uel gnadhauss uel stad
 Quamobrem. quare et cetera [?] ---- aduerbium [?] Etiam pro ergo
 ponitur; commune [?] est [?]
 Quominus. quosque
 Quodsi. set si
 Quodammodo. etlicher weiss
 Extimplo. subito et dum statim ubi quidam dicunt
 extemplo [w: *deleted by scribe*] Tempus non timpus saltem
 dices neque saltim Extemplo non extimplo
 docet artis amicus
 [erased reading]
 Apud ---- per [?] denarium [?] scribitur sicut apud presentem [?]
 Ad per denarium

PROVENANCE: Estate of Hans M. Calmann.

Pen drawings with black washes like the Woodner sheet are especially characteristic of central European work of the first half of the fourteenth century.[1] Close in drawing style to the Woodner sheet, particularly in the handling of the outlines at the edge of the drapery folds and in the modeling techniques and formulae for facial features and hands, are the major illustrations in the celebrated Passional of the Abbess Konhuta (Kunigunde) in the University Library in Prague,[2] which dates from circa 1312, when the text was composed, to circa 1321, when the manuscript was left incomplete at the death of the Abbess. Yet the Woodner drawing is certainly not by the hand of the same master. The St. Christopher at the left of the sheet is distinguished by his dynamic stride, by his sharp profile and squarish head, and by the view of his broad-shouldered back, all elements that came into Central European art under the influence of Giotto. Giottesque also is the architecture of the tabernacle. The St. Christopher at the right of the sheet, in his swaying pose and rich drapery folds as well as in his refined and ornamental beard, clearly shows the influence of French or even English book illumination of the late thirteenth century and early fourteenth century.

A combination of precisely these elements can be found in the major monument of Austrian painting in the first half of the fourteenth century, the four panels painted on the back of the Verdun altarpiece in the monastery of Klosterneuburg, now dated circa 1330/1, when Nicholas of Verdun's enameled ambo was remodeled into a winged altarpiece.[3] The same richness of the draperies, the squarish faces and strange profiles, and a Giottesque architecture can be found in these panels. The hand of the anonymous master does not, however, seem to be exactly the same as the one of the Woodner sheet, which seems slightly more refined and delicate, in sum, more French and less Giottesque. However, no close associate of the Klosterneuburg master is known, nor did he have any pupil that can be traced. None of his later known imitators in Austria retain the Italian elements, and the

back views in his work are practically unique in German art. So the sheet might indeed be either by the Klosterneuburg master at an earlier or later date or by a yet unknown very close associate of his.[4]

1. Zoroslava Drobna, *Gothic Drawing,* trans. by Jean Layton, Prague, 195-, pp. 19, 27-28, figs. 8-10.
2. Ibid., fig. 11.
3. *Die Zeit der frühen Habsburger. Dome und Klöster 1279-1379,* exhibition catalogue, Niederösterreichische Landesausstellung, Wiener Neustadt, 12 May - 28 October 1979, no. 239, pp. 443-445 ff., fig. 2.
4. This entry was written by Professor Konrad Oberhuber.

EXHIBITIONS: None.

BIBLIOGRAPHY: None.

POSTSCRIPT: Following completion of this entry, Professor Oberhuber received a communication indicating that Professors Pächt and Schmidt and Dr. Jenni believe this drawing to be English of about 1340.

38 CIRCLE OF HANS PLEYDENWURFF

Circa 1460 – 1470

Bust of a Female Saint or Sibyl

Pen and black ink and gray wash on cream colored paper; 199 x 142 mm. Inscribed on lower left in brown ink, "MW", and on verso in black ink, "Jos Camesinaj / Pomal 1825" (Lugt 429), in brown ink at lower left, "Wolgemuth f. 1439 / geb. Nuremburg 1492 1434 - 1420 (?) 5.7 1/2 / 6 5ᵈ / L" (Lugt 3002-3004), and at the right edge in graphite, "5".

PROVENANCE: Cornelis Ploos van Amstel, Amsterdam (Lugt 3002-3004); Josef Camesina de Pomal, Vienne (Lugt 429); Baron Robert von Hirsch (Sotheby's, London, 20 June 1978, lot 9).

In the sale catalogue of the collection of Baron von Hirsch this figure was identified as Mary Magdalene, and the similarity between her and two drawings of that subject in the British Museum was noted.[1] The two drawings in the British Museum are copies after the right panel of Rogier van der Weyden's altarpiece for Jean de Bracque now in the Louvre. The connection between them and the Woodner drawing is based on the fact that it also reflects a Rogierian type, though it is not a copy of any known figure by him. The physiognomic character of the Woodner drawing is similar to that of the two other sheets, but there is little reason to assume that the subject is the same. The absence of an ointment jar or of any other attribute associated with the Magdalene would suggest a different subject. The pseudo-Greek inscription on the headdress places the woman in ancient times, and she may be one of the sibyls (as suggested by Barbara Baxter).

The graphic style of the Woodner drawing is quite different from the British Museum copies after Rogier. The face is sensitively rendered with a fine brush and wash, but the pen work in the remainder of the figure and drapery is noticeably weaker, perhaps suggesting that the face alone depends directly on a Rogierian prototype. Baxter has proposed that the drawing was made by someone in the ambient of Hans Pleydenwurff, based in part on the appearance of figures and costumes derived from Rogier's work in paintings by him and his associates, such as the *Crucifixion* by Pleydenwurff in the Alte Pinakothek, Munich.[2] She also points to a general similarity between the style of the Woodner drawing and a drawing of the *Crucifixion* by a follower of Pleydenwurff, perhaps the Master of the Land-auer Altar, now in the Szépmüvéseti Múzeum, Budapest.[3] The attribution to the circle of Pleydenwurff is suggestive, but the paucity of drawings from that source make definitive judgment difficult.

1. *The Robert von Hirsch Collection. Volume One: Old Master Drawings, Paintings, and Medieval Miniatures,* Sotheby's, London, 20 June 1978, lot 9.
2. Alfred Stange, *Deutsche Malerei der Gotik,* vol. 9, Munich, 1969, pl. 73.
3. Edmund Schilling, *Nürnburger Handzeichnungen des XV. und XVI. Jahrhunderts,* Freiburg, 1929, no. 2, p. 25.

EXHIBITIONS: None.

BIBLIOGRAPHY: None.

39 MASTER OF THE STRASSBURG CHRONICLE

1492 - 1493

Two sheets from the Strassburg Chronicle:
(A) *Duke Maximilian of Austria on Horseback* (fol. 62v) and
(B) *The Crucifixion* (fol. 120v).

(A) Pen and brown ink over black chalk on cream colored paper (watermark: *tête de boeuf* similar to Briquet 14681-14684 [Würzburg, Colmar, circa 1400] and 14923-14935 [Zürich, S.W. Germany, Switzerland, circa 1400-1428]); 386 x 260 mm. (image); inscribed on lower right in brown ink, "1492" (fol. 62v). (B) Pen and brown ink over black chalk on cream colored paper (same watermark as fol. 62v); 387 x 265 mm. (image) (fol. 120v).

PROVENANCE: Biblioteca Künastiana, 1667 (inscription in upper cover); Christie's, London, 28 June 1972, lot 31.

The *Strassburg Chronicle,* a German manuscript written in brown ink, was begun in the fifteenth century and completed in the early seventeenth century. Based largely on the *Weltchronik* of Jacob von Königshofen (1346-1400), which was printed in 1476, the earlier fifteenth century text was augmented by the scribe Johann von Hungerstein. His additions chronicle events concerning the Hapsburgs and the Hungerstein family in Alsace in the second half of the fifteenth century.[1]

The manuscript contains five illustrations, other than marginalia: folio 3, *The Tree of Jesse*; and folio 62, verso, *Duke Maximilian of Austria on Horseback (A)*; folio 63, verso, *Coat of Arms of Maximilian as Roman King*; folio 120, verso, *Crucifixion (B)*; and folio 17, *Siege of Troy*. Of these, the first four are by an unknown Alsatian artist of considerable accomplishment, whereas the last is by a less significant artist. The four main illustrations are by the same hand as a sheet in Berlin (KdZ 26132) with the *Creation* on one side and a drawing on the other of the coat of arms of Johann von Hungerstein and Agathe Reiffs held by a nude woman beneath a crowned monogram of their initials bound together by a love knot. Anzelewsky has suggested that this sheet was produced for their marriage in 1489, or shortly thereafter.[2]

Both the Berlin sheet and the major drawings of the Strassburg Chronicle have been related to *Kabinettscheibe,* small glass paintings for private patrons which often treated armorial subjects. However, comparisons with the work of Peter Hemmel (circa 1422 - after 1501) and his workshop do not justify an attribution to him. This is true both of the glass painting by Hemmel in Stuttgart and of the drawings associated with him by Anzelewsky in the Albertina and Rodrigues collections.[3] These latter drawings are more advanced than those in the *Strassburg Chronicle,* even though they and the Stuttgart glass painting are contemporary with it. The artist responsible for the major illustrations of the *Strassburg Chronicle* reflects the work of Schongauer to some extent, as does Hemmel, but his connection with the great Colmar master is not a close one. The *Crucifixion* shows a clear dependence on Schongauer's engraving; but the figures in the *Chronicle* sheet are much stiffer, and the rich tonal effects of Schongauer's engraving are entirely lost. Anzelewsky has pointed to a connection between the Berlin sheet and the work of the Master E.S., and this general relationship may be extended to these illustrations as well.[4] Therefore, though

the illustrations of the *Strassburg Chronicle* date from 1492–3, they represent in certain respects an earlier stage of development.

1. For a description of the manuscript, see Woodner Collection 2, no. 1.

2. *Vom Späten Mittelalter bis zu Jacques-Louis David,* catalogue by Fedja Anzelewsky, Staatliche Museen Preussischer Kulturbesitz, Berlin, 1972, p. 11.

3. Paul Frankl, *Peter Hemmel Glasmaler von Andlau,* Berlin, 1956; Woodner Catalogue 2, no. 1; Fedja Anzelewsky, "Peter Hemmel und der Meister der Gewandstudien," *Zeitschrift des Deutschen Vereins für Kunstwissenschaft,* vol. 18, 1964, pp. 52–53; *Vom Späten Mittelalter...,* op. cit., p. 12.

4. *Vom Späten Mittelalter...,* loc. cit.

EXHIBITIONS: Woodner Collection 2, no. 1

BIBLIOGRAPHY: *Vom Späten Mittelalter bis zu Jacques-Louis David,* catalogue by Fedja Anzelewsky, Staatliche Museen Preussischer Kulturbesitz, Berlin, 1972, p. 11.

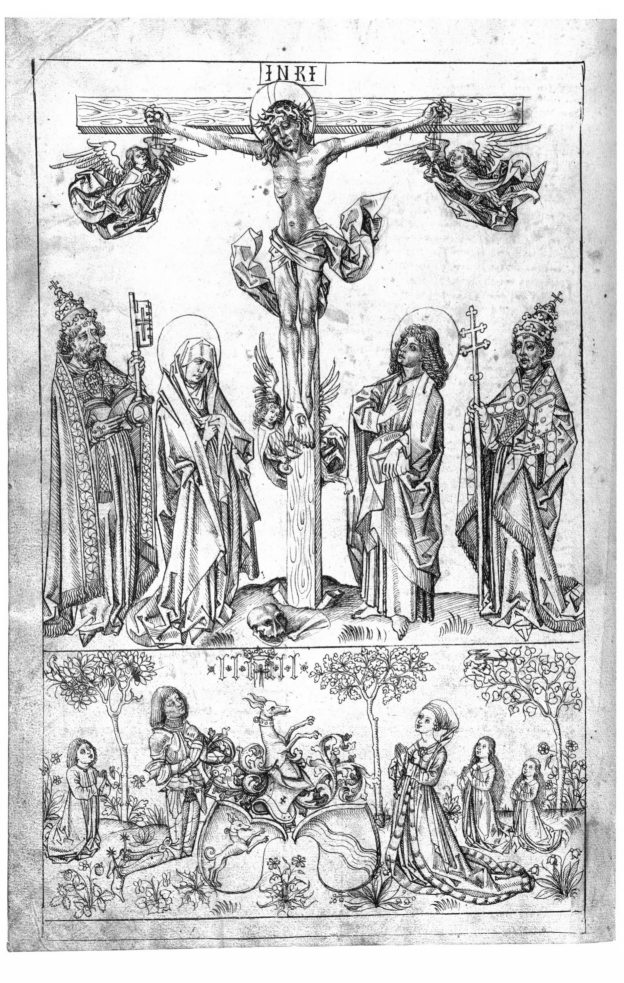

40 BASEL SCHOOL

Circa 1490

Scenes from the Life of Christ

Pen and black ink with gray wash (some retouching) on two sheets of buff paper (joined horizontally); 406 x 295 mm. Inscribed on verso in graphite, "Nº 123 M", in blue ink, "Propriete [illegible] Ressuri", and in blue crayon, "204".

PROVENANCE: Collector's mark on verso, "HM" inside two concentric circles; collector's mark on verso of Baron Adalbert Freiherr von Lanna (Lugt 2773); R.W.P. De Vries (*Catalogue* 2, Amsterdam, 1929, lot 56).

The primary subject of this drawing is the *Resurrection,* which is depicted in a compositional format found frequently in German art of the period and derived ultimately from the tradition of Dieric Bouts and Rogier van der Weyden (as in Bouts' painting of the Resurrection in the Alte Pinakothek, Munich).[1] The background scenes show the *Calling of St. Peter, Noli me Tangere,* and the *Harrowing of Hell.* The influence of Netherlandish artists such as Bouts is also apparent in the treatment of the figures in Hell.

The drawing was attributed to the "Swiss School 1480-1500" by Hyatt Mayor.[2] As De Vries has already suggested, it has much in common with drawings from the circle of Hans Holbein the Elder.[3] Similarities are apparent in the use of wash and physiognomic types, but Holbein's drawings are more animated and more dramatic in the contrast of light and shade. The rather even distribution of figures throughout the foreground and background scenes also differentiates the Woodner drawing from the more concentrated narratives of Holbein. Christiane Andersson has suggested that the Woodner sheet may be related to the ambient of Jörg Schweiger, a contemporary of Holbein in Basel.[4] There are analogies between drawings from his circle and the Woodner drawing in the use of wash and in the treatment of draperies and figure types, indicating that this is the likely environment from which it emerged.

Hyatt Mayor proposed that the drawing was made in preparation for glass painting, but the detailed background suggests that this is unlikely. It is far more probable that the highly finished graphic manner of the drawing indicates that it was copied from a painting.[5] The possibility that it is a copy, as Andersson has noted, is strengthened by the fact that the figure of Christ in the *Harrowing of Hell* has the clasps missing from his robe.

1. M. Frans Baudouin, *Dieric Bouts,* Palais des Beaux-Arts, Bruxelles, 1957-1958, no. 4, p. 30.
2. *15th and 16th Century European Drawings,* catalogue by Alpheus Hyatt Mayor, American Federation of Arts, New York, 1967-68, no. 3, p. 11; Woodner Collection 1, no. 52.
3. A.G.C. De Vries, *Dessins de Maîtres Anciens et Modernes,* no. 2; R.W.P. De Vries, Amsterdam, 1929, lot 56.
4. See T. Falk, *Katalog der Zeichnungen des 15. und 16. Jahrhunderts im Kupferstichkabinett Basel,* vol. 1, Basel, 1979, for example nos. 280 and 290.
5. A. Hyatt Mayor, loc. cit.

EXHIBITIONS: *15th and 16th Century European Drawings,* catalogue by Alpheus Hyatt Mayor, American Federation of Arts, New York, 1967-68, no. 3, p. 11; Woodner Collection 1, no. 52.

BIBLIOGRAPHY: None.

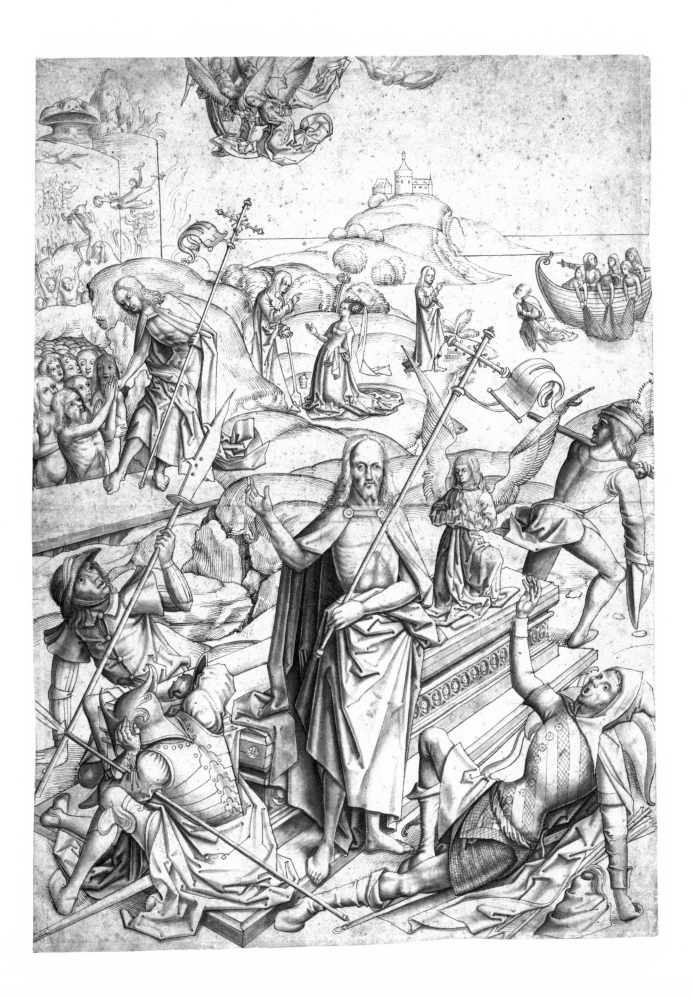

41 ALBRECHT DÜRER, School of

Early sixteenth century

Head of a Boy

Brush and black ink, heightened with white on blue-green prepared paper; 268 x 208 mm. Inscribed in lower left in black ink, "1508" and "y.5"; and in lower right "AD"; and on verso, top, in red chalk, "227".

PROVENANCE: B. Hertz; John Malcolm; Hon. A. E. Gathorne-Hardy; Geoffrey Gathorne-Hardy; Hon. Robert Gathorne-Hardy (Sotheby's, Amsterdam, 3 May 1976, lot 8).

Dürer began to make brush drawings of heads and other details for his paintings in 1506 in Venice, using blue Venetian paper. He continued this practice when he returned to Nuremberg, using prepared papers in various tones from blue to green.

The Woodner drawing was first published by Dodgson as an original; but he later changed his mind, calling it a copy after another version in pen and ink in Munich.[1] The authenticity of the Woodner drawing was maintained by Winkler and Strauss, although the majority of scholars (Wölfflin, Flechsig, Tietze, and Panofsky) have considered it a copy.[2] Tietze, following Dodgson, considered the Munich sheet the original, but all other scholars have supported Wölfflin's view that it is also a copy. The position that both drawings are copies seems to be correct. As Oberhuber points out, the Woodner drawing deviates from Dürer's style in that its line is more decorative and creates neither depth nor atmosphere. The Woodner drawing therefore appears to be a contemporary copy, but the Munich version in pen and ink remains problematical since it is an uncharacteristic medium for Dürer in 1508.

The original drawing may well have been a study for a figure in a painting such as the *Christ among the Doctors* in the Thyssen Collection.[3] As Wölfflin suggested, it resembles a head of a young woman by Cima da Conegliano in the Poldi-Pezzoli Museum, Milan.[4] The resemblance may be accidental, but the Italianate character of the drawing is clear.

1. Campbell Dodgson, *Dürer Society, Publications,* vol. 1, 1898, p. 7; ibid., Index, 1911, p. 62.
2. Friedrich Winkler, *Die Zeichnungen Albrecht Dürers,* Berlin, 1936-39, vol. 2, no. 437; Walter L. Strauss, *The Complete Drawings of Albrecht Dürer,* New York, 1974, vol. 2, p. 1058; Heinrich Wölfflin, *Die Kunst Albrecht Dürers,* 5th ed., Munich, 1926, p. 395; Eduard Flechsig, *Albrecht Dürer,* Berlin, 1928-31, vol. 2, p. 453; Hans Tietze, *Kritisches Verzeichnis der Werke Albrecht Dürers,* Augsburg, 1928-34, vol. 2, in no. 381; Erwin Panofsky, *Albrecht Dürer,* Princeton, 1945, vol. 2, no. 1063, p. 109.
3. E. Panofsky, loc. cit.
4. Heinrich Wölfflin, *Der Kunstwanderer,* 1920, p. 137.

EXHIBITIONS: *Albrecht Dürer und Lucas van Leyden,* Burlington Fine Arts Club, London, 1869, no. 145; *German Art 1400-1800 from Collections in Great Britain,* Manchester, October - December 1961, no. 116; *Loan Exhibition of Drawings by Old Masters from the Collection of Mr. Geoffrey Gathorne-Hardy,* P. and D. Colnaghi, London, 12 October - 5 November 1971, and Oxford, Ashmolean Museum, 20 November 1971 - 2 January 1972, no. 1.

BIBLIOGRAPHY: J. C. Robinson, *Descriptive Catalogue of Drawings by the Old Masters Forming the Collection of John Malcolm of Poltalloch, Esq.,* London, 1869, no. 520; Campbell Dodgson, *Dürer Society, Publications,* vol. 1, 1898, p. 7, pl. 7; ibid, Index, 1911, p. 62; Heinrich Wölfflin, "Dürer and Cima da Conegliano," *Der Kunstwanderer,* 1920, p. 137; idem, *Die Kunst Albrecht Dürers,* 5th ed., Munich, 1926, p. 395; Friedrich Lippmann and Friedrich Winkler, *Drawings by Albrecht Dürer,* Berlin, 1883-1929, vol. 7, 1929, no. 749, Hans Tietze, *Kritisches Verzeichnis der Werke Albrecht Dürers,* Augsburg, 1928-1934, vol. 2, in no. 381; Eduard Flechsig, *Albrecht Dürer, Sein Leben und seine künstlerische Entwicklung,* Berlin, 1928-31, vol. 2, no. 437; Friedrich Winkler, *Die Zeichnungen Albrecht Dürers,* Berlin, 1936-39, vol. 2, no. 437; Erwin Panofsky, *Albrecht Dürer,* Princeton, 1945, vol. 1, p. 117, vol. 2, no. 1063, p. 109; Friedrich Winkler, *Albrecht Dürer, Leben und Werk,* Berlin, 1957, p. 191; Walter A. Strauss, *The Complete Drawings of Albrecht Dürer,* New York, 1974, vol. 2, p. 1058.

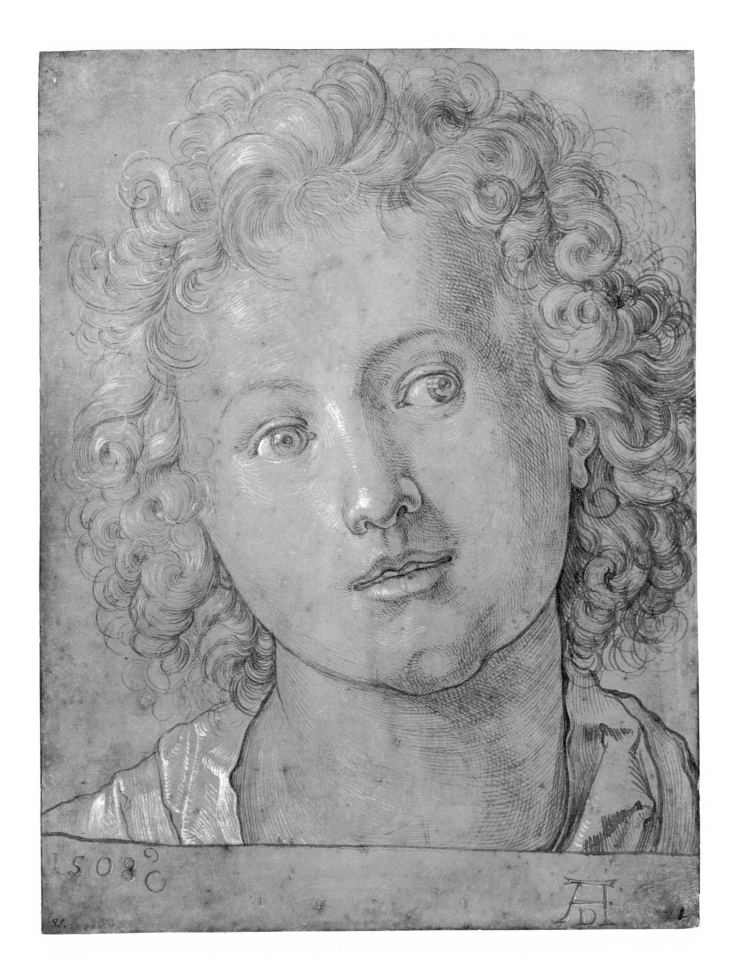

42 ALBRECHT DÜRER, attributed to

Nuremberg 1471 – Nuremberg 1528

Left Wing of a European Roller

Pen and black ink, watercolor, and gouache on vellum, 189 x 238 mm. Inscribed on recto in pen and black ink with AD monogram and date of 1524.

PROVENANCE: William Esdaille (Lugt 2617); Christies's, London, 20 June 1840, lot 511; Alfred Morrison and by descent to Lord Margadale of Islay; Christie's, 6 July 1982, lot 107.

This watercolor is one of several by Dürer and his followers depicting the wing of a blue roller.[1] The primary example, in the Albertina, is signed with his monogram and dated 1512 and is, like the Woodner drawing, on vellum.[2] A second version in Bayonne, which is very similar to the one in the Albertina but drawn on paper, has been ascribed by Konrad Oberhuber to Dürer and dated to around 1500 (it is not signed or dated).[3] Oberhuber believes that the Albertina watercolor is a repetition on vellum—albeit with a few changes in detail—of the Bayonne drawing and that both are by Dürer. The Woodner watercolor is quite different from the ones in Bayonne and Vienna. As the entry to the Christie's catalogue notes, the Woodner wing is shown from a different angle and belongs to a different bird, one clearly older than the one-year-old bird depicted in the Albertina version.[4] In addition, the wing is more ornithologically accurate than the Albertina drawing. As Oberhuber notes, the Woodner watercolor is somewhat drier and is more rationally organized than the Albertina drawing. He considers the stylistic distinction between the two the result of the evolution in Dürer's late style towards a more classical and less exuberant approach. He likens the difference to the handling of the fur in the *Portrait of Jacob Muffel* when compared with the portrait of a young man of 1507 in Vienna. Lastly, he notes the economy in the line, the use of washes, and the refinement of color in the Woodner drawing as points in favor of attribution to Dürer himself.

The Woodner drawing bears the date of 1524 and the AD monogram in black ink. Although much doubted at the time of the sale in July 1982, the issue of the authenticity of the monogram and date is quite difficult to resolve. Both the compiler and Christiane Andersson have independently noticed that under the existing date and monogram there are traces of earlier ones which have been gone over in black ink. Similarly, Oberhuber has pointed out that the format used here, with the monogram set between the numerals, may also be seen in Dürer's woodcut of the *Trinity* of 1511. Great caution should therefore be employed before dismissing the monogram and date as later additions.

Caution should in fact prevail in attempting to resolve the matter of whether the watercolor is by Dürer himself. It seems surely to have come from his workshop; it is a drawing of very great beauty in color and handling. It bears no relationship to watercolors by Hoffmann after Dürer, and, as Oberhuber notes, these are usually signed. Therefore, the Woodner drawing is either by the master himself or by a very able assistant.

1. Walter L. Strauss, *The Complete Drawings of Albrecht Dürer,* New York, 1974, p. 610, for a list of other versions.
2. *Die Dürer Zeichnungen der Albertina,* catalogue by Walter Koschatzky and Alice Strobl, Vienna, 12 October – 19 December 1971, no. 33.
3. Ibid.
4. Christie's, London, 6 July 1982, lot 107.

EXHIBITIONS: None.

BIBLIOGRAPHY: Walter L. Strauss, *The Complete Drawings of Albrecht Dürer,* New York, 1974, *Supplement* 2, 1982, *Appendix* 2:7a.

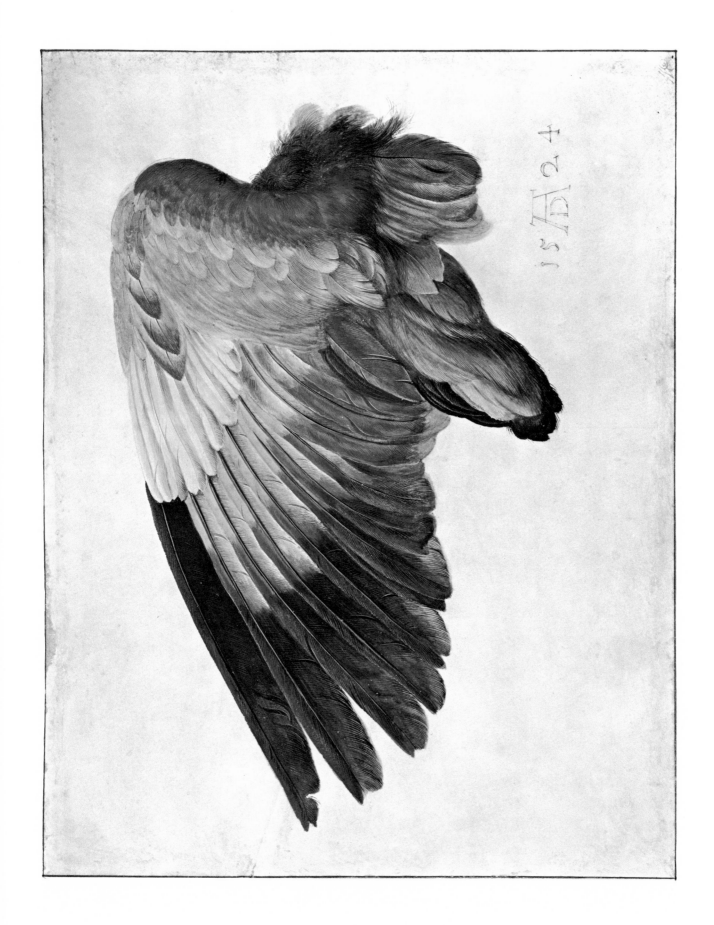

43 HANS HOLBEIN THE YOUNGER, attributed to

Augsburg 1497/8 – London 1543

Bust of a Young Man

Black, red, pink, and yellow chalks on cream colored paper; 300 x 195 mm.

PROVENANCE: Everhard Jabach (?) (Lugt Suppl. 299lb); S. von Festetits; Hofrat Dräxler (Drechsler) von Carin; Joseph Carl Ritter von Klinkosch (sale, Wavra, Vienna, 15 April 1889, lot 474); Baron Alfred Liebig; Baron H. Thyssen-Bornemisza; Countess Margit-Batthyany; William Schab (acquired 7 March 1960).

This drawing exists in a second version at Chatsworth (of smaller vertical size) which has sometimes been considered the original.[1] Ganz and Oberhuber have ascribed the Woodner drawing to Holbein himself, calling the Chatsworth drawing a copy, whereas Popham and Waterhouse favor the Chatsworth version.[2] Christiane Andersson has indicated that she does not accept the Woodner drawing as by Holbein. Oberhuber has pointed out that the Chatsworth drawing is less delicate than one expects from Holbein and shows a lack of understanding in the rendering of the clothing. No final resolution of this problem is possible until the two drawings can be seen side by side and along with securely attributed portrait drawings by Holbein. It should be recognized that it is not inconceivable that both were copied from a lost original by Holbein.

As is true of many of Holbein's portrait studies, it has been suggested that the drawing was reworked later.[3] This is a difficult and much-debated problem, in which recent scholars have tended to be much more lenient than was Ganz. Here, too, caution should prevail; and it may well be that the reworking is limited to minor additions of color, as on the lips. This drawing is a relatively early example of Holbein's use of colored chalk; as Mongan and Sachs noted, he was preceded in this by Leonardo and his circle.[4]

Ganz dated the drawing between 1524 and 1527, whereas Oberhuber prefers 1524-5. This seems perfectly reasonable in the context of datable works of the period.

1. *Old Master Drawings from Chatsworth; a Loan Exhibition from the Devonshire Collection,* catalogue by James Byam Shaw, circulated by the Smithsonian Institution, 1962-1963, Washington, D.C., 1962, no. 106, p. 42.
2. Paul Ganz, *Les Dessins de Hans Holbein le Jeune,* Geneva, 1939, no. 465, p. 196; Konrad Oberhuber, unpublished notes; *Old Master Drawings from Chatsworth,* catalogue by Arthur Ewart Popham, Arts Council of Great Britain, London, 1949, no. 54; Ellis K. Waterhouse, in *Catalogue of the Exhibition of Works by Holbein and other Masters of the 16th and 17th Centuries,* Royal Academy, London, 1950-1, vol. 1, no. 133, p. 63.
3. Ganz, op. cit., no. 465, p. 196.
4. Agnes Mongan and Paul J. Sachs, *Drawings in the Fogg Museum of Art,* Cambridge, Massachusetts, 1946, vol. 1, pp. 194-5.

EXHIBITIONS: Woodner Collection 1, no. 53.

BIBLIOGRAPHY: Gustav Friedrich Waagen, *Die vornehmsten Kunstdenkmäler in Wien,* Vienna, 1866-7, vol. 2, p. 196; Paul Ganz, *Les Dessins de Hans Holbein le Jeune,* Geneva, 1939, no. 465, Rudolf Heinemann, "Verzeichnis der Gemälde," in *Stiftung Sammlung Schloss Rohoncz,* Lugano-Castagnola, vol. 1, 1937-41, no. 198, pp. 73-74; Paul Ganz, *Handzeichnungen Hans Holbeins des jüngeren, in Auswahl,* Basel, 1943, no. 20; *Catalogue of the Exhibition of Works by Holbein and Other Masters of the 16th and 17th Centuries,* Royal Academy of Arts, London, 1950-51, vol. 1, no. 133, p. 64 (Ellis K. Waterhouse).

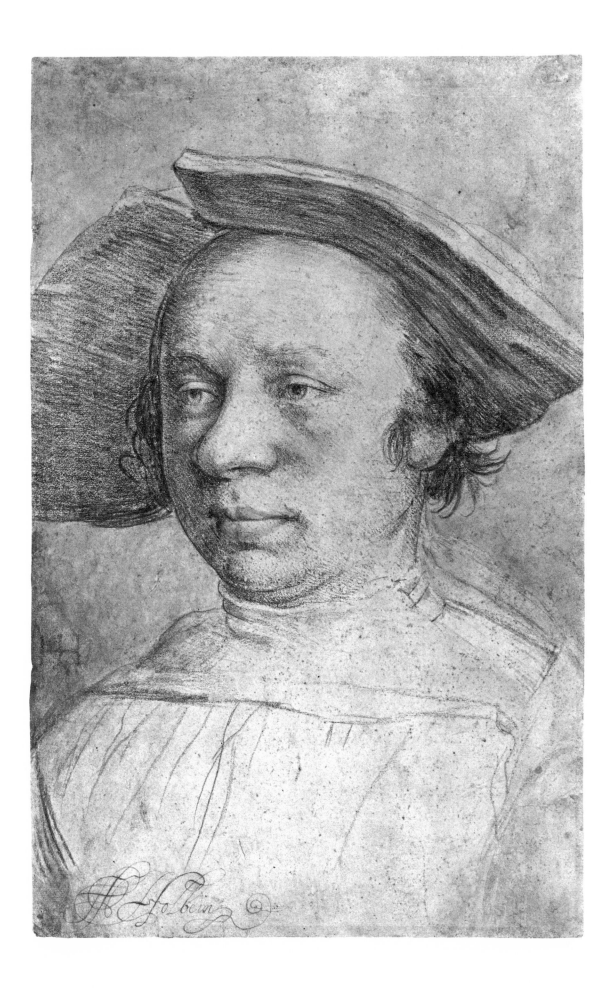

DUTCH
AND
FLEMISH
DRAWINGS

44 ALBERT BOUTS, attributed to

Louvain circa 1460 - Louvain 1549

The Four Latin Fathers of the Church

Pen and black ink (with slight retouching) on vellum; 160 x 215 mm. Inscribed in black ink in lower left corner, "Raph" and "Urbin", and in lower right corner, "1572" and "Roma".

PROVENANCE: Sotheby's, London, 13 July 1972, lot 1.

This drawing has been attributed to Albert Bouts on the basis of the close stylistic similarity between it and the sheet showing *Christ's Entry into Jerusalem* which Benesch first published as his in the catalogue of the Netherlandish drawings in the Albertina.[1] In addition, the two drawings were made in the same medium and are almost identical in size. The hypothesis that they are by the same master is accepted in the second Woodner catalogue and by Boon, though he denies that the artist in question is Albert Bouts.[2] Boon sees these two drawings as part of the earlier work of the so-called Aert Ortkens (or Pseudo-Aert Ortkens) group. Although there is some similarity between the Albertina and Woodner drawings and the Aert Ortkens drawings, Benesch was probably correct in differentiating the Aert Ortkens group and the Albertina drawing. The Albertina drawing results from a still fifteenth-century conception of the figure and its relative isolation in space as opposed to the more unifying sixteenth-century manner of integrating form and its ambient and the much more convincing rendering of light and atmosphere in the Aert Ortkens drawings.

The attribution of the Woodner and Albertina drawings to Albert Bouts is suggestive but hardly demonstrable. Benesch ascribed the Vienna drawing to him on the basis of similarities between it and Bouts' painting of the *Last Supper* and his altarpiece of the *Assumption of the Virgin,* both now in the Musées Royaux des Beaux-Arts, Brussels. The drawings share, with these and other Bouts' paintings, "phlegmatic types" with half-closed eyes and a characteristic manner of rendering drapery with clearly defined tubular ridges folding sharply into flat planes of fabric. The Woodner drawing should also be studied alongside the painting of *Christ in the House of Simon* in the Musées Royaux des Beaux-Arts, Brussels, in which a group of seated figures is shown with a comparable sense of restraint and isolation. Despite these similarities, no definitive attribution to Albert Bouts can be achieved, as there are no certain drawings by him with which the Albertina and Woodner sheets may be compared.[3]

1. Otto Benesch, *Die Zeichnungen der Niederländischen Schulen des XV. and XVI. Jahrhunderts,* Vienna, 1928, no. 27, pp. 5-6.
2. Woodner Collection 2, no. 76; Karel G. Boon, *Netherlandish Drawing of the Fifteenth and Sixteenth Centuries,* The Hague, 1978, vol. 2, p. 138.
3. The attribution to Bouts is accepted by Konrad Oberhuber.

EXHIBITIONS: Woodner Collection 2, no. 76.

BIBLIOGRAPHY: Karel G. Boon, *Netherlandish Drawings of the Fifteenth and Sixteenth Centuries,* The Hague, 1978, vol. 2, p. 138 and n. 7.

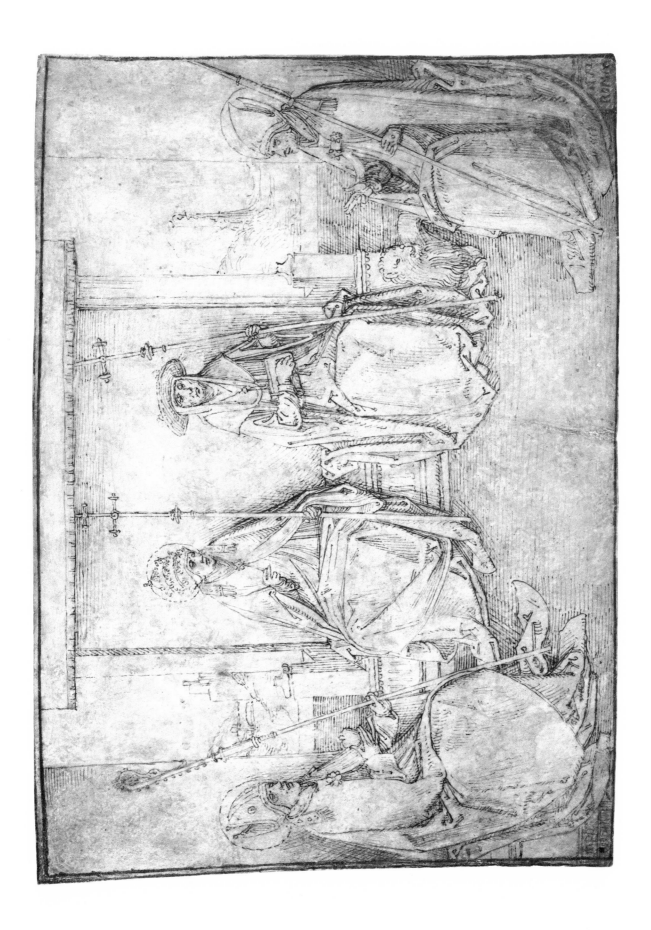

45 SIMON BENING, circle of

Late fifteenth – first half of sixteenth centuries

The Adoration of the Magi

Tempera with gold on vellum, attached to panel; 167 x 226 mm. On verso of panel, a red wax seal of coat of arms—shield flanked by rampant dogs, crown above with flanking flags, surmounted by a winged horse—with motto, "in Bello Forti(s)".

PROVENANCE: Alfred Morrison; by descent to Lord Margadale of Islay; Christie's, London, 20 March 1973, lot 116.

The Woodner illumination was produced for insertion into an already existing manuscript. Its composition is derived from a lost painting by Hugo van der Goes, which is known through a copy in the Berlin-Dahlem Museum and a freer adaptation by Gerard David in the Alte Pinakothek, Munich.[1] The Woodner miniature is closer to the painting by David, both in composition and in details. It also may be related to miniatures in the Breviary of Isabella of Spain (British Library) and to a miniature formerly in the Fauconnier Collection, Mons.[2]

The Woodner *Adoration of the Magi* is part of a group of manuscripts assigned to a Bruges-Ghent atelier active in the last decades of the fifteenth century and the first half of the sixteenth century. This workshop, which seems to have enjoyed a monopoly on Flemish luxury manuscripts of the period, is grouped around three masters: Alexander Bening, Gerard Horenbout, and Simon Bening. The attribution of these manuscripts remains problematic and is complicated by the volume of material and the frequent repetition of compositions and motifs drawn from paintings and other miniatures.

The difficulties are somewhat enhanced by the fact that the miniature formerly in Mons appears to be very close to this one and has the same donor. The Woodner miniature was attributed to Simon Bening in the 1973 Christie's sale catalogue and in the second Woodner catalogue.[3] It is, however, somewhat more decorative and less concerned with depth than is often the case with Simon Bening's work. It is perhaps best, therefore, to leave the attribution of the miniature to a specific hand open for the time being.

1. Max J. Friedländer, *Early Netherlandish Painting,* vol. 4, *Hugo van der Goes,* Leiden, 1969, p. 72, pl. 34.
2. Ibid., vol. 4, pl. 34, no. 20a (British Library, MS 18851 f. 41) and vol. 4, pt. 2, pl. 192, no. 181a (Fauconnier). Another version of the miniature is referred to by Friedrich Winkler, *Hugo van der Goes,* Berlin, 1964, p. 190, as in Detroit; but it is untraceable. In addition, the Christie's sale catalogue of 20 March 1973, lot 116, refers to still another variant in the H. Young Collection, New York, in 1928.
3. Christie's, 20 March 1973, lot 116; Woodner Collection 2, no. 77.

EXHIBITIONS: *Fanfare for Europe,* London, 1973, no. 37; Woodner Collection 2, no. 77.

BIBLIOGRAPHY: None.

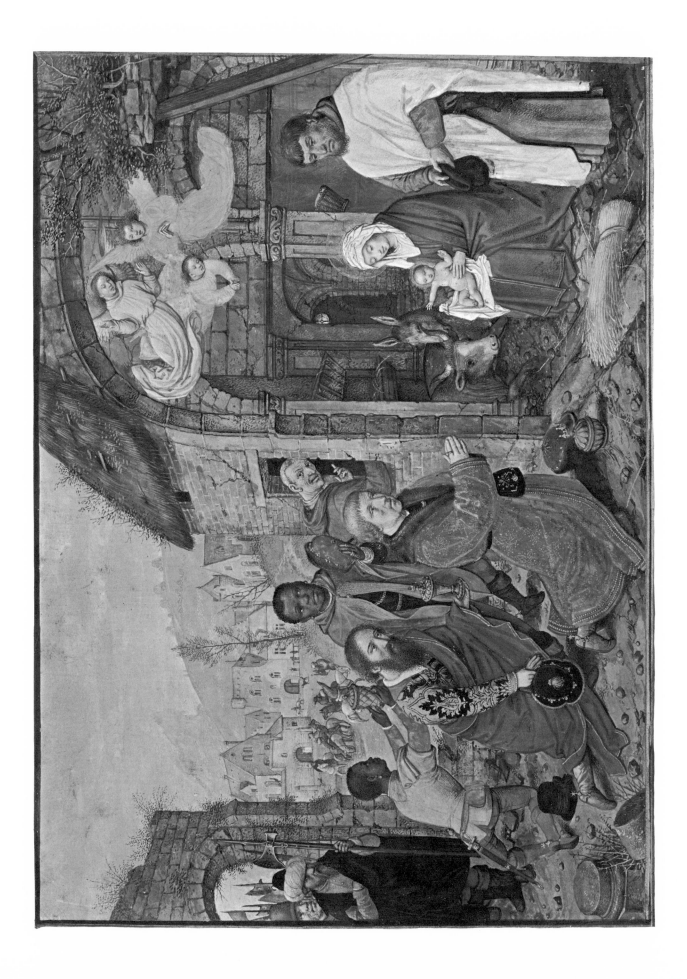

46 PIETER BRUEGEL THE ELDER

Circa 1525 Breda – 1569 Amsterdam

The Bagpipe Player

Pen and brown ink on light brown paper with heavy restorations in areas of loss (especially the figure's left foot); 205.5 x 145 mm. Inscribed on lower left edge in brown ink, "P. Bruegel f".

PROVENANCE: Hôtel Drouot, Paris, 20 May 1966, lot 11.

Bagpipers appear with some frequency in Bruegel's work, often shown leading the villagers in song in his genre paintings. Van Mander reports that Bruegel and his friends would dress as peasants and go into the country to mingle at peasant weddings and festivals.[1] This interest in peasant life reflects an overall sixteenth century current, and other artists such as David Vinckboons and Jan van de Velde also recorded peasant life.[2]

This drawing was first published by Charles de Tolnay who related it to three drawings which he regarded as close to the "Naer het leven" series (*The Shepherd,* Kupferstichkabinett, Dresden; *Four Men in Conversation,* Louvre, Paris; *The Painter and the Connoisseur,* Albertina, Vienna).[3] Although the "Naer het leven" group is now usually recognized as being the work of Roelandt Savery, the attribution of the Woodner drawing to Bruegel seems quite secure.[4] The assurance and economy of the line and the simple expressive clarity of the form relate it to the figures in the drawings of *Spring* and *Summer.*[5] Similarly, the crosshatching in these drawings is quite comparable to the technique in *The Bagpiper.* The roundness and solidity of *The Bagpiper* is somewhat disturbed by the reinforcement of the outlines by another hand. However, the overall effect is animated and vibrant, close in character to the late paintings of Bruegel and to drawings such as his *Spring* and *Summer.*

1. Carel Van Mander, *Dutch and Flemish Painters,* New York, 1936, p. 154.
2. Svetlana Alpers, "Bruegel's festive peasants," *Simiolus,* vol. 6, 1972-73, no. 3/4, pp. 171-173.
3. Charles de Tolnay, in *Miscellanea for I.Q. van Regteren Altena,* Amsterdam, 1969, pp. 62-63; idem, *The Drawings of Pieter Bruegel the Elder,* London, 1952, nos. 116 (Dresden), 117 (Paris), 118 (Vienna), p. 85.
4. Joaneath Ann Spicer, "The 'Naer Het Leven' Drawings: by Pieter Bruegel or Roelandt Savery?," *Master Drawings,* vol. 7, no. 1, Spring 1970, pp. 3-30.
5. C. de Tolnay, *Drawings,* op. cit., nos. 67 and 68, p. 76.

EXHIBITIONS: Woodner Collection 1, no. 61; *Pieter Bruegel d.A. als Zeichner,* Staatliche Museen Preussischer Kulturbesitz, Berlin, 19 September – 16 November 1975, no. 103, p. 89.

BIBLIOGRAPHY: Charles de Tolnay, "A Contribution to Pieter Bruegel the Elder as Draughtsman," *Miscellanea for I.Q. van Regteren Altena,* Amsterdam, 1969, pp. 62-63; Axelle de Gaigneron, "Ian Woodner, amateur américain de réputation mondiale, commente quelques oeuvres majeures de sa collection," *Connaissance des Arts,* no. 310, December 1977, p. 102; Egbert Haverkamp-Begemann, "Dutch and Flemish Figure Drawings from the Collection of Harry G. Sperling," *Master Drawings,* vol. 12, Spring 1974, p. 37, n. 1.

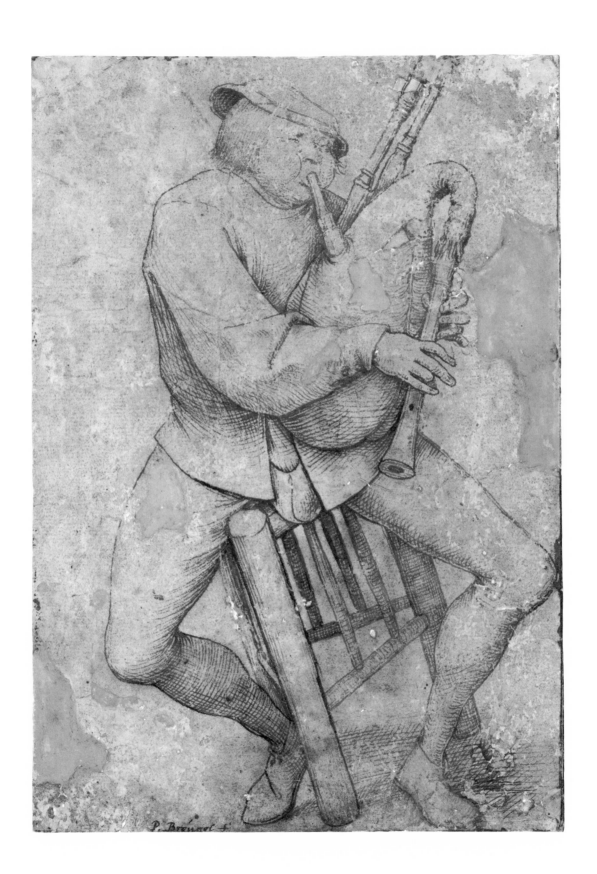

47 THE MASTER OF THE EGMONT ALBUMS

Active Netherlands (?), circa 1580-1600

The Good Samaritan Paying the Innkeeper

Pen and brown ink over black chalk on cream colored paper; 270 x 346 mm.

PROVENANCE: N. Chaikin, New York (1962, formerly with *St. Cecilia Playing the Organ Surrounded by Angels,* now private collection, Montreal); P. and D. Colnaghi, London; Sotheby's, London, 22 March 1973, lot 28.

This anonymous artist takes his name from six albums containing several of his drawings that were assembled by the first Earl of Egmont (1683-1748) and are now preserved in the Yale University Art Gallery.[1] The provisional name was given to him by Pouncey who began the process of gathering drawings by the same hand. The vigorous and highly-charged style of his drawings combines Italian and Netherlandish qualities. The facial types, relatively flat forms, and expressive distortions of space attest to a Northern origin. In addition, later inscriptions on some of the sheets attribute them specifically to artists of Northern origin: the German Hans von Aachen and the Netherlanders Jacob de Gheyn II, Frans Francken II, and Otto van Veen. Efforts have been made to identify the master with Anthonis Blocklandt and Domenico Beccafumi, but no consensus has yet formed around these or any other artist.[2]

The Woodner drawing shows an episode in the story of the Good Samaritan (*Luke* 10.25-37). In response to the question, "Who is my neighbor?" Jesus recounted the parable of a man set upon by thieves, stripped of his clothing, and left to die. A priest and a Levite separately came upon the man and passed by without helping him. Finally a Samaritan took pity on the victim, bound up his wounds, and brought him to an inn. Before departing the following day, the Samaritan paid the innkeeper and offered to pay for any further expenses in caring for the man. Jesus concluded by asking rhetorically, "Which of these three, do you think, proved neighbor to him who fell among robbers?" The Egmont Master has conflated two moments in the story, the taking of the wounded man into the inn and the payment to the innkeeper the next day.

The animated style of the Wooder drawing situates it firmly within the oeuvre of the Egmont Master.[3] The expressive gestures and genre-like ambient speak for its Northern heritage, though the nude figure of the wounded man owes much to Michelangelo's lost *Leda,* undoubtedly known to the Egmont Master through the print by Cornelis Bos since he shows the figure facing in the same direction as the print and reversed from the painting.

1. Egbert Haverkamp-Begemann and Anne-Marie S. Logan, *European Drawings and Watercolors in the Yale University Art Gallery: 1500-1800,* New Haven, 1970, vol. 1, pp. 265-267.
2. Karel G. Boon, *L'Epoque de Lucas de Leyde et Pierre Bruegel: Dessins des Anciens Pays-Bas Collection Frits Lugt,* Institut Néerlandais, Paris, 1980-1981, pp. 21-22, nos. 2 and 3.
3. For a discussion of the Master of the Egmont Albums' drawing style, see Hans Mielke, *Simiolus,* vol. 11, no. 1, 1980, p. 49.

EXHIBITIONS: None.

BIBLIOGRAPHY: Egbert Haverkamp-Begemann and Anne-Marie S. Logan, *European Drawings and Watercolors in the Yale University Art Gallery: 1500-1800,* New Haven, 1970, vol. 1, pp. 265-267, n. 2; Mary Cazort Taylor, *European Drawings from Canadian Collections, 1500-1900,* The National Gallery of Canada, Ottawa, 1976, no. 6; Hans Mielke, "review of K. G. Boon, *Netherlandish Drawings of the Fifteenth and Sixteenth Centuries; Catalogue of the Dutch and Flemish Drawings in the Rijksmuseum,*" vol. 2, *Simiolus,* vol. 11, 1980, p. 49.

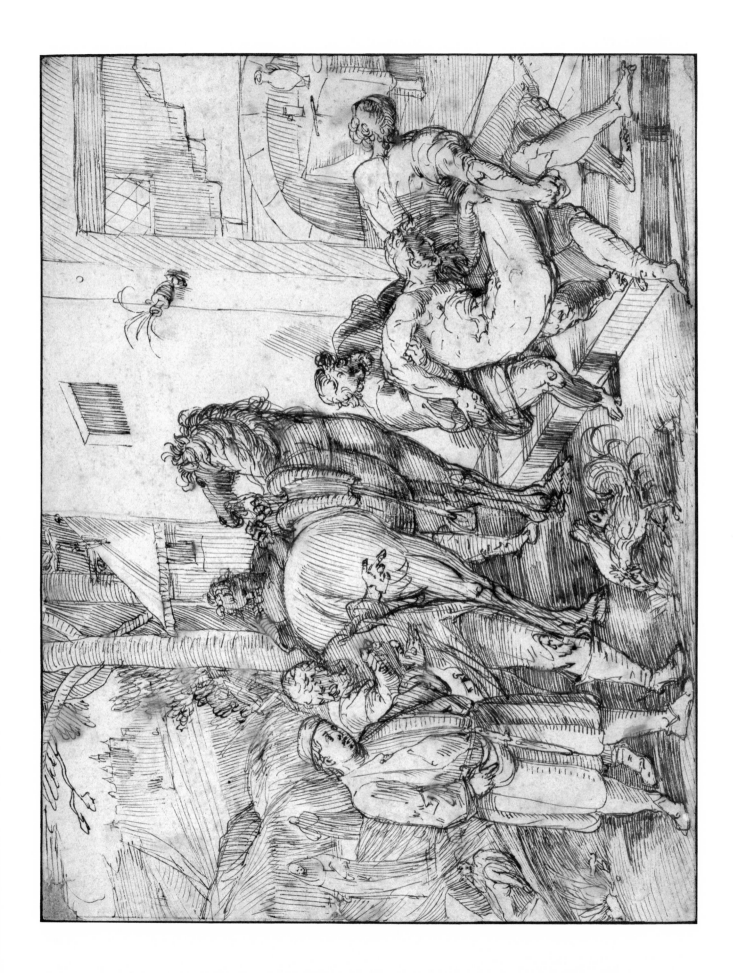

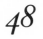

48 ABRAHAM BLOEMAERT

Dordrecht 1564 – Utrecht 1651

Acis and Galatea

Pen and brown ink with brown wash over black chalk on cream colored paper (watermark close to Briquet 7123); 314 x 298 mm. (roundel with flattened sides). Inscribed on verso in graphite, "Gernt... [illegible] cf. Pieters" and "130788".

PROVENANCE: Dr. Matthias Konrad Hubrecht Rech (Lugt 2745b); Sotheby's, London, 27 June 1974, lot 169.

The subject of this drawing is the story of Acis and Galatea from Ovid's *Metamorphoses.* In the foreground the two large figures of Acis and Galatea embrace. They are apparently oblivious to their imminent danger, though the pointing finger of Galatea is ambiguously suggestive. In the distant background the jealous Cyclops, having discovered their love-making, is shown crushing his rival with a boulder. In her grief Galatea then transformed her lover into a river. Two painted grisaille tondos by Bloemaert are known with scenes from the *Metamorphoses (Apollo and Daphne,* Busch-Reisinger Museum, Cambridge, Massachusetts, and *Arachne,* private collection, Mexico), which have been dated to circa 1592-6, and this drawing may have been made in connection with a third painting of the series.[1]

The Woodner drawing, as Tracie Felker has proposed, dates from circa 1592-5. She compares it to the painting of *Apollo and Daphne* (Museum der bildenden Künste, Breslau) which is dated 1592, in the use of exaggerated gestures, in the discontinuities of space, and in the figural proportions. Later in the 1590's Bloemaert moved to simpler compositions with fewer extreme contrasts of light. Lavin has shown that the *Apollo and Daphne* in Breslau and the two painted tondos were based upon engravings by Goltzius.[2] Felker has noted a similarity between the figures in the Woodner drawing and Goltzius prints such as the *Apollo and Coronis,* but there is no clear correspondence between the drawing and any surviving prints.

1. Marilyn Aronberg Lavin, "An attribution to Abraham Bloemaert: Apollo and Daphne," *Oud Holland,* vol. 80, 1965, no. 2, pp. 124-125.
2. Ibid., pp. 123-129.

EXHIBITIONS: None.

BIBLIOGRAPHY: None.

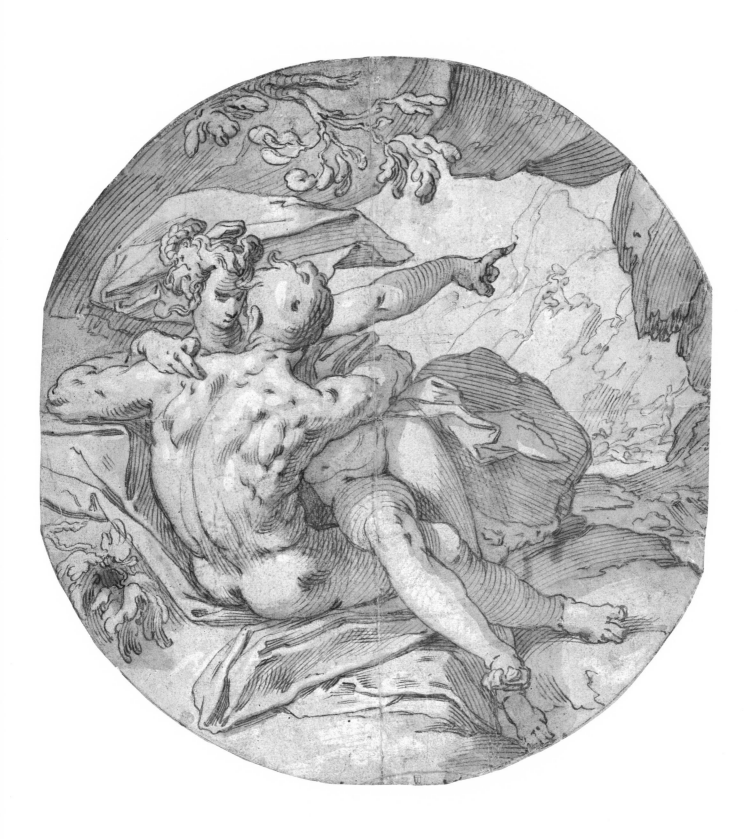

49 ROELANDT SAVERY

Courtrai 1576 – Utrecht 1639

Mountainous Landscape with Castles and Waterfalls

Black, ochre, red, and blue chalks on gray-green paper (watermark is close to Briquet 9722); 352 x 492 mm.

PROVENANCE: Friedrich Quiring (Lugt 1041b - 1041c); Herbert List; Hans M. Calmann (1973).

In 1604 Savery arrived at the imperial court of Rudolph II at Prague, joining such artists as Bartolomaus Spranger and Hans von Aachen. According to Sandrart, he was sent by the emperor to the Tyrol because of his gift for making mountain landscapes. His trip resulted in a wide range of drawings, many of which were used in subsequent paintings. The date of Savery's trip to the Tyrol is the subject of much debate. Based on the appearance of the mountainous terrain in the *Tyrolean Landscape* of 1606 in the Hermitage, Leningrad, Schulz argued that it took place in 1604, whereas Erasmus suggested 1606.[1] Spicer, by contrast, has convincingly proposed the spring of 1607, denying the Alpine character of the Hermitage painting and pointing to the *Travellers by a Waterfall,* of 1607, Ambras, as the first dated Alpine painting.[2]

Spicer considers the Woodner drawing to be among the earliest by Savery of an Alpine waterfall and proposes that the insertion of Roman-style ruins atop the cliffs is his acknowledgment of Tivoli as the source for the waterfall imagery. She also notes the "lack of finesse" in the drawing.[3] By contrast, Tracie Felker prefers a slightly later date for the Woodner sheet, suggesting that it was made soon after Savery's return to Prague rather than during his trip. She contrasts it with nature studies of the period, *Rocks* (Kunsthalle, Hamburg), and *Mountain Waterfall* (Institut Néerlandais, Paris), noting the greater freshness of detail in these drawings and the more schematic and abstract treatment of the rocks in the Woodner drawing. Although not susceptible of definitive proof, Felker's dating appears convincing. Schulz and van Hasselt had already speculated that many of Savery's Alpine views were drawn after his return to Prague.[4]

1. Kurt Erasmus, *Roelandt Savery, sein Leben und seine Werke,* Halle, 1908, p. 258, n. 9; Wolfgang Schulz, "Doomer and Savery," *Master Drawings,* vol. 9, Autumn 1971, p. 255.
2. Joaneath Spicer, *The Drawings of Roelandt Savery,* diss., Yale University, 1979, p. 13.
3. Ibid., p. 21.
4. W. Schulz, loc. cit; Carlos van Hasselt, *Flemish Drawings of the Seventeenth Century from the Collection of Frits Lugt, Institut Néerlandais, Paris,* 1972, p. 119.

EXHIBITIONS: Hamburg, 1965, no. 120; Woodner Collection 2, no. 80; *Old Master Drawings from American Collections,* catalogue by Ebria Feinblatt, Los Angeles County Museum of Art, 29 April - 13 June, 1976, no. 215, p. 198; *Drawings from the Holy Roman Empire: A Selection from North American Collections, 1540 - 1680,* catalogue by Thomas DaCosta Kaufmann, The Art Museum, Princeton University, 1982, p. 166, no. 61.

BIBLIOGRAPHY: Joaneath Spicer, *The Drawings of Roelandt Savery,* diss. (unpublished) Yale University, 1979, pp. 21, 64 ff., no. 18.

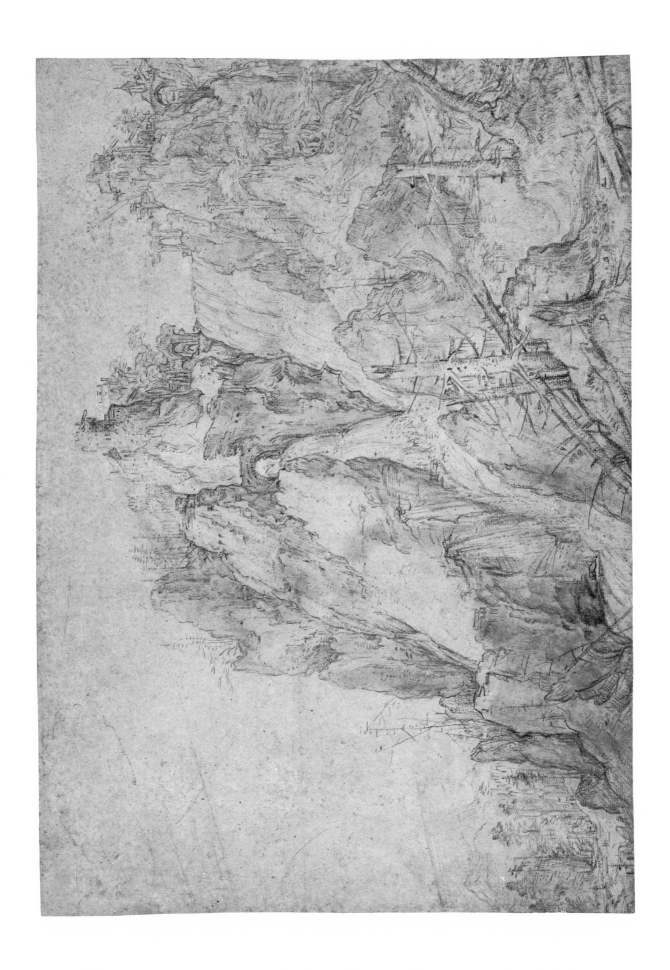

50 HENDRICK AVERCAMP

Amsterdam 1585 – Kampen 1634

Kolf on the Ice on the River Ijsel near Kampen

Pen and brown ink, watercolor, and gouache over black chalk on cream colored paper (watermark: a stylized bird with two wings displayed, similar to Heawood 195); 200 x 330 mm. Inscribed on recto in lower left corner in watercolor with artist's monogram "Ⱥ" and the collector's mark of William Esdaille (Lugt 2617); on verso in brown ink, "1833 WE (illegible) G. Hibbert's coll[n]", "Thomas van Campen", and the collector's mark of J. P. Heseltine (Lugt 1507).

PROVENANCE: George Hibbert: Stomme Van Campen; William Esdaille (Lugt 2617; Christie's, London, 24 June 1840, lot 1178); John Postle Heseltine; Henry Oppenheimer; Eric Oppenheimer (Christie's, London, 6 July 1976, lot 150); Christie's, London, 7 July 1981, lot 121.

Hendrik Avercamp was the first painter to develop and popularize the winter genre scene, although the type derives in part from several paintings by Pieter Bruegel the Elder. Avercamp combined the panoramic scope and high vantage point of Bruegel's work with a focus on anecdotal detail to create a new category of Dutch painting.

Within Avercamp's overall oeuvre, watercolors hold a prominent position. He often made them as finished works of art in their own right without any intention of developing them into paintings, presumably for the commercial market. In these "presentation drawings" Avercamp would sometimes use stock figure types. As Carlos van Hasselt has pointed out, the young, richly dressed couple at the right appears in a drawing in the Institut Néerlandais, Paris, and also in a sheet in the Rijksmuseum, Amsterdam. It should be added that the *kolf* player in the Woodner drawing is found at the center of another drawing by Avercamp in the Teyler Museum, Haarlem.[1] These repetitions may reflect drawings with standard figure types that Avercamp could use for more finished compositions. At the same time, Avercamp's watercolors show great spontaneity, and numerous pentimenti can be detected among the various figures of the Woodner sheet.

Avercamp's work is rarely dated, but a painting entitled *Skating on the Ice* (private collection), which seems to be dated 1620, is very close to the Woodner drawing.[2] By the time of this painting and the Woodner drawing, Avercamp had dispensed with the coulisse used in earlier compositions and, in a more or less static arrangement, had allowed the figures to predominate, while the architectural details dissolve into the atmospheric background.

1. Carlos van Hasselt, *Dessins Flamands et Hollandais du Dix-Septième Siècle,* Paris, 1974, no. 3, pp. 5-6.
2. Albert Blankert, *Frozen Silence,* Amsterdam, 1982, no. 10, p. 103.

EXHIBITIONS: *Commemorative Catalogue of the Exhibition of Dutch Art,* catalogue by Arthur Mayger Hind, Royal Academy, London, January–March 1929, no. 554; *Drawings by Old Masters,* catalogue by Karl Theodore Parker and James Byam Shaw, Royal Academy, London, 13 August – 25 October 1953, no. 329.

BIBLIOGRAPHY: John Postle Heseltine, *Reproductions of Original Drawings in Colour from the Collection of J. P. Heseltine,* Bushey, Herts., 1903, no. 4; Clara J. Welker, *Hendrick Avercamp en Barent Avercamp "Schilders tot Campen,"* Zwolle, 1933, no. 129, p. 253; *Illustrated London News,* Christmas edition, 1956, p. 20; Carlos van Hasselt, *Dessins Flamands et Hollandais du Dix-Septième Siècle,* Paris, 1974, no. 3, pp. 5-6.

51 PIETER JANSZOON SAENREDAM

Assendelft 1597 – Amsterdam 1665

Interior of St. Bavo Cathedral, Haarlem

Pen and brown ink and gray wash over graphite on two sheets of cream colored paper (joined horizontally), squared for transfer with red chalk; 490 x 357 mm.

PROVENANCE: Weigel Collection, Leipzig (no. 377); Vincent van Gogh (A.G.C. de Vries, Amsterdam, 16-17 July 1930, lot 162); J.M.C. Hoog, Haarlem; Edward Speelman, London; Lodewijk Houthakker, Amsterdam (no. x.24.m).

This is one of several drawings Saenredam made for his largest known painting, *The Interior of St. Bavo Cathedral,* now in the National Gallery of Scotland, Edinburgh. The Cathedral of St. Bavo was one of Saenredam's favorite subjects; he completed more than a dozen paintings of the church, each exploring it from a different visual aspect. It is interesting to note that throughout his career Saenredam preferred Romanesque and Gothic churches to contemporary structures.

Saenredam's use of preparatory drawings in his work can be well understood from the evolution of *The Interior of St. Bavo Cathedral*. He began with a rather free drawing, containing considerable detail, in which the actual proportions of the structure were treated rather casually (Municipal Archives, Haarlem, dated August 25, 1635). The next stage consisted of the preparation of a "construction drawing" that was much more precise, employing a consistent one-point perspective scheme. The Woodner drawing, according to Swillens, is the lower right portion of the large construction drawing for the painting, the lower left section of which is in the Haarlem Municipal Archives.[1] This latter part of the drawing bears Saenredam's inscription dated December 15, 1635, which provides a firm basis for dating the Woodner drawing. It is squared for transfer with red chalk lines, the method Saenredam used to enlarge this precise composition when he came to create the much larger painting in 1648.

The Woodner drawing contains qualities in addition to structure which are comparable to Saenredam's painted work. The magnitude of space, the subtle play of light and shade on the great walls of the church, and the overwhelming size of the church compared to its diminutive visitors are all exemplary of his overall accomplishment and intention.

1. P. T. A. Swillens, *Pieter Janszoon Saenredam,* Amsterdam, 1935 (reprint 1970), no. 87, p. 63.

EXHIBITIONS: *Pieter Jansz. Saenredam,* exhibition catalogue and catalogue raisonné, Centraal Museum, Utrecht, 1961, no. 61, pl. 63.

BIBLIOGRAPHY: P. T. A. Swillens, *Pieter Janszoon Saenredam,* Amsterdam, 1935 (reprint 1970), no. 86, pp. 39, 60-61, pls. 69, 69bis.

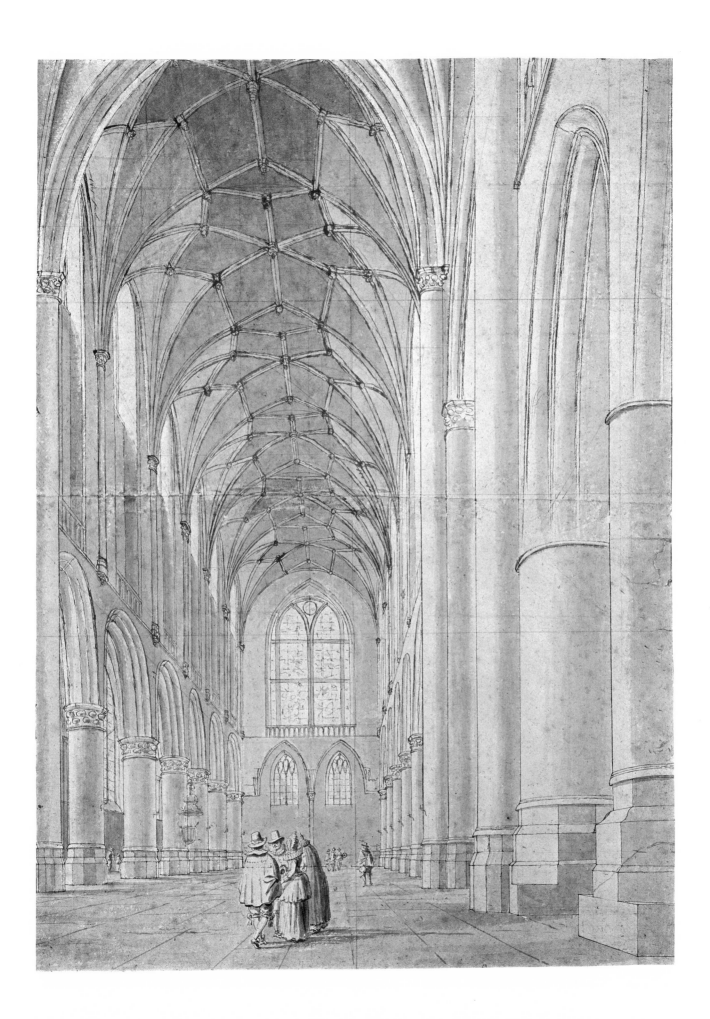

52 REMBRANDT HARMENSZOON VAN RIJN

Leiden 1606 – Amsterdam 1669

The Parable of the Publican and the Pharisee

Pen and brown ink with brown wash heightened with white on cream colored paper; 206 x 187 mm.

PROVENANCE: Jonathan Richardson, Sr. (Lugt 2183); Thomas Hudson (Lugt 2432); Mrs. Symonds (sale, Oxford, 11 April 1951); Sotheby's, London, 12 March 1963, lot 66.

Narrative themes comprise fully one-third of the roughly 1400 surviving drawings by Rembrandt. They were a means by which he could re-think dramatic and psychological meanings in time-honored subjects, as well as a vehicle for him to create compositional structure. In this drawing of the parable of the Publican and the Pharisee, Rembrandt isolates the two men within a vast architectural space. The diagonal arrangement of the foremost column at the left and of the row of columns at the right encourages a visual association and contrasts the two protagonists. The publican cannot lift his eyes to heaven and beats himself on the chest, while the pharisee gestures with his right arm extended, saying, "God, I thank thee, that I am not as other men are…or even as the publican" (*Luke* 18.11). The dramatic focus lies in the contrast of gestures, poses, and facial expressions. Rembrandt is exploring a narrative, correcting details (like the all-important hand of the publican gone over in white by him), and yet creating a unified and deeply moving scene.

 The Woodner drawing was first published by Benesch who dated it circa 1647, comparing it with two drawings of the *Presentation in the Temple* (Benesch 588 and 589), with a sheet of *Elijah and the Prophets of Baal* (Benesch 593), and with the etching of *The Marriage of Jason and Creusa* (Bartsch 112) which is signed and dated 1648.[1] The similarities he notes are telling, with the drawings in terms of graphic style and spatial setting and with the etching in the conception of space. The Woodner drawing is characteristic of Rembrandt's work in the 1640's when the rather brusque stroke of the reed pen replaced the more curving and baroque line of the previous decade.

1. "Neuendeckte Zeichnungen von Rembrandt," *Jahrbuch der Berliner Museen,* vol. 6, 1964, pp. 105-150, reprinted in Otto Benesch, *Collected Writings,* vol. 1, New York, 1970, p. 258.

EXHIBITIONS: Woodner Collection 1, no. 64.

BIBLIOGRAPHY: Otto Benesch, "Neuentdeckte Zeichnungen von Rembrandt," *Jahrbuch der Berliner Museen,* vol. 6, 1964, pp. 127-129, fig. 26; idem, *Collected Writings,* ed. by Eva Benesch, vol. 1, New York, 1970, p. 258; idem, *The Drawings of Rembrandt,* rev. and ed. by Eva Benesch, vol. 3, London, 1973, no. 587a, p. 159.

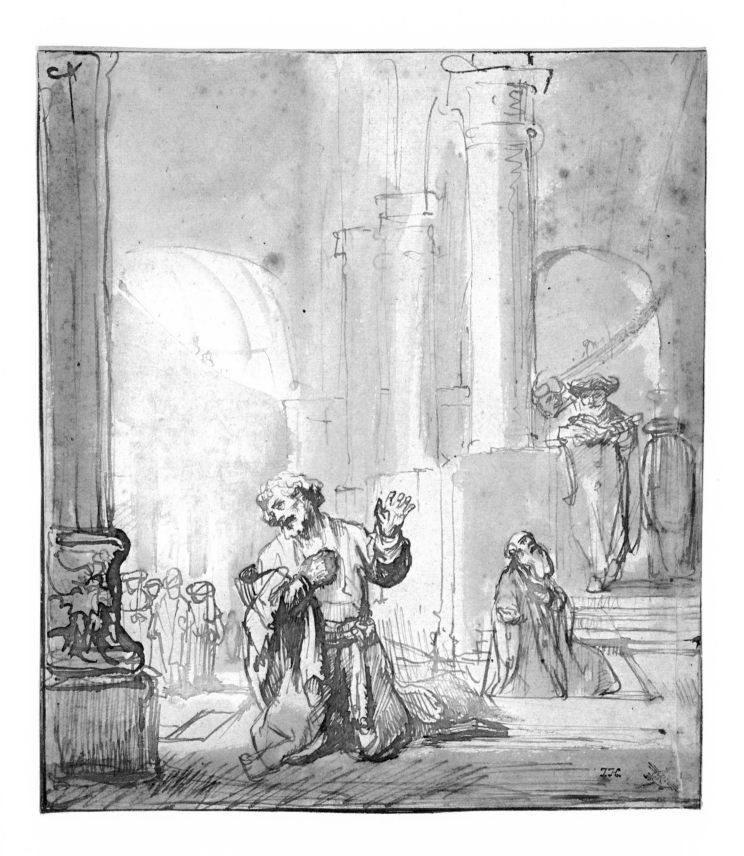

53 ROELANT ROGHMAN

Amsterdam 1627 – Amsterdam 1692

The Castle of Cuilemburg

Black chalk and gray wash on off-white paper (watermark: close to Heawood 1721a or 1724); 332 x 496 mm. Inscribed on verso in black chalk, "slos (?) te Cuillenborgh".

PROVENANCE: Probably Laurens Baeck; Albert (or Hillebrand) Bentes; Christian van Hoeck; Anthonie van Hoeck; Cornelis Ploos van Amstel (sale, Amsterdam, 3 March 1800, album KK, nos. 1-6).

This sheet belongs to a well-known series of 247 drawings by Roghman illustrating the castles and country manors of the northern Netherlands.[1] The series was perhaps commissioned by Laurens Baeck in the mid-1640's and remained intact until 1800.[2] The Woodner drawing depicts the castle of Cuilemburg, a fourteenth-century structure with many additions by Roghman's time. A second view of the castle from a different vantage point, showing only one structure in common with the drawing under discussion (the extreme left tower), is in the Teyler Museum, Haarlem.[3] These and the other drawings in the series demonstrate what Robinson called "the rage for documentation" in Holland at the time when the country was achieving religious freedom, political independence, and wealth.[4]

The impact of the drawing is one of simplicity and grandeur. The large geometric forms of the castle's structures are set behind a plane of water with their reflections. The variations of tonal value through the careful manipulation of gray wash lend variety and movement to the surface and illuminate the forms.

1. *Rembrandt and His Century; Dutch Drawings of the Seventeenth Century: From the collection of Frits Lugt, Institut Néerlandais, Paris,* catalogue by Carlos van Hasselt, Pierpont Morgan Library, New York, 8 December 1977 - 19 February 1978, 1978, p. 139.
2. Dr. Werner Sumowski has kindly confirmed his opinion of a date of 1646-47 and intends to publish his findings in volume 10 of his series, *Drawings of the Rembrandt School*.
3. *Drawings from the Teyler Museum, Haarlem,* catalogue by Johan Q. van Regteren Altena and Peter W. Ward-Jackson, Victoria and Albert Museum, London, 1970, no. 19, p. 23.
4. *Seventeenth Century Dutch Drawings from American Collections,* catalogue by Franklin W. Robinson, International Exhibitions Foundation, Washington, D.C., 1977, no. 26, pp. 28-29.

EXHIBITIONS: Woodner Collection 2, no. 83.

BIBLIOGRAPHY: None.

54 JAN VAN GOYEN

Leiden 1596 – The Hague 1656

Village Scene

Black chalk and gray wash on cream colored paper; 165 x 270 mm. Inscribed in lower right, monogrammed and dated, "VG 1653".

PROVENANCE: Bellingham-Smith sale (Amsterdam, 5 July 1927, lot 39); A. W. M. Mensing sale (Amsterdam, 27 April 1937, lot 224); Bernard Houthakker, Amsterdam; H. E. ten Cate, Almelo; C. G. Boerner, Dusseldorf; Alfred Brod, London; R. M. Light and Co., Santa Barbara, California (1981).

Van Goyen was an extremely prolific draughtsman, as is attested by the approximately 1500 surviving drawings by him. They fall into two major categories: cursory sketches from his wanderings in the Netherlands, which were made directly from nature and used later as the basis for paintings or finished drawings, and elaborate drawings which were conceived as complete works of art in themselves and are often signed with his monogram and dated. These finished drawings were the principal focus of Van Goyen's activity during several periods of his career. They are larger than the sketches and were made in his studio. The Woodner drawing is a fine example of this type of drawing. It is one of 225 signed and dated drawings by Van Goyen from 1653, which was part of a span of three years during which he expended more energy on these finished drawings than he did on paintings.

The Woodner drawing represents a fair or market day in a Dutch village. Goods are being sold from the canopied booths along the main street, and a crowd has gathered to watch a performance by a troupe of itinerant actors. Numerous drawings of this period by Van Goyen depict similar scenes; in fact, the same stage and actors appear in another finished drawing of 1653[1] (as pointed out by William Robinson). The *Village Scene* epitomizes Van Goyen's mature style. The play of light and shadow animates all the forms in the scene and creates a subtle fluctuation of tone through the use of varying combinations of chalk and gray wash.

1. Hans-Ulrich Beck, *Jan Van Goyen: 1596-1656,* vol. 2, Amsterdam, 1972, no. 378, p. 131.

EXHIBITIONS: *Dessins exposés chez Bernard Houthakker,* July/August, 1952, no. 29.

BIBLIOGRAPHY: D. Hannema, *Catalogue of the H.E. ten Cate Collection,* Rotterdam, 1955, no. 223; *Catalogue C.G. Boerner,* Dusseldorf, December, 1964, no. 56; *Catalogue Alfred Brod,* London, Winter 1963-66, no. 77; Hans-Ulrich Beck, *Jan Van Goyen: 1596-1656,* vol. 2, Amsterdam, 1973, no. 378, p. 131.

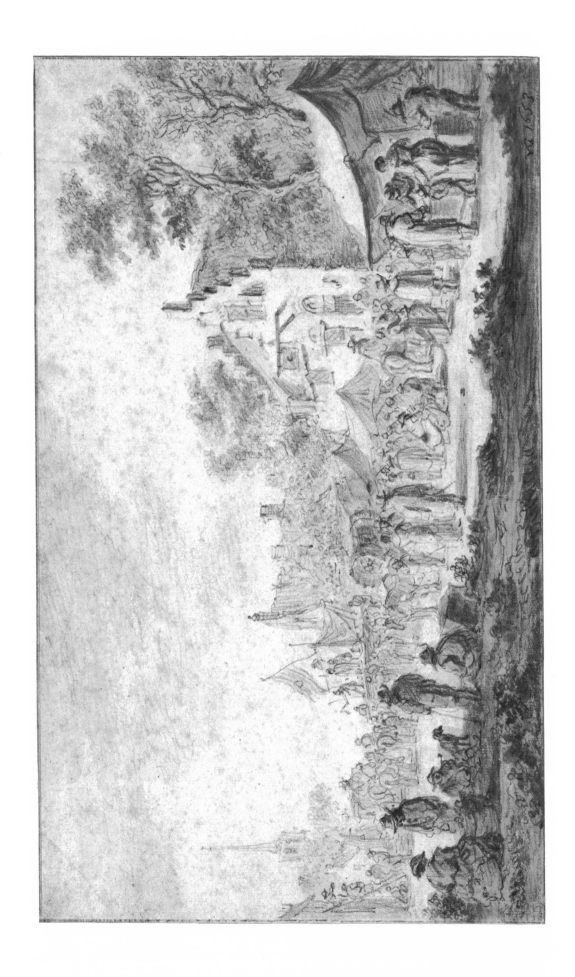

FRENCH
AND
SPANISH
DRAWINGS

55 FRANÇOIS QUESNEL

Edinburgh 1543 - Paris 1619

Portrait of a Lady (Catherine-Charlotte de Trémoille, princesse de Condé?)

Red, black, ochre, and white chalks on cream colored paper (watermark of grapes, very close to Briquet 13196); 285 x 224 mm.

PROVENANCE: Henri du Bouchet de Bournonville; his brother Jean-Jacques du Bouchet de Villeflix; Charles Wickert (Galerie George Petit, Paris, 3 May 1909, no. 43); Edward M. Hodgkins, Paris; Duveen Brothers (1941); William H. Schab Gallery, New York (1960).

The fashion for portrait drawings in chalk was a specifically French taste (with the notable exception of Holbein), fostered by Catherine de' Medici.[1] It enjoyed considerable, though relatively short-lived, popularity until the beginning of the seventeenth century. François Quesnel and his brother Nicholas, also an artist, were born in Edinburgh, the sons of Pierre Quesnel, a painter attached to the court of James V of Scotland. They moved to France in 1572 and worked for the courts of Henry III and Henry IV. The style of the Woodner drawing corresponds fully with the refined and elegant manner associated with François Quesnel and with the pictorial approach that Adhémar suggests separates him from other pastelists.[2] It reflects great subtlety in the suggestion of substance through the light chalk strokes on the dress and ruff and clarity in the more sharply defined areas of the face and hair.

French pastel portraits are rather generalized in comparison with those of Holbein. This makes the identification of individual sitters quite difficult, as individual features are submerged beneath the formal presentation which takes on the nature of a formula in drawings of this type. Nevertheless, a strong case exists for identifying the sitter as Catherine-Charlotte de la Trémoille, princesse de Condé. The primary basis for this identification is the resemblance between the sitter in the Woodner drawing and the engraved portrait of Catherine-Charlotte by Jaspar Isac.[3] The Isac portrait shows her at an advanced age—her garb is of the late 1620's—but the form and expressive character of her face are quite similar.

There are several other portrait drawings that have been identified as Catherine-Charlotte; they are Dimier 651, 930, 943, 951, and 1050 (Adhémar 150, 112, 443, 460, and 231, respectively).[4] Of these, the first four bear little or no resemblance to the woman in the Woodner drawing and the Isac engraving, while the last is unlikely to be Catherine-Charlotte if Dimier's date of circa 1600 is correct, since Catherine-Charlotte was thirty-five in 1600 and the woman in this drawing is much older. Possibly, Dimier's dating should be revised by about fifteen years.

Catherine-Charlotte de la Trémoille became the second wife of Henry I de Bourbon, a Protestant general and cousin of Henry of Navarre. In 1588 her husband died under mysterious circumstances, and she was accused of poisoning him. The evidence against her was insufficient, but she spent the next eight years in seclusion in Saint-Jean d'Angely until she was pardoned by Henry IV and the Parliament of Paris in 1596. As Miriam Stewart points

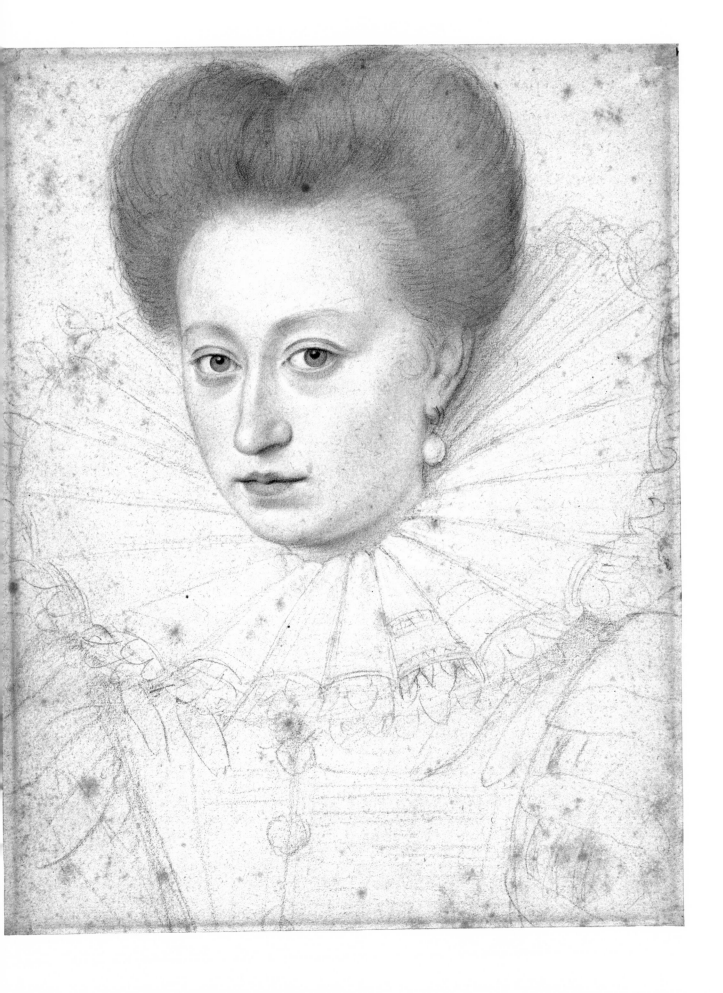

out, the costume in the Woodner drawing suggests a date between 1585 and 1595, and the drawing is unlikely to have been made while she was in seclusion. A date around 1585 would conform to her appearance as a woman in her early twenties.

1. Jean Adhémar, *Les Clouet & la Cour des Rois de France,* Paris, 1970, pp. 7, 11.

2. Ibid., p. 52.

3. Ambroise Firmin-Didot, *Les Graveurs de Portraits en France,* vol. 1, Paris, 1875-77, no. 982.

4. Louis Dimier, *Histoire de la peinture de portrait en France au XVI^e Siècle,* Paris, 1924; Jean Adhémar, "Les Portraits Dessinés du XVI^e Siècle au Cabinet des Estampes," *Gazette des Beaux-Arts,* vol. 82, September 1973, pp. 121-198.

EXHIBITIONS: *French Drawings and Water Colors,* The Toledo Museum of Art, 2 November - 14 December 1941, no. 3; Woodner Collection 1, no. 55.

BIBLIOGRAPHY: Louis Dimier, *Histoire de la Peinture de Portrait en France au XVI^e Siècle,* Paris, 1924, vol. 2, no. 1006; Etienne Moreau-Nélaton, *Les Clouets et leurs Emules,* Paris, 1924, vol. 3, p. 153; Axelle de Gaigneron, "Ian Woodner, amateur américain de réputation mondiale, comme quelques oeuvres majeures de sa collection," *Connaissance des Arts,* no. 310, December 1977, p. 106.

6 CLAUDE GILLOT

Langres 1673 - Paris 1722

Scene from the Italian Comedy
verso: *Ornamental and Architectural Studies*

Pen and brown ink with gray wash (recto) and graphite, pen, and brown ink (verso) on cream colored paper; 157 x 211 mm. Inscribed on verso in graphite with numerals.

PROVENANCE: Strolin et Bayser, Paris.

In the second Woodner catalogue this drawing was titled *The Illness of Harlequin,* but, as Eunice Williams has noted, there is no reason for this identification.[1] The scene shows seven figures within a stage-like space consisting of paired columns and archways, with a curtain drawn at left (a Baroque convention alluding to the stage). Williams suggests that the central figure may be Scaramouche, who is shown wearing a cape and tunic; he is smoothing his beard and moustache while looking into a mirror held by his companion, who wears a sword. She also notes that Pierrot may be the figure at the extreme right and that if Harlequin is present at all he is likely to be the kneeling figure at the left who is kissing the train of the woman next to him and who may be wearing his half-mask, although this is not entirely clear.

Gillot made many drawings of theatrical subjects; seventy-five of them appeared in the sale of Quentin de Lorengère in 1744 alone.[2] In the second half of the seventeenth century, the Comédie Italienne had established itself in France and achieved great success. It was banished by Louis XIV in 1697 after he was angered by a play, *La Fausse Prude,* which he believed to be aimed at his second wife, Madame de Maintenon. Members of the troupe remained in Paris, performing improvisational plays and adaptations of the material of the Comédie Italienne. Gillot's theatrical scenes date from the period of the banishment of the Comédie Italienne.[3]

As Williams points out, the Woodner drawing is a free sketch, with many reworkings by Gillot. In contrast to the sanguine washes of his more finished drawings, this was made with gray washes. It is executed with great freedom in the pen strokes; and the nervous, attenuated forms remind one of marionettes.[4] Perhaps the Woodner drawing is a first drawing, based loosely upon a performance which Gillot had just witnessed, and which he perhaps later intended to make into a more finished and readable composition.

On the verso, the bands of naturalistic foliage and formalized interlacing reflect Gillot's training under Audran. The arabesque style of Berain has been transformed into an open, lacy Rococo manner. In this respect, as in his work dealing with the theater, Gillot had a considerable influence on Watteau and on the evolution of the Rococo style.

1. Woodner Collection 2, no. 95.
2. Sale of Quentin de Lorengère, Paris, March 2ff, 1744 (Lugt 590).
3. Emile Dacier, "Les Scènes et Figures Théatrales de Claude Gillot, *Revue de l'Art,* vol. 45, 1925, pp. 44-45.
4. Bernard Populus, *Claude Gillot (1673-1722): Catalogue de L'Oeuvre Gravé,* Paris, 1930, p. 25.

EXHIBITIONS: Woodner Collection 2, no. 95.

BIBLIOGRAPHY: Joseph T. Butler, "Old Master Drawings from the Woodner Collection II," *The Connoisseur,* vol. 186, 1974, pp. 56-57.

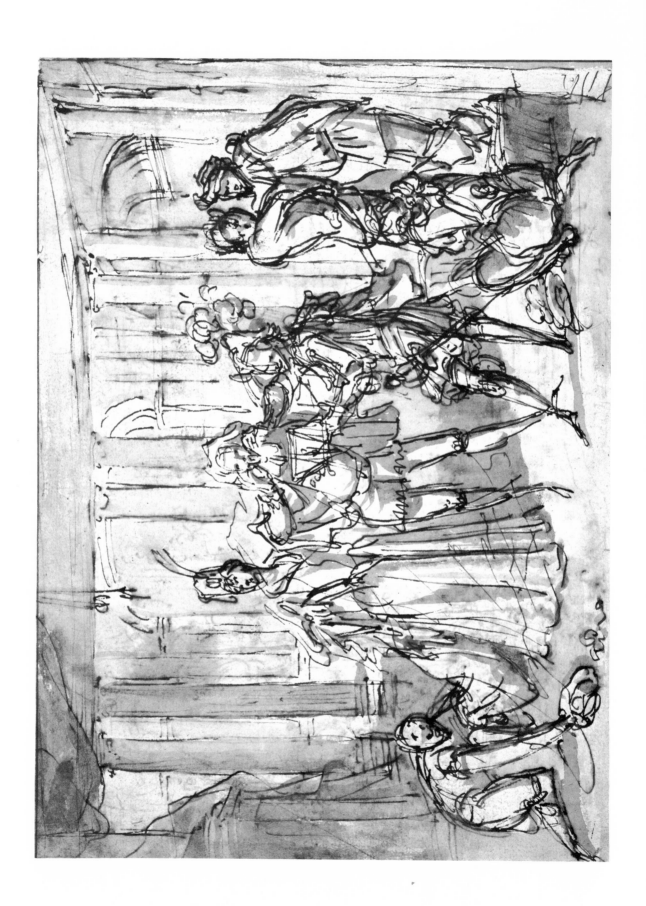

57 ANTOINE COYPEL

Paris 1661 – Paris 1722

Venus Crowned by Cupid

Red, black, and white chalk on blue-gray paper, squared for transfer; 327 x 241 mm. Inscribed on recto in lower right corner in brown ink with an illegible paraph and on the verso in graphite, "Coypel".

PROVENANCE: Baron Louis Auguste Schwiter (Lugt 1768), sale, Hôtel Drouot, Paris, 20–21 April 1883, lot 26; Strolin et Bayser, Paris.

Antoine Coypel was the second member of a dynasty of painters. He was a precocious student of his father Noël; when the latter was appointed director of the French Academy in Rome, Antoine had the opportunity to see the work of the Baroque artists of Italy such as Bernini and Maratta. When he returned to Paris in 1676, he broke with the Poussinist tradition of French classicism and moved towards a lighter and more colorist manner. He was quickly successful: accepted into the Academy at the age of twenty and made painter to the Duke of Orléans in the same year.

The subject of this drawing was identified in the second Woodner catalogue as the Triumph of Venus, but as Tracie Felker has noted, the figure is shown seated on clouds, not on the crest of waves as one would expect if it showed the Triumph of Venus.[1] She proposes that the drawing is related to the decoration of the Gallery of Aeneas that was commissioned from Coypel by the Duc d'Orléans in 1701.[2] The style of the Woodner drawing is closely comparable to the many surviving sketches of this kind (mostly in the Louvre, see for example nos. 2765, 2766, and 2832 in Guiffrey-Marcel).[3] They are in the same *trois crayons* medium, and the handling of light is very similar. It is difficult to associate the Woodner drawing directly with any specific figure in the Gallery of Aeneas program, though as Felker suggests, it may be a rejected sketch for the figure of Venus in *Vulcan Displaying the Arms of Aeneas,* to which it bears a considerable resemblance. After completing a preliminary sketch for the ceiling in 1702, Coypel made many preparatory studies in *trois crayons,* and by the summer of 1703 the ceiling was completed. He then began with four voussoirs, which include the scene of *Vulcan Displaying the Arms of Aeneas*; these were finished in 1705. It seems likely that the Woodner drawing would then date from about 1703–5. Finally, Coypel set aside the remainder of the work on this commission for a decade on account of other projects, bringing it to completion only in 1715.

1. Woodner Collection 2, no. 92.
2. Antoine Schnapper, "Antoine Coypel: La Galerie d'Enée au Palais Royal," *Revue de l'Art,* no. 5, 1969, pp. 33–42 describes the project and its evolution.
3. Jean Guiffrey and Pierre Marcel, *Inventaire général des Dessins du Musée du Louvre et du Musée de Versailles,* vol. 4, 1909, pp. 15–35.

EXHIBITIONS: Woodner Collection 2, no. 92.

BIBLIOGRAPHY: None.

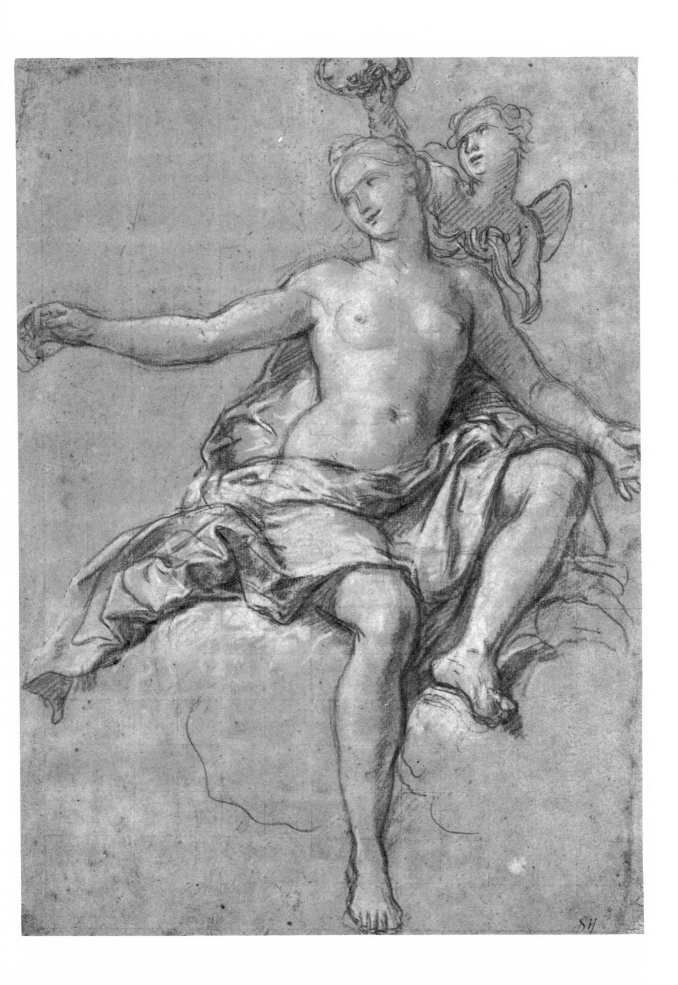

58 JEAN-BAPTISTE GREUZE

Tournus 1725 - Paris 1805

Head of the Paralyzed Father

Black, red, and white chalk (with the chalks stumped and wetted in places) on buff paper; 463 x 374 mm.

PROVENANCE: David Weill Collection, Neuilly; Cranbrook Academy of Art, Bloomfield Hills, Michigan; Sotheby's, London, 13 July 1972, lot 13.

This drawing of the head of an old man was probably made as a study early in the evolution of one of Greuze's most famous paintings, *Le Paralytique soigné par sa famille* (*Filial Piety*) or *Le Fruit de la bonne éducation* (*Fruit of a Good Education* —Greuze called it by this latter title), now in the Hermitage, Leningrad. The painting was exhibited at the Salon of 1763. In 1767 an engraving of the painting was made by Jean-Jacques Flipart and dedicated to Catherine II, Empress of Russia, who had purchased the painting the previous year for her gallery in St. Petersburg.[1]

The painting was in gestation for some time, and Greuze had exhibited a preparatory drawing for it at the Salon of 1761, which is now in the Musée des Beaux-Arts, Le Havre.[2] Diderot praised the painting highly and referred specifically to the beauty of the heads of the old man, his wife, and his son.[3] A further study of the old man, closer to the figure in the final painting, is in the Hermitage. It shows the old father in a much more deteriorated state than in the Woodner drawing. Related drawings are to be found in the Cafmeyer Collection, Paris (formerly?), and in the Yale University Art Gallery, New Haven, the latter a study for the bride's father in *A Marriage Contract*.[4] Other studies for *Filial Piety* are recorded but are not traceable.[5]

This monumental study demonstrates the extent to which Diderot was right when he pointed to Greuze's deep involvement with his subjects: "When he is working he is completely bound up in his work; he is deeply moved himself; he brings into the world the character of the subjects he is treating in his studio...."[6] At the same time, the drawing shows the full range of Greuze's subtlety, working with red, white, and black chalks to create an effect as rich in its graphic bravura as in its emotional impact.

1. Information conveyed by Baron Melchior Grimm in correspondence of 1767, quoted by Jean Martin, *Catalogue raisonné de l'oeuvre peint et dessiné de Jean-Baptiste Greuze,* Paris, 1905, no. 186, p. 15.
2. Jean Baptiste Greuze, 1725-1805, catalogue by Edgar Munhall, Wadsworth Atheneum, Hartford, Connecticut, 1976, no. 106, p. 21.
3. Denis Diderot, *Salons* (ed. Jean Seznec and Jean Adhémar), Oxford, 1957, vol. 1, p. 135 (quoted by E. Munhall, op. cit., p. 80).
4. Egbert Haverkamp-Begemann and Anne-Marie S. Logan, *European Drawings and Watercolors in the Yale University Art Gallery: 1500-1900,* New Haven, 1970, vol. 2, no. 53, pp. 30-31; E. Munhall, op. cit., p. 80.
5. See J. Martin, loc. cit.
6. D. Diderot, loc. cit.

EXHIBITIONS: *French Pastels and Drawings from Clouet to Degas,* Wildenstein, New York, 9 February - 2 March 1944, no. 45; Woodner Collection 2, no. 110.

BIBLIOGRAPHY: Gabriel Henriot, *Collection David Weill Dessins,* Paris, 1928, vol. 3, pt. 1, pp. 213-214; Edgar Munhall, *Jean-Baptiste Greuze, 1725-1805,* Wadsworth Atheneum, Hartford, Connecticut, 1976, p. 80, in no. 31.

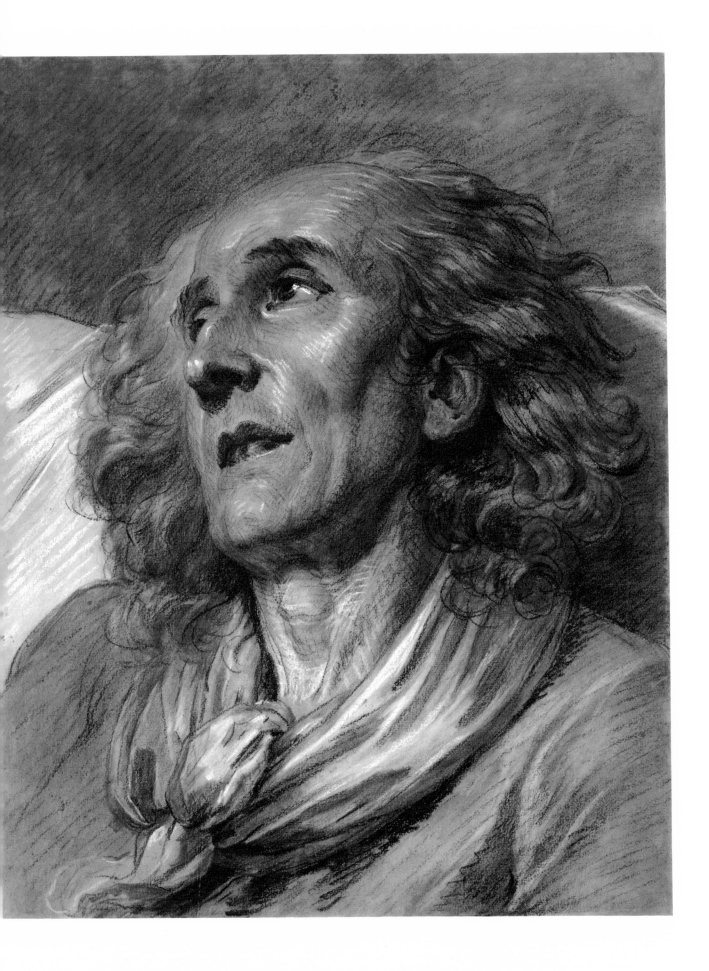

59 FRANÇOIS BOUCHER

Paris 1703 – Paris 1770

Seven Amorini (The Target)

Black and white chalk on tan paper (lightly foxed); lunette shape 255 x 852 mm. Inscribed on lower right, "F. Boucher 1765. f".

PROVENANCE: Randon de Boisset; Baron Alphonse de Rothschild, Vienna; Nathaniel de Rothschild, Vienna (sale, lot 274); Rosenberg and Stiebel, Inc.; Sydney L. Lamon, New York (Christie's, London, 27 November 1973, lot 317); Harry Michaels, Esq. (Christie's, London, 11 December 1979, lot 158); Thomas Agnew and Sons, with Spencer Samuels.

This is a fine example of a major preparatory drawing by Boucher for a decorative project, perhaps an overdoor. In subject, composition, and overall feeling it is analogous to three paintings of the following year that were formerly in the Renée de Becker Collection, Rome.[1] They, however, are of rectangular shape and therefore seem likely to have been made for a different project. In addition, a print of Louis-Martin Bonnet after another, presumably lost, version of this subject by Boucher was made two years after the artist's death in 1770; it too is of rectangular format.[2]

The drawing shows Boucher at his best as a decorative draughtsman. The use of black and white chalks is rich and creates a general effect of great luminosity. The playful conception and liveliness of action are highly characteristic of the artist and his age.

1. Christie's, London, 11 December 1979, lot 158; Alexandre Ananoff and Daniel Wildenstein, *L'Opera completa di Boucher*, Milan, 1980, nos. 622, 623, 624, p. 135.
2. Pierette Jean-Richard, *L'Oeuvre gravé de François Boucher dans la Collection Edmond de Rothschild*, Paris, 1978, no. 362, p. 117.

EXHIBITIONS: *Five Centuries of Drawings*, Montreal Museum of Fine Arts, 1953, no. 173.

BIBLIOGRAPHY: None.

60 PIERRE PAUL PRUD'HON

Cluny 1758 – Paris 1823

Female Allegorical Figure with Two Putti

Black and white chalk on blue paper; 131 x 125 mm. Inscribed on verso in graphite, "vue 19 1/2 21 / 21 22 1/2".

PROVENANCE: Galerie Heim-Gairac, Paris (1975).

This small drawing has sometimes been called the *Abduction of Psyche,* but, as Eunice Williams has pointed out, there is little to support this identification. The figure is shown flying, with draperies billowing out from her body and a putto who holds a torch guiding her ascent at her left arm. In her right arm she cradles a tablet or book, which has perhaps just been given to her by the second putto. As Williams has noted, these putti do not support her in the way that one finds in representations of the *Abduction of Psyche*.[1] Equally, the tablet (or book) and the torch and the classical wreath in her hair suggest that the female figure is allegorical in meaning, perhaps representing Truth or Wisdom. Given her pose and spatial position, she may well have been intended for a ceiling decoration.

Surrounding the primary image, especially at the upper left and lower right, are remains of sketches which indicate that this was once part of a larger sheet. Prud'hon typically began with small-scale exploratory notations from which larger schemes could be developed. Despite the limitations of scale and the undefined nature of an early sketch, Prud'hon imparts a feeling of great monumentality to the image. The white highlights on the torso and legs lend substance and contour to the form, which, in turn, owes much to the Italian Renaissance tradition.

1. Jean Guiffrey, *L'oeuvre de P. P. Prud'hon, peintures, pastels et dessins,* Paris, 1924, nos. 146, 148-151.

EXHIBITIONS: None.

BIBLIOGRAPHY: None.

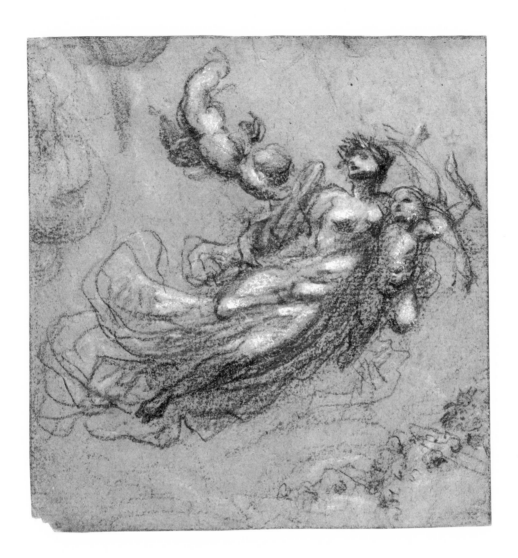

61 FRANCISCO JOSE DE Y LUCIENTES, known as GOYA

Fuendetodos 1746 - Bordeaux 1828

Loco Furioso (Raging Madman)

Soft black crayon on gray-green paper (watermark of large rounded heart with a trefoil); 193 x 145 mm. Inscribed on recto in black chalk, "Loco Furioso", "Goya", "3", and on verso in black chalk, "Goya".

PROVENANCE: Hyadès, Bordeaux; Jules Boilly, Paris; Hôtel Drouot, Paris, 19-20 March, 1869, lot 48; Leurceau; A. Strolin, Lausanne.

In 1824 Goya left the court of Ferdinand VII and his position as court painter and moved to France. He attended the Salon of 1824 and then settled in Bordeaux for the remaining four years of his life. During this period he produced more than twenty paintings, the lithograph series *The Bulls of Bordeaux,* and two albums of drawings which are now referred to as Albums G and H. The Woodner *Loco Furioso* is sheet 33 of Album G.

The Woodner drawing is from a series of thirteen illustrating various types of lunatics ("locos"). It is typical of Goya's late work, in which he frequently returns to the themes of superstition and madness and to the interplay of rational and irrational states. The "locos" range from figures suffering from social insanity (*Loco p.ᵣ errar – Mad through Erring*) to generic categories such as *Loco Africano*. Stuffmann relates the Woodner drawing to another in the series with the same *Loco Furioso* inscription by Goya.[1] In this latter example, however, the animated struggle of the Woodner figure is replaced by one who is debilitated by inner anguish. The Woodner drawing may also be contrasted with the *Loco Africano,* seen from within a cell rather than from the outside.

Goya's series of madmen in these drawings shows his continuing interest in a theme which had occupied him earlier, as in the paintings *Yard with Lunatics* (Meadows Museum, Dallas) of 1793-4 and *The Madhouse* (Prado, Madrid) of circa 1812-19. By tradition, insane people were portrayed as being demonically possessed, a popular attitude that arose from their association with witchcraft and religious damnation. Despite the power and expressive grandeur of his images of these people, Goya, unlike his contemporary Géricault, continued to represent them in this traditional way.

1. *Goya, Zeichnungen und Druckgraphik,* catalogue by Margret Stuffmann, Frankfurt, Städtische Galerie, 1981, p. 219.

EXHIBITIONS: Woodner Collection 2, no. 116; *Goya in der Krise seiner Zeit,* catalogue by Rainer Burbach, Württembergischer, Stuttgart, 1 April - 18 May 1980, no. 215; *Goya, Zeichnungen und Druckgraphik,* catalogue by Margret Stuffmann, Städtische Galerie im Städelschen Kunstinstitut, Frankfurt, 13 February - 5 April 1981, p. 219.

BIBLIOGRAPHY: A. L. Mayer, "Some Unknown Drawings by Francisco Goya," *Old Master Drawings,* no. 34, September 1934, pl. 22; Pierre Gassier and Juliet Wilson, *Goya, His Life and Work,* London, 1971, no. 1738, p. 339; Pierre Gassier, *Dibujos de Goya, Los Albumes,* 1973, no. G 3 (3) 391, p. 531; idem, *The Drawings of Goya, The Complete Albums,* New York, 1973, no. 391; Axelle de Gaigneron, "Ian Woodner, amateur américain de réputation mondiale, comme quelques oeuvres majeures de sa collection," *Connaissance des Arts,* no. 310, December 1977, p. 105; Jutta Held, *Francisco de Goya in Selbstzeugnissen und Bilddokumenten,* Hamburg-Reinbeck, 1980, p. 141.

Loco furioso

62 JEAN-AUGUSTE-DOMINIQUE INGRES

Montauban 1780 - Paris 1867

Portrait of Mlle. Louise Vernet

Graphite on off-white wove paper (laid down); 327 x 252 mm. Inscribed on lower left in graphite, "à Madame / horace Vernet, / Ingres Del / 1835 / à Rome".

PROVENANCE: Mme. Horace Vernet, née Louise-Jeanne-Henriette Pujol (to whom the drawing is dedicated, mother of the sitter); in the Delaroche-Vernet Family until 1952; Jean Dieterle Gallery, Paris (January 1952); Knoedler Gallery, New York (1952); Mrs. Charles Suydam Cutting (née Helen McMahon?), New York; Helen McMahon Cutting Sale +, Savoy Art and Auction Galleries, New York, 25-26 June 1964, lot 102.

Ingres made this portrait of Anne-Elizabeth-Louise Vernet shortly after his arrival in Rome in January 1835 to assume the directorship of the French Academy. Louise Vernet, who was just twenty-one at the time, was the great granddaughter of Moreau *le jeune* and the daughter of Horace Vernet, Ingres' close friend and predecessor as director. Later the same month she was married to the painter Paul Delaroche. Louise Vernet was a much admired young figure in the social circle of her father in Rome and was described as having "joined the beauty of antique statues to the charm of medieval virgins."[1]

The elegance and grace of Louise Vernet were well-suited to the direction of Ingres' portraiture at this point in his career. Naef has pointed to a growing idealization and spirituality in artists' conception of portraiture in the 1830's, qualities which are beautifully conveyed in Mlle. Vernet's face.[2] Her starkly pure and abstract face is enlivened by the billowing movement of her sleeves and the relatively free handling of the dress.

1. Amaury-Duval, "L'atelier d'Ingres, souvenirs par Amaury-Duval," Paris, 1878, pp. 2, 172f., quoted by Hans Naef, *The Art Quarterly,* vol. 20, 1957, p. 290.
2. Hans Naef, *Die Bildniszeichnungen von J.-A.-D. Ingres,* Bern, 1980, vol. 3, p. 214.

EXHIBITIONS: *Loan Exhibition of Paintings and Drawings by Ingres,* Knoedler, New York, 11-29 November 1952; *From the Collection of Mrs. C. Suydam Cutting,* Newark Art Museum, 8 February - 25 April 1954, no. 1; *Ingres in American Collections,* Paul Rosenberg Gallery, New York, 1961, no. 47, p. 45; *Nineteenth and Twentieth Century Master Drawings* (no catalogue), Museum of Modern Art, New York, 1965; *Ingres Centennial Exhibition, 1867-1967,* Fogg Art Museum, Harvard University, Cambridge, Massachusetts, 1967, no. 76; *Berlioz and the Romantic Imagination,* Arts Council of Great Britain, London, 17 October - 14 December 1969, no. 196; *Ingres in Rome* (shown but not included in catalogue), National Gallery of Art, Washington, D.C., 1971; *Eighteenth and Nineteenth Century French Drawings and Prints,* University Art Museum, University of Texas at Austin, 6 February - 20 March 1979, no. 9.

BIBLIOGRAPHY: Henri Delaborde, *Ingres, sa vie, ses travaux, sa doctrine,* Paris, 1870, no. 424, p. 313; Stuart Preston, "Ingres," *House and Garden,* vol. 104, October 1953, p. 169 (as Mme. Horace Vernet); Hans Naef, "Notes on Ingres Drawings, part II: Mademoiselle Vernet," *The Art Quarterly,* vol. 20, 1957, pp. 289-291; Mark Roskill, "Ingres, Master of the Modern Crisis," *Art News,* vol. 60, 1961, pp. 27-28, 57-59 (as Mme. Vernet); Hans Naef, *Die Bildniszeichnungen von J.-A.-D. Ingres,* Bern, 1980, vol. 2, p. 255, vol. 3, pp. 208-215, 244, 302, 303, 368, vol. 5, p. 214; Axelle de Gaigneron, "Les nouveaux choix de Mr Woodner," *Connaissance des Arts,* no. 348, February 1981, p. 78.

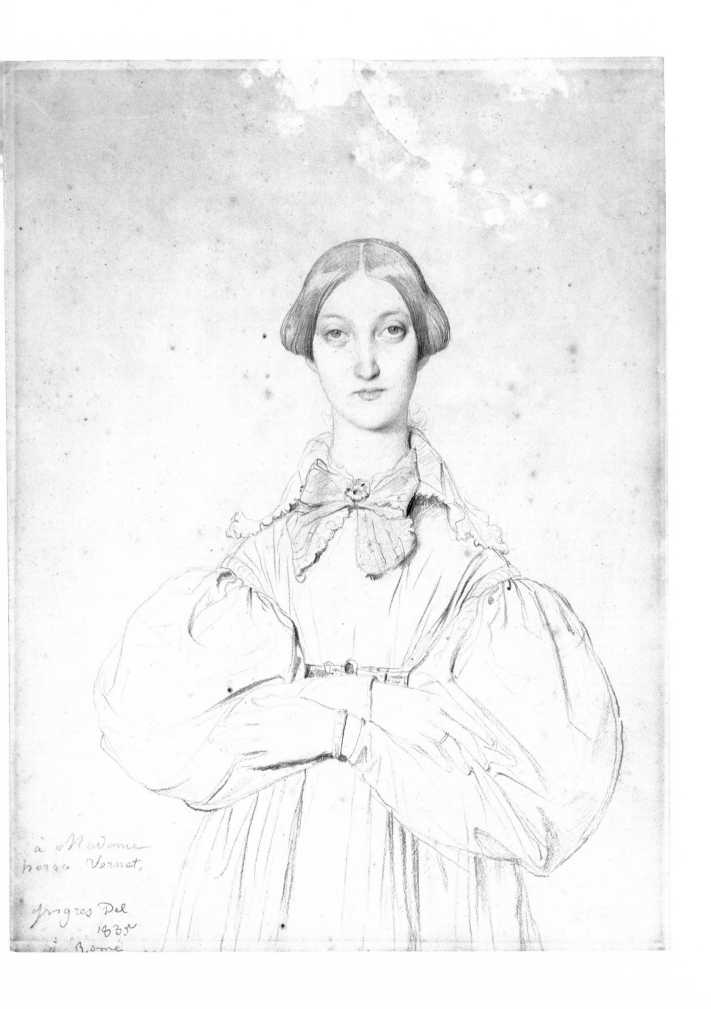

à Madame
horca Vernet,

Jngres Del
1835
à Rome

63 GUSTAVE COURBET

Ornans (Doubs) 1819 – La Tour-de-Peilitz 1877

Portrait of a Man (Urbain Cuénot?)

Charcoal and chalk heightened with white on blue-gray paper; 410 x 280 mm.

PROVENANCE: Gallery Claude Aubry, Paris; Adolphe Stein, Paris.

The identification of the sitter in this monumental portrait has been the subject of recent dispute. Fernier calls it either Jules Bracquemond or Félix Gaudy, a friend of Courbet and senator of the Départment around Doubs.[1] This identification would suggest a date of around 1867. Conversely, Margret Stuffmann has pointed to a close relationship between the drawing and Courbet's 1847 portrait of his friend *Urbain Cuénot,* now in the Academy of Fine Arts, Philadelphia.[2] The physiognomic details, as well as the general character of expression, support this proposal. Stuffmann has also convincingly compared the style and handling of this drawing to the *Self-Portrait with a Pipe* by Courbet in the Wadsworth Atheneum, Hartford, of 1847-8. The form emerging from a dark background, the great psychological impact, and details of graphic technique argue for this position.

This is one of the grandest and most imposing of all Courbet's drawn portraits. At the same time, it shows more sensitivity than the *Self-Portrait* mentioned above and casts the sitter in a mood of thoughtful introspection. It is also noteworthy for the subtle effects of light and shade, ranging from the full blacks at the edges of the sitter's clothing through a graduated scale up to the highlights on the face and chest. It is interesting to compare Courbet's technique in this respect with that of Seurat (see nos. 66, 67, and 68).

1. Robert Fernier, *La Vie et l'Oeuvre de Gustave Courbet: Catalog Raisonné,* Paris, 1978, vol. 2, no. 58, pp. 306-307.
2. *Courbet und Deutschland,* catalogue by Margret Stuffmann, Hamburger Kunsthalle, 19 October - 17 December 1978, no. 310, p. 340.

EXHIBITIONS: *Exhibition of Old Master Drawings in the Collection of Adolphe Stein,* Terry-Engell Gallery, London, 3 July - 19 July 1973, no. 98, pl. 81; *Courbet und Deutschland,* catalogue by Margret Stuffmann, Hamburger Kunsthalle, 19 October - 17 December 1978 and Städtische Galerie im Städelschen Kunstinstitut, Frankfurt-am-Main, 17 January - 18 March, 1978, no. 310, p. 340.

BIBLIOGRAPHY: B.N., "Current and Forthcoming Exhibitions," *Burlington Magazine,* July 1973, pp. 474-5, fig. 91; Robert Fernier, *La Vie et l'Oeuvre de Gustave Courbet: Catalog Raisonné,* Paris, 1978, vol. 2, no. 58, pp. 306-307.

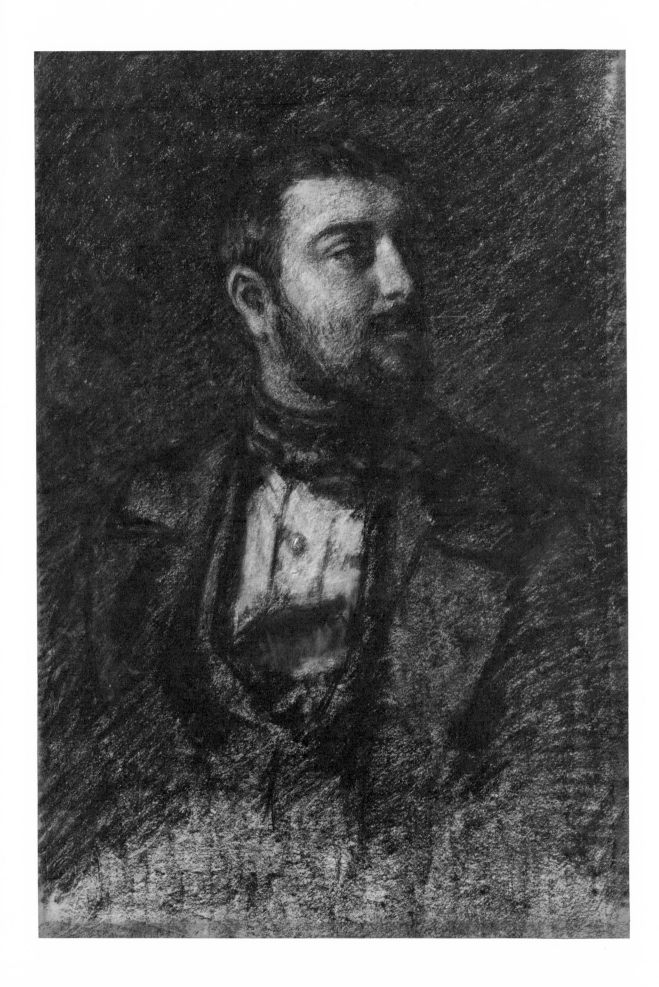

64 RODOLPHE BRESDIN

Frêne près Ingrandes 1822 - Sèvres 1885

Two drawings: (A) *Cavalière Orientale* and (B) *Cavalier Oriental*

(A) Pen and black ink with gray wash on cream wove paper; 272 x 183 mm. Inscribed on lower right in black ink, "rodolphe Bresdin/1858". (B) Pen and black ink on cream wove paper laid down to original mount (paper has darkened); 275 x 179 mm. Inscribed on lower center in black ink, "rodolphe Bresdin/1858".

PROVENANCE (A and B): Paul Prouté, Paris (*Dessins originaux, anciens et modernes,* 1978, no. 99).

These two drawings exemplify Bresdin's fascination with the theme of "oriental" riders; he returned repeatedly to this theme during the 1850's and 1860's in both prints and drawings. The exotic rider was a common subject in Romantic art, and Peters has suggested that Bresdin was inspired by paintings at the Salon of 1845—the *Sultan of Morocco* by Delacroix (Musée des Augustins, Toulouse) and *Ali Ben Ahmed, Caliph of Constantinople, followed by his Escort* by Théodore Chassériau (Musée National, Versailles).[1] The latter was in fact copied by Bresdin (Art Institute of Chicago, inv. no. 49-61). An equally Romantic stimulus may have been the action in the Crimean War, which ended in the same year as these drawings were made.[2]

Bresdin was himself a rather romantic figure, leading a picturesque though, if judged by material standards, not terribly successful life. He was a hermitic figure with a lyrical and poetic mind, which lends credence to Peters' idea that the female rider may be the "dream bride" of Bresdin's imagination.[3] He was appreciated in his time by great literary figures such as Victor Hugo and Charles Baudelaire but little noticed by fellow artists except Redon, whose etchings of riders in the 1860's were clearly inspired by Bresdin. His work is remarkably concentrated on the minutiae of nature and possesses great fineness and precision. His vision is often elaborate and remote, and yet the experiencing of Bresdin's art is highly intimate and personal, in part due to its extreme delicacy of touch.

1. *Die Schwarze Sonne des Traums, Radierungen, Lithographien und Zeichnungen von Rodolphe Bresdin (1822 -1885)*, catalogue by Albert Peters, Wallraf-Richartz-Museum, Cologne, 20 September - 19 November 1972, p. 42.
2. *Französische Zeichnungen aus dem Art Institute of Chicago*, catalogue by Margret Stuffmann, Städtische Galerie im Städelsches Kunstinstitut, Frankfurt, 10 February - 10 April 1977, p. 104.
3. *Schwarze Sonne,* op. cit., p. 72.

EXHIBITIONS: None.

BIBLIOGRAPHY: None.

65 GUSTAVE MOREAU

Paris 1826 – Paris 1898

Pittacus the Tyrant, in War Costume (study for the opera Sappho*)*

Graphite and watercolor on off-white paper (laid down); 329 x 183 mm. Inscribed on lower right in graphite, "Casque ou plumes bleues (?) / Baudrier / bâton de commandement / rouge saturne / Cuirasse & jambières / en or manteau & / tunique blancs ornements / noir & or. / PITTACUS- / Tyran- / Costume de Guerre / G M", and on lower left in graphite, "Opéra de Sapho".

PROVENANCE: Hôtel Drouot, Paris (4 March 1932, no. 99); Galerie J.-C. Gaubert, Paris (*Sources du fantastique,* 1973).

In 1883 the director of the Paris Opera commissioned costume designs from Moreau for Gounod's opera, *Sappho,* originally composed in 1851, which was to open again on April 2, 1884.[1] This drawing is one of twenty-three known designs by Moreau for this project. They were never used, however, perhaps on account of cost, and costumes by Eugène Lacoste were substituted.[2]

Sappho was a popular subject in the nineteenth century. She was featured in many literary interpretations and was painted by artists such as Baron Gros and Théodore Chassériau. Moreau himself had painted her several times before the costume commission which produced the Woodner drawing.[3]

This drawing was made for the costume of Pittacus, the tyrant of Mytilene. Moreau made several studies for Pittacus' costume, including one in the Fogg Art Museum, Cambridge. The Woodner drawing was probably made for Act III, Scene 2, in which Pittacus enters Sappho's house wearing battle garb. The costume is loosely based on authentic Greek armor. Pittacus is shown wearing a chiton beneath a splendidly detailed cuirass. The chlamys is fastened with a large brooch at the shoulders, and he wears greaves to protect his shins. The entire ensemble culminates in the fantastic helmet, which is vaguely reminiscent of the one worn by the Athena Parthenos but far more flamboyant. The richness of color and the graphic manner of the costume contrast with the rather severe and Archaic-looking face of the tyrant.

1. Pierre-Louis Mathieu, *Gustave Moreau, with a catalogue of the finished paintings, watercolors and drawings,* Boston, 1976, p. 348.
2. Ibid., p. 349.
3. Ibid., nos. 82, 83, and 473.

EXHIBITIONS: *Aspects du XIXe siècle français,* Galerie du Fleuve, Paris, January 1973, no. 50; *Sources du fantastique,* Galerie J.-C. Gaubert, Paris, 1973.

BIBLIOGRAPHY: Pierre-Louis Mathieu, *Gustave Moreau, with a catalogue of the finished paintings, watercolors and drawings,* Boston, 1976, no. 309, p. 348.

160

PITTACUS=
Tyran=

Opéra de Sapho=

Costume de Guerre

66 GEORGES SEURAT

Paris 1859 – Paris 1891

Nursemaid with Infant

Conté crayon on cream colored paper; 320 x 244 mm. Inscribed on verso in blue crayon, "g Seurat / £" and in red crayon, "312".

PROVENANCE: Seurat family; Octave Mirbeau; Mme. Vve. Octave Mirbeau; Dikran K. Kelekian; M. Albert Roothbert.

This is one of several drawings Seurat made depicting nurses, usually shown with small children. With one exception (a study for *La Grande Jatte*), they are independent studies, unconnected to paintings. Seurat's interest in this theme is an indication of his deep concern for the representation of common people. In this respect he follows the mid–nineteenth century tradition of artists such as Daumier and Millet. In the early part of the 1880's Seurat was especially intrigued by peasant scenes; this is a highly developed sample of this genre.

Technically, the drawing demonstrates Seurat's maturation as a draughtsman. His early drawings were often linear and academic, but he gradually evolved the method of drawing with conté crayon for which he is best known, with great masses of form constructed out of values of black, gray, and white. The opposition of bold areas of white and black produced an effect which he called "irradiation," frequently achieved by surrounding one value with its opposite so as to heighten its impact. This approach to the relationship of values and forms is in many ways analogous to the methods used by Rembrandt, and still more by Goya, in their prints. In fact, the Woodner drawing has been convincingly related by Herbert to Goya's etching entitled "Poor Dears" from the *Caprichos*.[1]

1. Robert L. Herbert, *Seurat's Drawings,* New York, 1962, p. 73.

EXHIBITIONS: *Georges Seurat Oeuvres Peintes et Dessinées,* L'Exposition de *La Revue Blanche,* Paris, 19 March – 5 April 1900; *Collection Octave Mirbeau,* Galerie Durand-Ruel, Paris, 24 February 1919, no. 52; *Collection Dikran K. Kelekian,* American Art Association, New York, 30 January 1922, no. 12; *Paintings and Drawings by Georges Seurat,* Joseph Brummer Galleries, New York, 4 – 27 December 1924, no. 31.

BIBLIOGRAPHY: Umbro Apollonio, *Disegni di Seurat,* Venice, 1945, pl. 2; Germain Seligman, *The Drawings of Georges Seurat,* New York, 1947, no. 54, pp. 24, 80, pl. 42; César M. de Hauke, *Seurat et Son Oeuvre,* Paris, 1961, vol. 2, no. 488, p. 92; Robert L. Herbert, *Seurat's Drawings,* New York, 1962, pp. 73-74, fig. 66; John Russell, *Seurat,* London, 1965, no. 130, pp. 87, 280; Denys Sutton, "A Don Juan of Idealism," *Apollo,* vol. 107, 1978, p. 51, fig. 7; Axelle de Gaigneron, "Les nouveaux choix de Mʳ Woodner," *Connaissance des Arts,* no. 348, February 1981, pp. 78-79.

67 GEORGES SEURAT

Paris 1859 – Paris 1891

Drawbridge in Paris

Conté crayon with touches of white chalk on cream colored paper (watermark: mic); 243 x 305 mm. Inscribed on verso in blue crayon, "a Seurat"; in graphite, "Mouss (?)", and at lower right in red crayon, "228".

PROVENANCE: Mr. and Mrs. Samuel A. Lewisohn; Mrs. David Crowell (daughter of Lewisohns); Mr. and Mrs. Sidney Simon.

From 1882 through 1885 Seurat became increasingly interested in scenes of urban industrial society. He frequently derived his subject matter from the Parisian industrial suburbs of Courbevoie and Asnières;[1] for example, his painting of *Une Baignade,* contemporary with this drawing, is set in Asnières. It is true that other artists had already responded to these themes in paintings such as Monet's *Gare Saint Lazare,* but Seurat offers a much more deeply interpretive approach to this type of subject. *The Drawbridge* does not include human figures, which is atypical, but this allows the artist to stress the brooding and barren quality of the setting. In the suggested grandeur of scale of the arms of the draw-bridge, one feels the overwhelming power and oppressiveness of the new industrial age.

The Drawbridge is exemplary of Seurat's fully developed use of conté crayon on rough paper. The choice of this sort of paper meant that the crayon would only graze the surface unless pressed strongly. This allowed him to explore wide ranges of black, grays, and white and to create both grand forms and striking light effects. The somewhat ambiguous relationship of plane and depth are enhanced by the swirling lines, perhaps inspired by the etching technique of Rembrandt.

1. Robert L. Herbert, *Seurat's Drawings,* New York, 1962, p. 89.

EXHIBITIONS: *Rétrospective Georges Seurat,* Galerie Bernheim-Jeune, Paris, 14 December 1908 - 9 January 1909, no. 113; *Modern Drawings,* The Museum of Modern Art, New York, February 1944, p. 97; *Nineteenth Century French Drawings,* California Palace of the Legion of Honor, San Francisco, 8 March - 6 April 1947, no. 150, p. 92; *Seurat: Paintings and Drawings,* Knoedler Gallery, New York, 10 April - 7 May 1949, no. 58; *Seurat Paintings and Drawings,* The Art Institute of Chicago, 16 January - 7 March, 1958, no. 45.

BIBLIOGRAPHY: John Rewald, *Georges Seurat,* New York, 1943 (reprint 1946) no. 44, p. 71; Jacques de Laprade, *Georges Seurat,* Monaco, 1945, no. 78; Germain Seligman, *The Drawings of Georges Seurat,* New York, 1947, no. 51, p. 78, pl. 39; John Rewald, *Georges Seurat,* Paris, 1948, no. 90, p. 131; Robert L. Herbert, "Seurat in Chicago and New York," *Burlington Magazine,* vol. 100, no. 662, 1958, p. 149, fig. 9; César M. de Hauke, *Seurat et Son Oeuvre,* Paris, 1961, vol. 2, no. 608, p. 190; Robert L. Herbert, *Seurat's Drawings,* New York, 1962, pp. 61, 81, fig. 83; John Russell, *Seurat,* London, 1965, no. 170, p. 189.

68 GEORGES SEURAT

Paris 1859 – Paris 1891

Les Saltimbanques

Conté crayon on cream colored paper (illegible watermark [letters] across top); 243 x 318 mm.

PROVENANCE: Paul Signac, Paris; Mme. Berthe Paul Signac.

In the latter part of the 1880's, Seurat shifted his attention to the popular entertainments of the city, as exemplified by this preparatory study of 1887 for *La Parade,* which was completed in 1888 and is now in the Metropolitan Museum of Art, New York. The life of street fairs, circuses, and vaudeville provided central themes for the literary and artistic world of Paris at that moment.[1] This interest was certainly not new in France, having its ancestry in the early eighteenth century world of Gillot and Watteau and, more recently, brought up to date by Degas. This was also the time in which poster art became important and began to interact with painting and printmaking.

Seurat approached this type of theme quite differently from his predecessors and from his contemporaries like Toulouse-Lautrec. He abstracted the forms from any specific, identifiable context, giving the theme—as is characteristic of Seurat—a timeless monumentality. It was undoubtedly from Degas that he borrowed the *repoussoir* spectator, but he does not use this figure as a means of involving the viewer by association into the scene. He employs the broad weave of conté crayon lines to flatten the image and to leave undefined the relationships of surface and three-dimensionality. In this respect also he differs from Degas, whose spatial organization frequently encourages the viewer to enter the painted space.

1. Robert L. Herbert, *Seurat's Drawings,* New York, 1962, pp. 121-122.

EXHIBITIONS: *Rétrospective Georges Seurat,* Galerie Bernheim-Jeune, Paris, 14 December 1908 - 9 January 1909, no. 173; *Les Dessins de Seurat,* Galerie Bernheim-Jeune, Paris, 29 November - 24 December 1926, no. 60; *A Selection of Paintings, Sculpture, and Works on Paper,* arranged by Richard Nathanson, The Fine Arts Society, Ltd., London, 20 June - 9 July 1977.

BIBLIOGRAPHY: Gustave Kahn, *Les Dessins de Georges Seurat,* Paris, 1928 (reprinted New York, 1971), pl. 65; César M. de Hauke, *Seurat et Son Oeuvre,* Paris, 1961, vol. 2, no. 670, p. 248; Robert L. Herbert, *Seurat's Drawings,* New York, 1962, fig. 106, pp. 122-3.

69 ODILON REDON

Bordeaux 1840 - Paris 1916

Cactus Man

Charcoal on tan wove paper (extensive scratch work, probably has been fixed); 490 x 322 mm. Inscribed on lower left, "Odilon Redon".

PROVENANCE: Marquis de Bouilly, Paris; private collection, London; Matthiesen Gallery, London; sold to Ian Woodner 15 July 1959.

Cactus Man finds its spiritual place among Redon's eerie images of the 1880's of flowering faces and fantastic combinations of plants, animals, insects, and humans. As Seznec notes, Redon's plants and animals often take on human characteristics; in *Cactus Man* the plant becomes human.[1] Redon was much admired by his contemporaries for his ability to create an imaginary world such as that evoked in this drawing. Redon believed that his originality consisted of

> bringing to life, in a human way, improbable beings and making them live according to the laws of probability, by putting, as far as possible, the logic of the visible at the service of the invisible.[2]

The head of the cactus man recalls images of Christ wearing the crown of thorns, while at the same time it shows an African influence, with Negroid features and the cactus thorns of the desert regions of that continent. Further complexity is added by the relief on the front of the vase, which recalls pseudo-antique Renaissance reliefs in paintings by artists such as Bellini and Titian; the subject is difficult to ascertain but may be Selene and Endymion.

Cactus Man is a brilliant example of Redon's use of charcoal. He said of this medium, "charcoal, a volatile matter which can be lifted in a breath, granted me the rapidity of a gestation conducive to the docile and easy expression of my feelings."[3] The rich, emotive use of black reflects Redon's belief that it "is the most essential of all colors" and that it "is an agent of the spirit far more than the fine color of the palette or the prism."[4]

1. Jean Seznec, "Odilon Redon and Literature," in *French 19th Century Painting and Literature,* ed. by Ulrich Finke, Manchester, 1972, p. 289.
2. "Odilon Redon à soi-même (Journal 1867-1915)" in Klaus Berger, *Odilon Redon; Fantasy and Colour,* trans. Michael Bullock, New York, 1965, p. 117 (1894).
3. From notes for a lecture delivered in Holland in 1913 in "Odilon Redon à soi-même," quoted in *Odilon Redon/ Gustave Moreau/Rudolphe Bresdin,* exhibition catalogue, The Museum of Modern Art, New York, 1961-1962, pp. 22, 47, n. 27.
4. *Odilon Redon à soi-même* in K. Berger, op. cit., p. 118.

EXHIBITIONS: Klaus Berger, *Odilon Redon 1840-1916, A Loan Exhibition of Paintings, Pastels and Drawings in aid of Corneal Graft and Eye Bank Research,* Matthiesen Gallery, London, May - June 1959, no. 15; *Odilon Redon/Gustave Moreau/Rodolphe Bresdin,* Museum of Modern Art, New York, in collaboration with the Art Institute of Chicago, 1961-62, no. 100, p. 59; *Retrospective Odilon Redon,* Biennale, Venice, 1962, no. 36; *Symbolists,* Spencer A. Samuels and Co., Ltd., New York, November 1970, no. 134.

BIBLIOGRAPHY: Klaus Berger, *Odilon Redon; Fantasy and Colour* (trans. Michael Bullock), New York, 1965, no. 621; Jean Seznec, "Odilon Redon and Literature," in *French 19th Century Painting and Literature,* ed. by Ulrich Finke, Manchester, 1972, p. 289, fig. 187; Axelle de Gaigneron, "Ian Woodner, amateur américain de réputation mondiale, commente quelques oeuvres majeures de sa collection," *Connaissance des Arts,* no. 310, December 1977, p. 105; Michael Wilson, *Nature and Imagination: the Work of Odilon Redon,* Oxford, 1978, fig. 12.

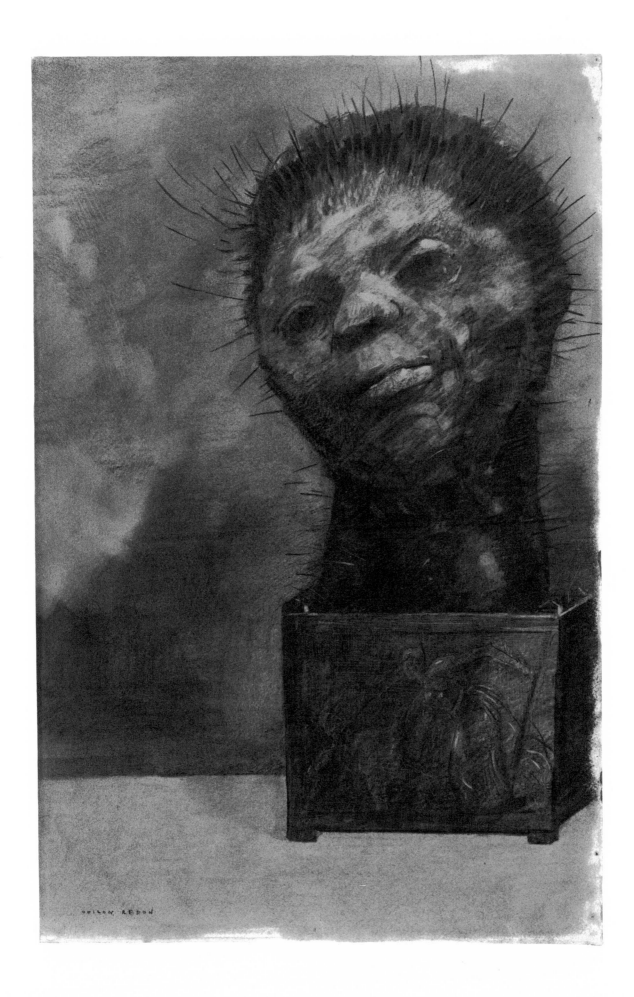

70 ODILON REDON

Bordeaux 1840 – Paris 1916

Diogenes

Charcoal on green-blue wove paper, framing lines in red chalk (by framer?); 523 x 374 mm. Inscribed in lower left in charcoal, "Odilon Redon"; on verso, in graphite, "16/56 x 73".

PROVENANCE: Ambroise Vollard; Muriel Julius, 2 March 1959.

This drawing apparently depicts the episode in the legend of the ancient Greek Cynic philosopher Diogenes in which he walked the streets of Corinth in the daytime with a lighted lantern, looking for a man. There is an implicit anomaly in Redon's depiction of the scene not in daylight but in extreme darkness, calling to mind his comment that "the title is justified only when it is vague, indeterminate and even tending to create confusion and ambiguity. My drawings *inspire,* and are not to be defined."[1] A further ambiguity is suggested by the face on the front of the lantern, which is more recognizably human than that of Diogenes himself. The finely tuned gradations, from the rich blacks of the shadows to the softly glowing lighter areas, are reminiscent of Rembrandt, an artist much admired by Redon who wrote of him, "Such drawing flows naturally and easily from the vision of the mysterious world of shadows, which Rembrandt revealed and endowed with a language."[2]

 The drawing seems to date from around 1890, a point at which the more clearly delineated forms of Redon's earlier drawings gradually give way to atmospheric and crepuscular visions, often with a more comprehensible depiction of space.

1. From "Odilon Redon à soi-même (Journal 1867-1915), Notes sur la Vie, l'Art et les Artistes," in Klaus Berger, *Odilon Redon: Fantasy and Colour* (transl. Michael Bullock), New York, 1965, p. 116.
2. Ibid, p. 117.

EXHIBITIONS: *19th and 20th Century European Drawings,* The American Federation of Arts, July 1965 - July 1966, no. 46; *The Academic Tradition,* catalogue by Sarah Whitfield, Indiana University Art Museum, Bloomington, 1968, no. 86.

BIBLIOGRAPHY: None.

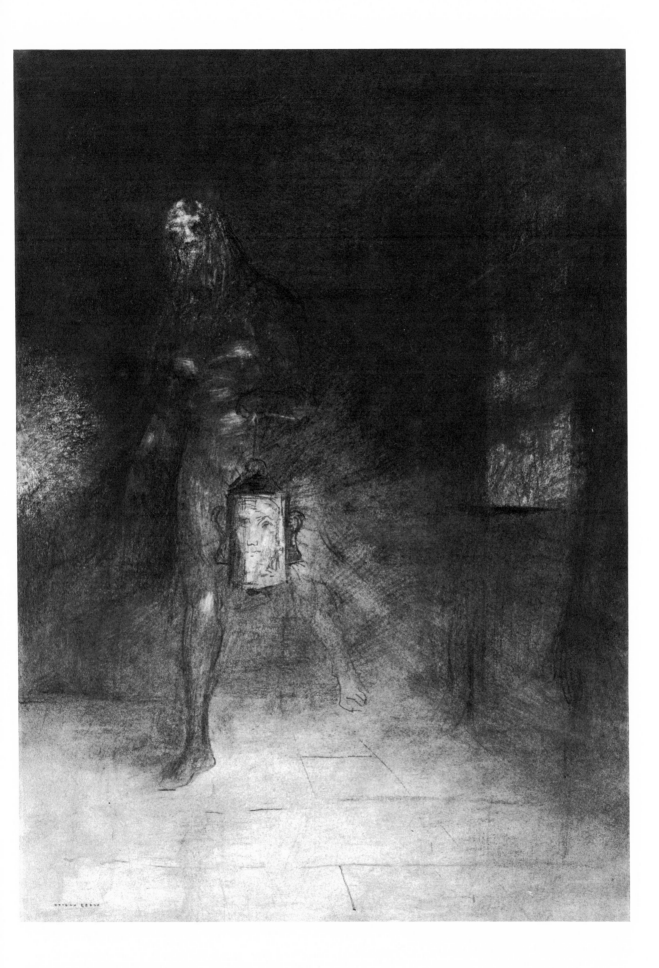

71 PAUL CÉZANNE

Aix-en-Provence 1839 – Aix-en-Provence 1906

Sloping Trees

Graphite on gray paper; 312 x 482 mm.

PROVENANCE: Thannhauser, Berlin; L. Lichtenhan, Basel; A. Deuber, Basel; Renée A. Daulte, Lausanne; Edwin Vogel, New York; Stanley Moss, New York.

This large sheet marks a point in the artist's rendering of a subject at which his forms become increasingly complex and agitated. The various trees and branches are presented as an impenetrable screen woven together by a combination of parallel and crossing diagonal rhythms. The overall impact is one of great dynamic force, reminiscent of the great bather paintings of the period (for instance, the example in the Philadelphia Museum of Art). At the same time, the forms are modeled so as to emphasize their individual contours, contrasting with the lack of depth in the composition as a whole. As Chappuis has noted, the effect of the drawing is one of melancholy despite the physical energy of the diagonal movement.[1]

1. Adrien Chappuis and Barbara Marchutz, *The Drawings of Paul Cézanne,* Greenwich, Connecticut, 1973, vol. 1, no. 1181, p. 266.

EXHIBITIONS: *Paul Cézanne: Offentliche Kunstsammlung,* Kunsthalle, Basel, 30 August - 12 October 1936, no. 145; *De Watteau à Cézanne,* Geneva, 1951, no. 89.

BIBLIOGRAPHY: Lionello Venturi, *Cézanne: son art, son oeuvre,* Paris, 1936, no. 1499; Adrien Chappuis and C. F. Ramuz, *Dessins de Cézanne,* Lausanne, 1957, pp. 44-45, 90; Adrien Chappuis and Barbara Marchutz, *The Drawings of Paul Cézanne: Catalogue Raisonné,* Greenwich, Connecticut, 1973, no. 1181; Lionello Venturi, *Cézanne,* Geneva, 1978, pp. 99, 164.

72 PABLO PICASSO

Malaga (Spain) 1881 – Mougins (France) 1973

Neapolitan Woman with a Fish

Graphite on off-white paper; 322 x 233 mm. Inscribed in lower left in graphite, "Picasso / 19" [1919].

PROVENANCE: Léonce Rosenberg, Paris (Sotheby's, London, 7 November 1962, lot 45).

This is one of a series of drawings of Neapolitan women selling fish that Picasso executed in Paris in 1919, based upon postcards he collected while visiting Naples in the spring of 1917.[1] He traveled to Naples with Stravinsky to gather material for the ballet *Pulchinella* which Diaghilev was producing for the Ballets Russes. Picasso designed the curtains, stageset, and costumes for the production, which was based on a Comedia dell'arte manuscript of 1700; the first performance was given in 1920. The drawings of the Neapolitan women served as the basis for the costume of Pimpinella, Pulchinella's sweetheart. Picasso collaborated with Diaghilev on other ballet projects during this period: *Parade* (1917), *Le Tricorne* (1919), and *Cuadro Flamenco* (1921). He married Olga Koklova, one of the dancers, in 1918.

The style of the *Neapolitan Woman with a Fish* is the extremely refined classical manner which Picasso used simultaneously with his "synthetic cubist" style during this period. Despite the absence of any modeling, the form attains grandeur and monumentality.

1. Douglas Cooper, *Picasso et le théâtre,* Paris, 1967, p. 43. For related drawings, see Christian Zervos, *Pablo Picasso, Oeuvres de 1917-1919,* vol. 3, figs. 243, 244, 246, vol. 6 (supplement), 1954, p. 161, fig. 1349.

EXHIBITIONS: None.

BIBLIOGRAPHY: Christian Zervos, *Pablo Picasso, Oeuvres de 1917-1919,* Paris, 1949, vol. 3, fig. 245.

73 HENRI MATISSE

Cateau – Cambrésis 1869 – Nice 1954

Seated Woman

Charcoal on off-white paper (watermark: ⬡); 562 x 478 mm. Inscribed on lower left in charcoal, "Henri / Matisse / Sept. 40" and on verso in graphite, "p h".

PROVENANCE: Stanley Moss, New York.

Matisse made this drawing shortly after arriving in Nice in August, 1940. He went there every year, because he appreciated "the richness and the silver clarity of the light"[1] and the tranquillity of the setting. He worked in a concentrated manner, drawing female models for six hours a day. Anxious about the war and about his declining health, he would have motion picture agents send him pretty girls for these drawing sessions because they did not need to be "animated" by him.[2] Often Matisse would work on a series of drawings or of drawings and paintings which were variations on a single pose. He wrote, "When I take a new model, I intuit the pose that will best suit her from her unselfconscious attitudes of repose, and then I become the slave of that pose."[3]

Matisse considered line drawing "the purest and most direct translation of [his] emotion."[4] However, before reaching that stage, he would begin with "a less rigorous medium"[5] such as charcoal, which would permit him to consider all of the variables. The Woodner drawing is a fine example of this stage in his work, showing a number of adjustments and variations of form. It is filled with vitality and rhythmic animation, creating a sense of liveliness in form and mood. In these respects it fulfills Matisse's statement that he

> never considered drawing as an exercise of particular dexterity, rather as principally a means of expressing intimate feelings and states of mind, but a means deliberately simplified so as to give simplicity and spontaneity to the expression which should speak without clumsiness, directly to the mind of the spectator.[6]

1. Jack D. Flam, *Matisse on Art,* New York, 1978, p. 93.
2. Pierre Matisse letter, in Alfred J. Barr, *Matisse: His Art and His Public,* The Museum of Modern Art, New York, 1951, p. 256.
3. Flam, op. cit., p. 82.
4. Ibid., p. 81.
5. Ibid.
6. Ibid.

EXHIBITIONS: None.

BIBLIOGRAPHY: Axelle de Gaigneron, "Les nouveaux choix de Mr Woodner," *Connaissance des Arts,* no. 348, February 1981, p. 78.

INDEX

Index by catalogue entry numbers

Design by Patrick Dooley
Camera work by Meriden Gravure Co. and Swan Graphics
Typography by Andresen Typographics, Los Angeles
Printed by Meriden Gravure Co.